THE SATURDAY EVENING POST

NORMAN ROCKWELL REVIEW

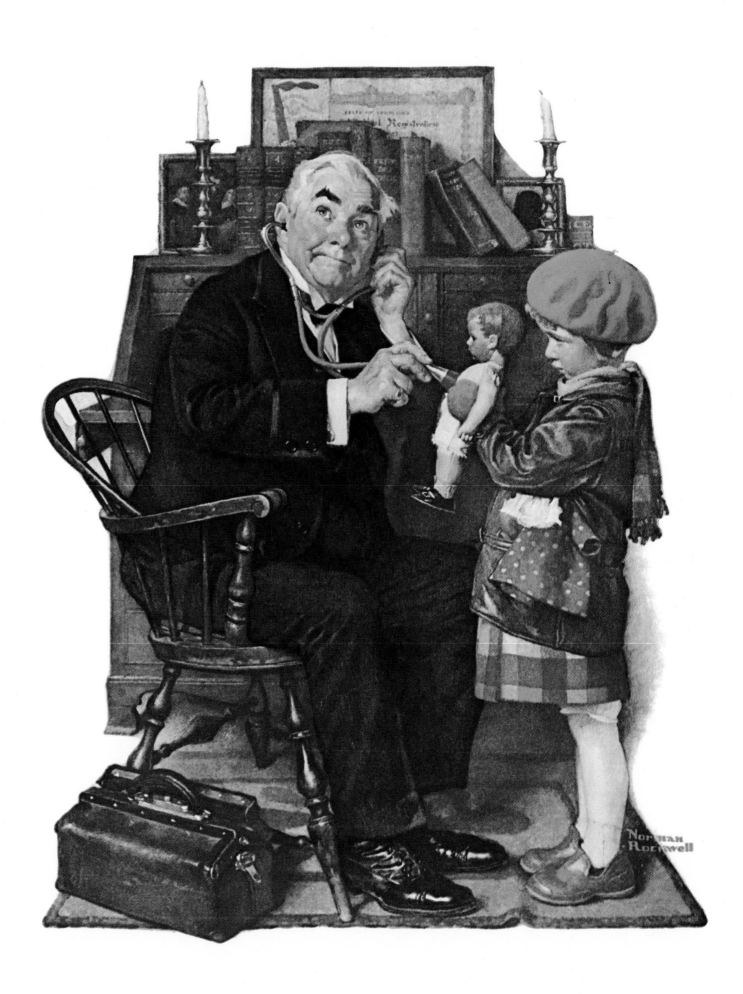

THE SATURDAY EVENING POST

NORMAN ROCKWELL REVIEW

THE CURTIS PUBLISHING COMPANY,
Indianapolis, Indiana

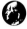

THE CURTIS PUBLISHING COMPANY
President, Curtis Book Division: Jack Merritt

The Norman Rockwell Review

Editors: Starkey Flythe, Jr.; Jean White;
Jacquelyn Sibert

Art Director and Designer: Jinny Sauer Hoffman

Art and Production Staff: Kay Douglas, Kathleen
Saunders, Patricia Stopa, Greg Vanzo

Compositors: Gloria McCoy, Penny Allison, Geri
Watson, Kathy Simpson

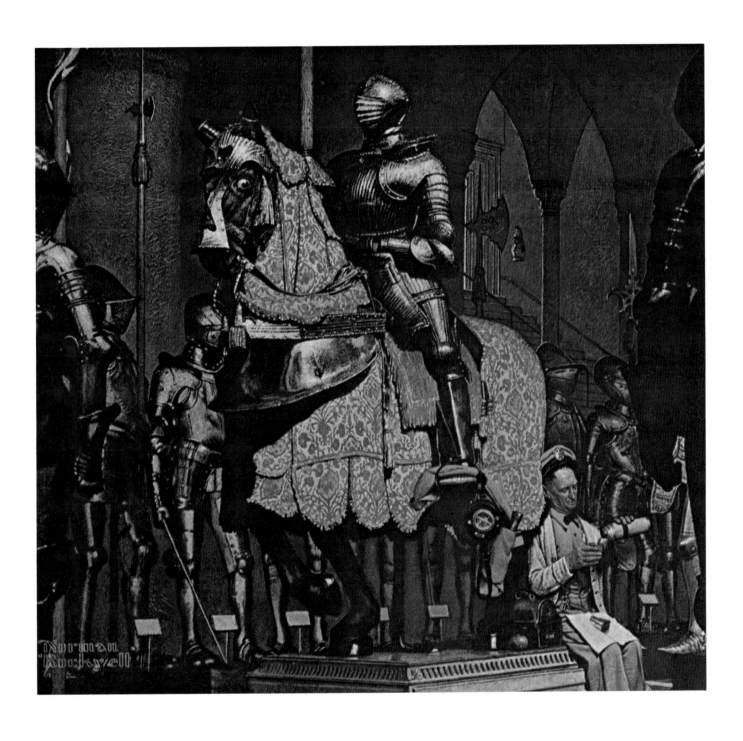

Norman Rockwell is forever a part of American innocence,
which in turn is also the indestructible
dead center of the American soul and character.
William Saroyan

An Introduction to a Legend

If a Man's Work and a Man's Life are Good, his Memory is a Living Treasure the World can Share

This book is a collection of Rockwell words and Rockwell work. For the more than 65 years of his working life he painted walls, advertisements, calendars, magazine covers, portraits, story illustrations, Christmas cards, and posters. Other artists have covered the same ground, but nobody else in American illustration— or in American art—has held the mirror of the people's yearnings up to their accomplishments so closely as Norman Rockwell.

To find a similar national mirror one would have to go back to Goya in Spain or to Daumier or Toulouse-Lautrec in France. Rockwell himself never encouraged such comparisons, but just as these artists speak most clearly to their own nationalities and their own times, so Rockwell speaks most eloquently to us and to our times, or to a time slightly past. Although his universality is mainly a melting pot approach, an American view, he was widely hailed abroad wherever his frequent travels took him.

His work is unpretentious and witty. Like the man. He was "scared to death," he said, every time he was called on to paint a President or a prime minister— though he must have known, in his later years, that he himself was a man of great achievement. Greater achievements than theirs? It is at least safe to say that his work will be remembered and loved when the legislative accomplishments of some of the political figures he portrayed have been forgotten.

He made few pronouncements about art, other than to study with the best and work hard. But from time to time he was worried about his work, sought new styles in Paris and other art centers, and tried to overcome the sameness of form his commissions demanded. Finally, he was able to vary his style by painting a more intensely realistic approach to a moral characterization of the American people, by capturing a dream of purpose and making it concrete. It is obvious he believed in what he painted. But he was not a preacher. He treated his more serious work lightly and laughed with the critics, though admitting he could be and was hurt by critical disfavor.

He put something of himself into every character he created. One man who knew him well said: "He himself is like a gallery of Rockwell paintings—human, deeply American, varied in mood, but full, always, of the zest of living."

Like the Boy Scouts whom he painted, he was loyal and true. To the magazine of which he was as much a part as Benjamin Franklin, he gave his best. And when the *Post* lost its way in the 1960's and suggested it no longer needed its number one artist, Rockwell went right on working, finding new outlets, changing his subject matter to go along with new times. The quality and sincerity of his work remained. And in the twentieth century it was not equaled by any other illustrator's.

Here then is a sample of the master's work and life, some comparisons, some suggestions about where he fits in art history and popular appeal. His place in our hearts needs no exploring.

The fleeing hobo (above left) was a Rockwell whimsy of the '30's. The triumphant tomboy, in the '50's, was another masterpiece of the storyteller supreme.

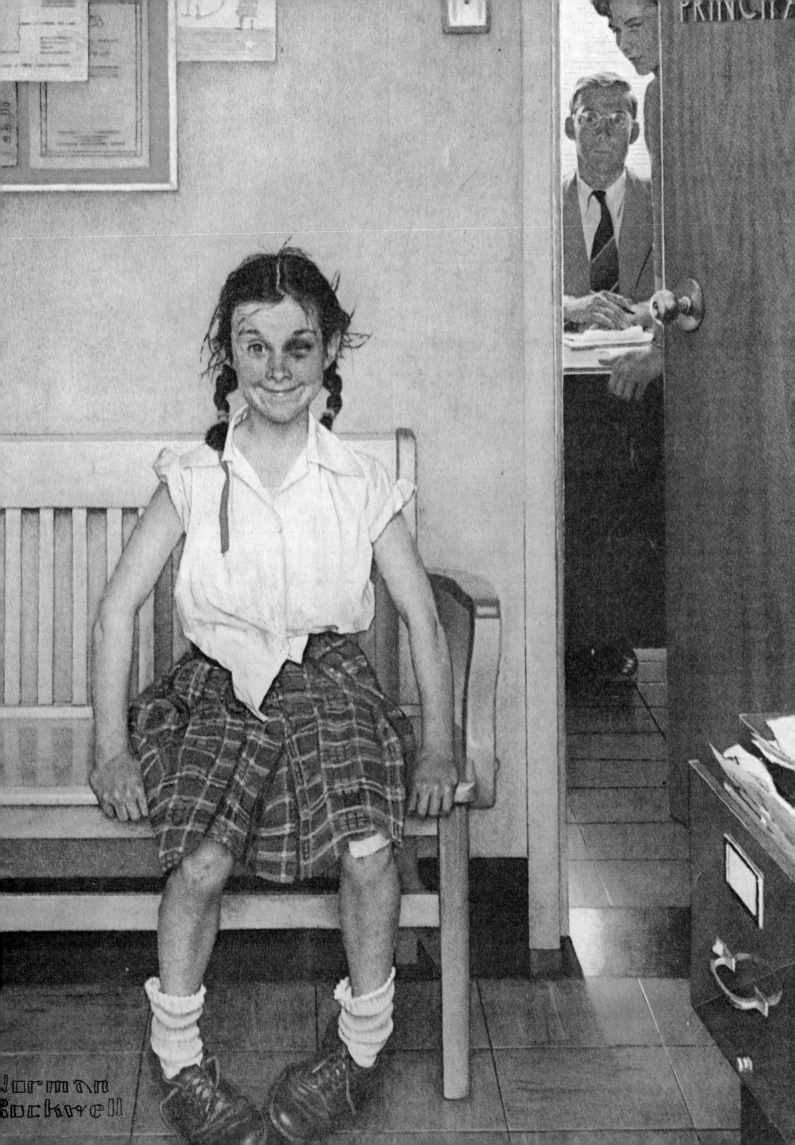

Contents

Art and the Artist

*"He took on the challenge with
a brush as facile as the best of
them and with a mind and heart
above any of his time. His rightful
place in the history of art has
not emerged yet. But make no
mistake about it, when that time
comes, the name of Norman Rockwell
will stand high."*

What You See is What They Saw, 12

The "Other" Rockwell, 18

The Narrative Element in Painting, 20

Norman Rockwell Paints Norman Rockwell, 26

Other Directions, 28

Norman Rockwell and the Post, 32

Favorite Themes

*"When he tuned in on themes like
the Four Freedoms he could*
*strike chords in the human heart
like a Beethoven or a Brahms. His
old duffers, his feisty old ladies,
the Romeo-and-Juliet quality of his
young lovers are a virtuoso performance."*

Rockwell's Wonderful Kids, 36

Ups and Downs, 38

April is the Foolingest Month, 42

The Pleasures of Music, 45

Blissful Summers, 48

Rockwell Loved a Loser, 52

Love & Marriage, 55

All in a Day's Work, 58

Famous Faces, 62

Norman Rockwell: Reporter

*"The Rockwell 'visits' comprise a very
special genre within the body of the*

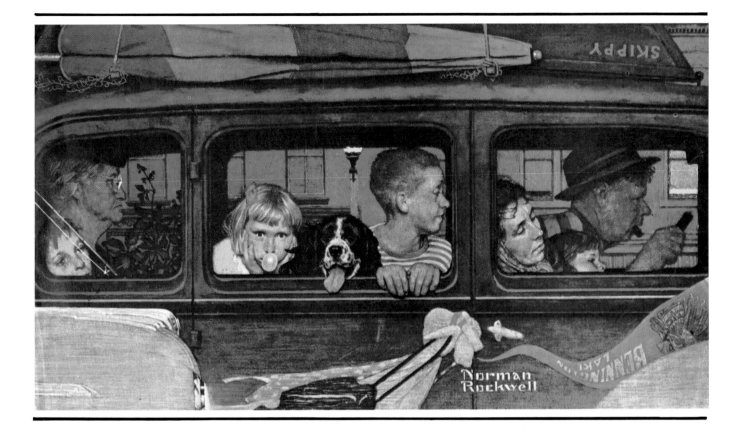

man's work—they are his most
literal depictions of American life.
Everything in these pictures is what
it appears to be. . .flesh-and-blood
people going about their daily tasks."

Rockwell Visits a Ration Board, 66

So You Want to See the President, 68

America at the Polls, 70

Rockwell Visits a Country Editor, 72

The Maternity Waiting Room, 74

Rockwell Visits a Country School, 76

Rockwell Visits a Family Doctor, 78

Rockwell Visits a County Agent, 80

My Studio Burns Down, 82

Stories to Read

"His story illustrations included some
of the most fresh and unusual of his
paintings. Intended to capture
attention, they are, by design,
intriguing and incomplete. The
pictures ask questions; you have to
read the stories to learn the answers."

The Inside Story, 84

River Pilot, 88

Jeff Raleigh's Piano Solo, 94

Great Post Covers

"Rockwell made the Post cover
a museum for the country's moral yearning.
Good and good times are crystallized
into the reality of the American Dream."

Parade of Hits, 104

Special Assignments

For the more than 65 years of his working
life he painted advertisements, calendars,
magazine covers and more. Other artists
have covered the same ground,
but nobody else in American
illustration has done it all so well."

The Artist Merits a Badge, 120

The Life and Times of Cousin Reginald, 126

The Norman Conquest, 132

The Soda Pop Saga, 136

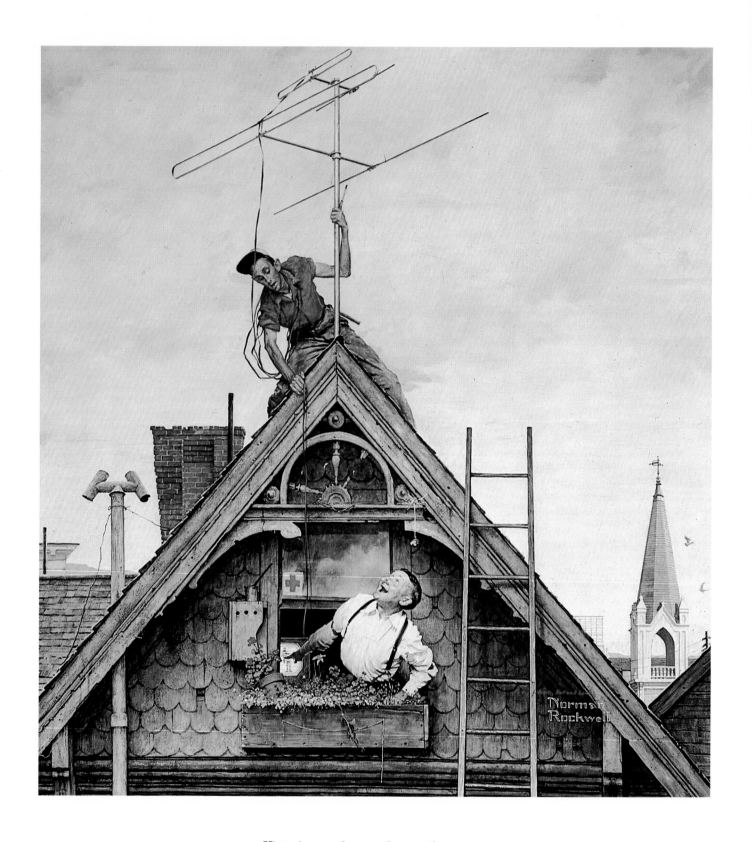

*Historians a thousand years from now
will be able to learn a great deal about what life was like
in the United States in the twentieth century
from studying these warm, human impressions by an artist
who obviously loved his subjects.*

Steve Allen

Art and the Artist

What You See is What They Saw

Rockwell Admired These Masters of the Golden Age.

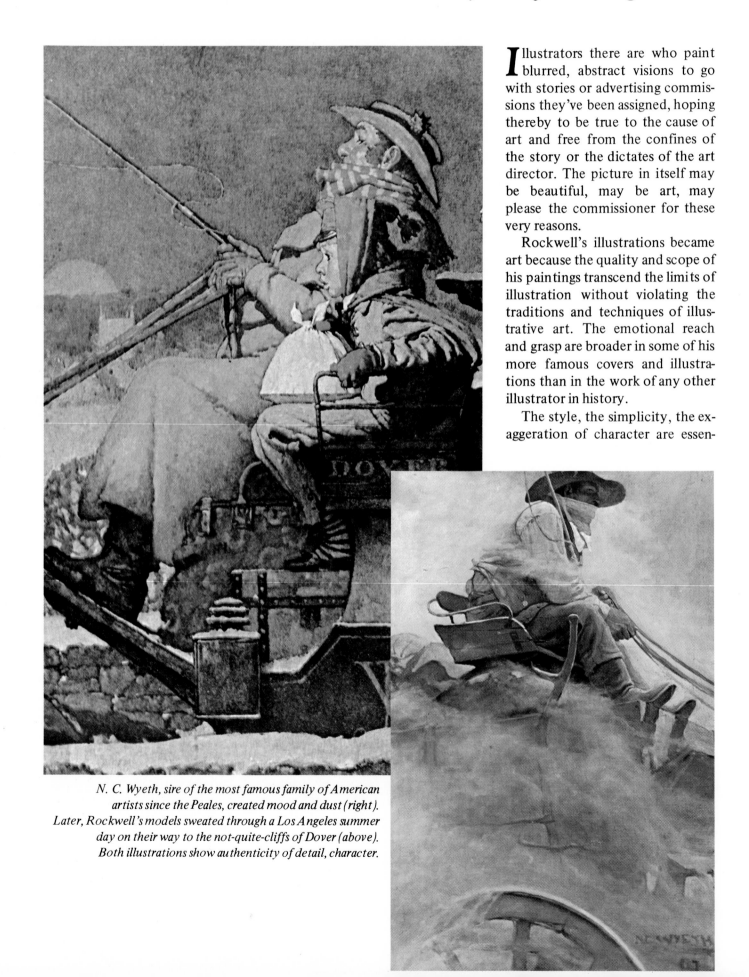

N. C. Wyeth, sire of the most famous family of American artists since the Peales, created mood and dust (right). Later, Rockwell's models sweated through a Los Angeles summer day on their way to the not-quite-cliffs of Dover (above). Both illustrations show authenticity of detail, character.

Illustrators there are who paint blurred, abstract visions to go with stories or advertising commissions they've been assigned, hoping thereby to be true to the cause of art and free from the confines of the story or the dictates of the art director. The picture in itself may be beautiful, may be art, may please the commissioner for these very reasons.

Rockwell's illustrations became art because the quality and scope of his paintings transcend the limits of illustration without violating the traditions and techniques of illustrative art. The emotional reach and grasp are broader in some of his more famous covers and illustrations than in the work of any other illustrator in history.

The style, the simplicity, the exaggeration of character are essen-

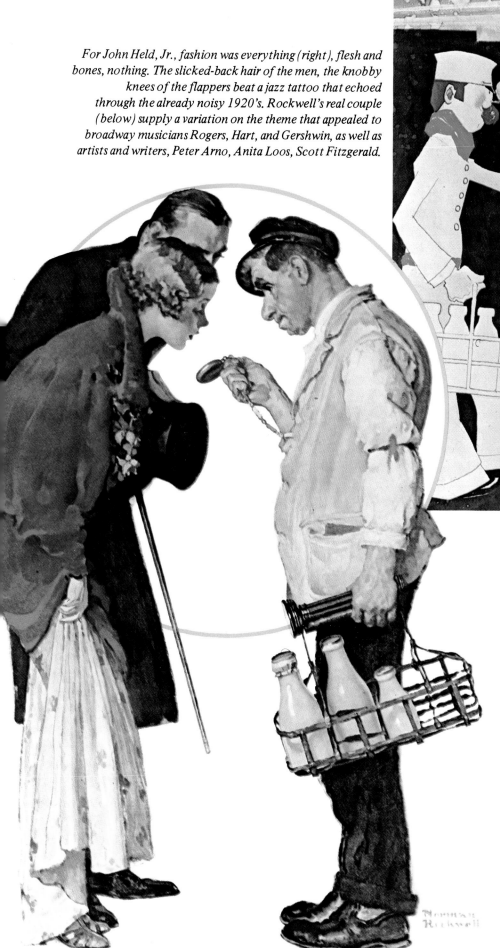

For John Held, Jr., fashion was everything (right), flesh and bones, nothing. The slicked-back hair of the men, the knobby knees of the flappers beat a jazz tattoo that echoed through the already noisy 1920's. Rockwell's real couple (below) supply a variation on the theme that appealed to broadway musicians Rogers, Hart, and Gershwin, as well as artists and writers, Peter Arno, Anita Loos, Scott Fitzgerald.

tially nineteenth century, though Rockwell owes a great deal to the cartoon-type covers of early magazines—the *Post, Life* (when it was a humor magazine), and *Judge*. They were, in effect, visual one-liners. On the other hand, Rockwell's schooling was based on accuracy of figure and costume, telling gesture, the great tradition of Edward Austin Abbey, Howard Pyle, Frederic Remington, and Winslow Homer. Details were painted with painstaking authenticity. Models stood for hours with excruciating facial expressions. Studios were built to create mood and atmosphere. Hulks of ships, cottage window sills, medieval chambers were reconstructed with scholarly verisimilitude.

The so-called Golden Age of Illustration nurtured Rockwell. Once asked whether he'd rather

have a Rembrandt painting or a Howard Pyle, he chose the illustrator. He admired Pyle's authenticity, his ability to capture mood and mystery, his perfect balance of intelligence and emotion.

When the illustrated classic—a handsome volume by a famous writer with pictures by a well-known illustrator—fell by the wayside, artists were forced into more popular markets. One was the mass magazine audience. Artists had to revise their subtleties. Art directors discovered most readers weren't particular about

authentic detail; they wanted entertainment with a burlesque impact. "Illustrators," Rockwell remembered a friend

saying, "were getting to be businessmen with a knack for drawing." Rockwell was caught up in this new wave of popular art, but his training, both as a draftsman and as an interpreter of humanity, was irrepressible.

Rockwell told the story with an honesty and directness the *Post* audience of millions could not miss. But the richness of his details, the weight of his moral

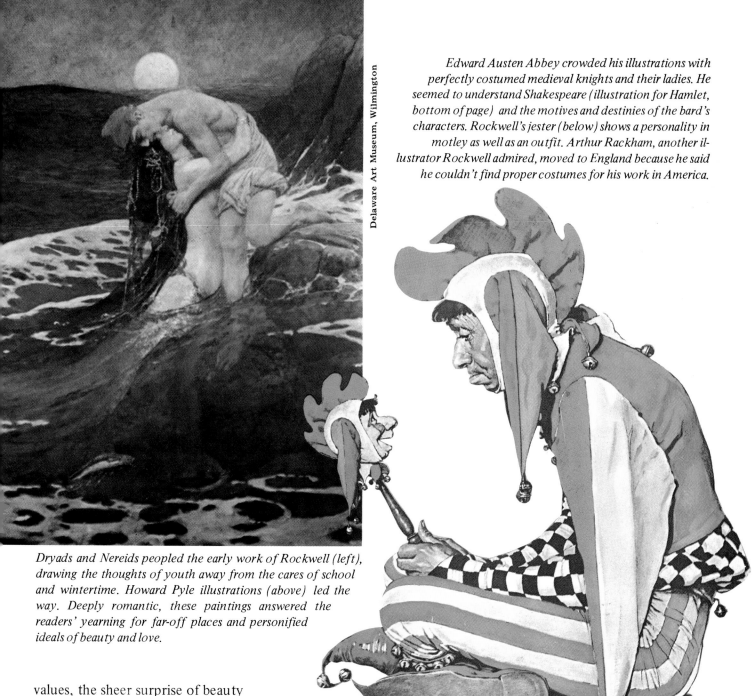

Edward Austen Abbey crowded his illustrations with perfectly costumed medieval knights and their ladies. He seemed to understand Shakespeare (illustration for Hamlet, bottom of page) and the motives and destinies of the bard's characters. Rockwell's jester (below) shows a personality in motley as well as an outfit. Arthur Rackham, another illustrator Rockwell admired, moved to England because he said he couldn't find proper costumes for his work in America.

Dryads and Nereids peopled the early work of Rockwell (left), drawing the thoughts of youth away from the cares of school and wintertime. Howard Pyle illustrations (above) led the way. Deeply romantic, these paintings answered the readers' yearning for far-off places and personified ideals of beauty and love.

values, the sheer surprise of beauty in the overlooked, drench the viewer in the warmth of significant human emotions.

"Part of the reason I went into illustration was that it was a profession with a great tradition, a profession I could be proud of. I guess my temperament and abilities were the other part."

Many fine artists have worked in tandem with themselves as illustrators. Remington, Glackens, Sloane, Hopper, Grant Wood, Andrew Wyeth all did pictures for the *Post*. In Europe, Goya, Daumier, and Toulouse-Lautrec worked for periodicals and did posters for special events. Often, illustrations must be abstract in concept, as

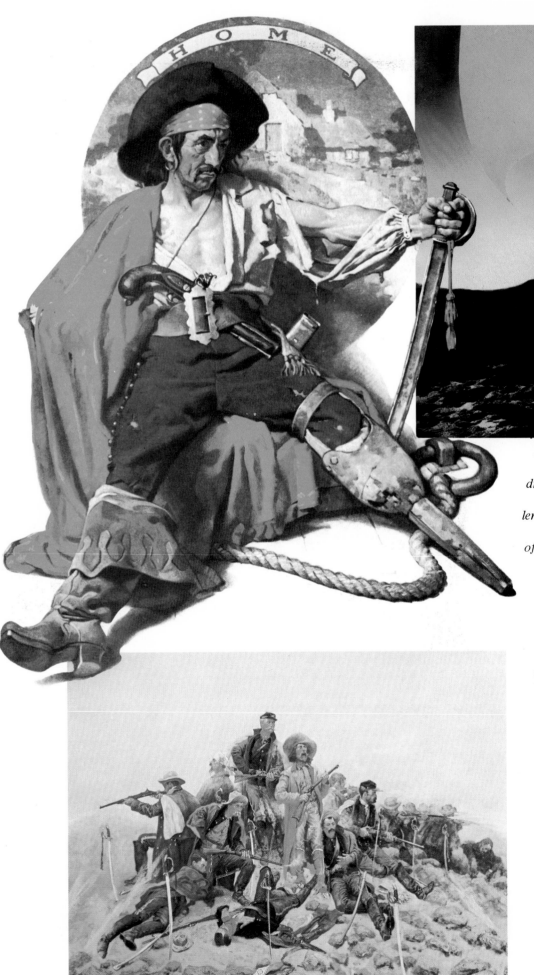

*Adventurers all—but in different worlds!
Maxfield Parrish's pirates (above) sail a
dream sea to fairytale exploits. Rockwell's
pirate (left) is a very human swashbuck-
ler who suffers from homesickness. Neither
artist attempted the sun-and-dust reality
of Frederic Remington's "The Last Stand"
(below). In the tradition of American
illustration there is room for all.*

Rockwell's *Four Freedoms* are ab-
stract. In effect, the artist who calls
his painting *Number 16* is not so far
from Rockwell who conceived his
painting to convey "Freedom of
Worship."

Illustration is art with a purpose.
And the purpose is people-inclu-
sive. If a serious illustrator were
asked whether a tree crashing in the
forest makes a sound if no one is
there to hear it, he would say no.
To an illustrator, art without an
audience is a blank canvas.

The illustrator's purpose is to
give meaning and feeling to words
and thoughts without bruising the
preconceived notions of literary
morality. No one succeeds like
Rockwell.

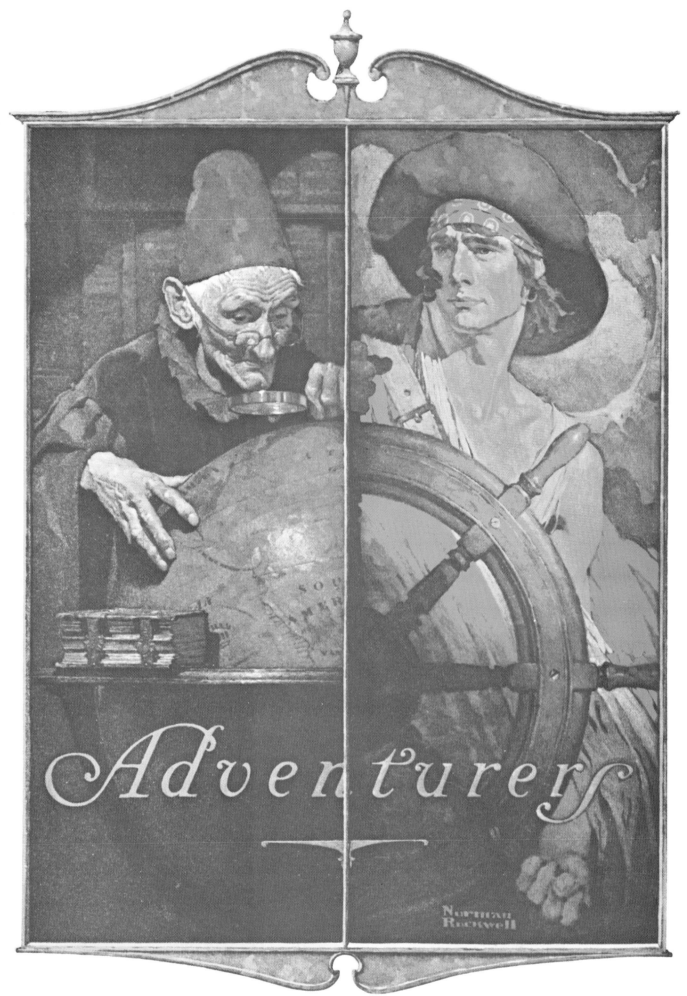

Howard Pyle might have painted this pirate but the aged mapmaker and the two-part design of this 1928 Post *cover are pure Rockwell.*

The "Other" Rockwell

(How Two Artists Shared
Name, Fame, and a Lot of Mail)

In the '30's and '40's, N. R. was one of two Rockwells regarded as America's favorite artists, and the similarity of their names led to endless confusion. Fortunately the two men accepted the situation with good humor, and periodically each sent on to the other an assortment of misdirected mail.

Rockwell Kent, who never painted a *Post* cover, received a great many letters commenting on *Post* covers that the readers assumed to be his work; and Norman Rockwell, who steered clear of all political involvement, received a great many letters accusing him of labor agitation, subversive activities, and Communist sympathies. (Rockwell Kent was eventually called before Senator Joe McCarthy's hearings, and the State Department denied him a passport.)

Confusion arose because both

A rugged outdoorsman who liked the cold, Rockwell Kent (above) painted the sere landscapes of Newfoundland, Greenland, Alaska, New England. The Trapper (below) is a Vermont scene.

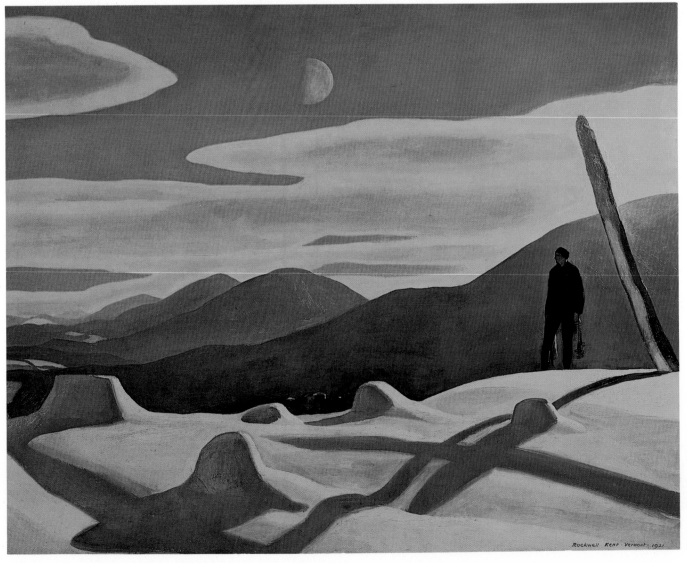

Rockwell Kent - Vermont - 1921

men achieved wide popularity at about the same time. Rockwell Kent was 15 years older, but he had had a successful career as an architect before finding his true metier as illustrator. There is, actually, little similarity between the two men's work. Kent worked more in black and white, developing a distinctive style that might be called Art Deco woodcut. Kent painted more scenery, but he always treated nature as symbolic, and his rocks and hills are blocklike. Kent's human figures are statues rather than flesh-and-blood men and women; their gestures are symbolic movement akin to the positioning of figures in Depression-era murals.

It seems unlikely that anyone would ever mistake one's work for the other, but in the public mind Norman Rockwell and Rockwell Kent were inextricably mixed. N. R. told of attending dinner parties at which his table partners assumed he was Kent and the conversation made no sense at all; Kent told of receiving letters that said, "What do you know about the Four Freedoms, you Red!"

N. R. described a typical episode that took place in Washington during a war bond drive:

"At a banquet that night I sat beside a Mrs. Du Pont. She kept trying to bring me out. 'Where do you live, Mr. Kent?' she asked (thinking I was you-know-who). 'I live in Vermont,' I said. 'Oh, Thurman,' Mrs. Du Pont said, turning to Assistant Attorney General Thurman Arnold, who was sitting beside her, 'did you hear what Mr. Kent said? The most interesting thing. He said he lives in Vermont.' And Mr. Arnold cast a cold, steely, crime-buster eye on Mrs. Du Pont and said nothing. Then Mrs. Du Pont turned back to me: 'What is it like in Vermont?' 'It's pretty cold,' I said. 'Thurman,' she said, 'do you know what Mr. Kent just said?' Again the cold eye: 'No.' 'He said it's quite cold in Vermont.' 'Ah,' Mr. Arnold replied gravely, leaning forward to look at me."

Norman Rockwell and Rockwell Kent never met, but were always on friendly terms.

Fortunately, the two men admired each other's work. When asked about "that other one," Rockwell Kent said: "Norman Rockwell is. . .a distinguished artist. He can paint newsboys, schoolboys, old men, and other characters out of American life like nobody's business. I take off my hat to him, and so do 99 people out of every 100 that I meet—east, west, south, north—who tell me they love his work."

(Below) In Norman Rockwell's world it was usually summer, occasionally spring or autumn. If winter, it was likely to be Christmas. He was quite capable of painting a snow scene and making it cozy.

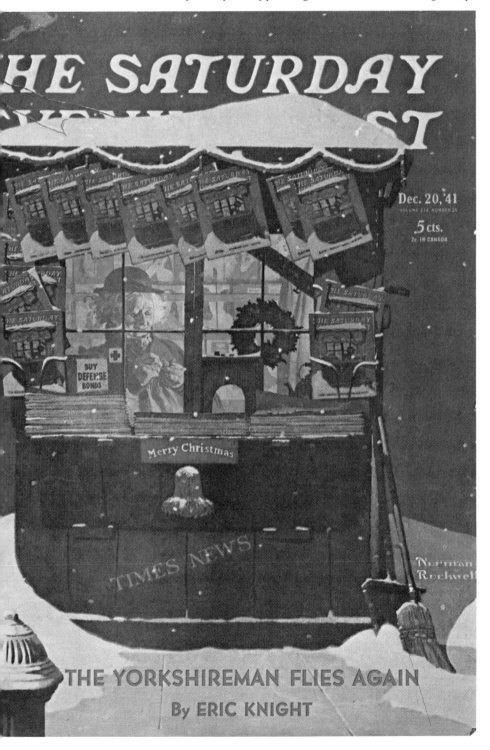

The Narrative Element in Painting

by F. X. O' Connor

Norman Rockwell belongs to the great tradition of story-telling art. The story, like music, is a universal language. Home, family, happiness, tragedy—these transcend tongue.

Coming upon a mosaic floor in the ruins of Pompeii or a wall painting of the year 13,000 B.C. in the caves at Lascaux, we recognize the unchanged human condition; we recognize ourselves though we do not know the words of the cave man, or even the Latin of Pompeii.

The scraps on the floor in the mosaic worked out in tiny pieces of stone and glass are today's garbage, familiar to any housewife or husband who has been admonished to carry out the trash. Even the family dog would recognize the mosaic's chicken bones. The animals on the walls of Lascaux still spur the hunting instinct in man, still point to our fears of psychological dangers in a dark and unknown world.

Rockwell knows how to make a story plain and simple and yet fill it

with the complex emotions that speak universally to man. As a narrative painter, he has a firm grasp on the obvious. To the despair of magazine editors who were pressed by deadlines, Rockwell liked to ask his neighbors, strangers in the street, anybody, what they thought of his pictures, if they understood them. "If they don't understand the story I'm trying to tell, I figure I haven't made it clear enough and that a lot of other people around the country won't un-

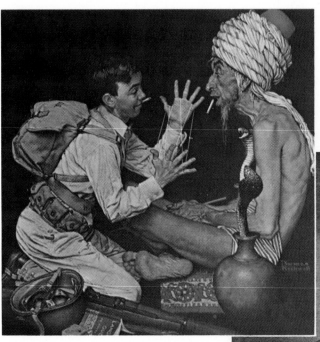

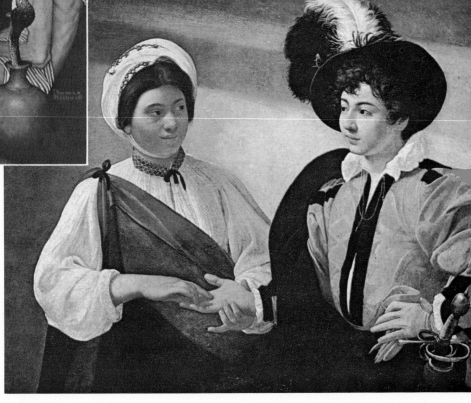

Willie Gillis (left) befuddles an Indian fakir just as Caravaggio's fortuneteller (below) hypnotically strokes a young dandy's palm while surreptitiously slipping the ring from his finger. Caravaggio's dramatically simple background, his realistic treatment of models focus the viewer's attention on the story the artist has to tell.

(Below) Dutch master Gabriel Metsu's sick child invites the universal sympathy felt for pain inflicted on innocence. Rockwell's child-inflicted babysitter invites another kind of sympathy (right). The details needed to invoke emotion are much more obvious, but the end is the same: reaction from the audience.

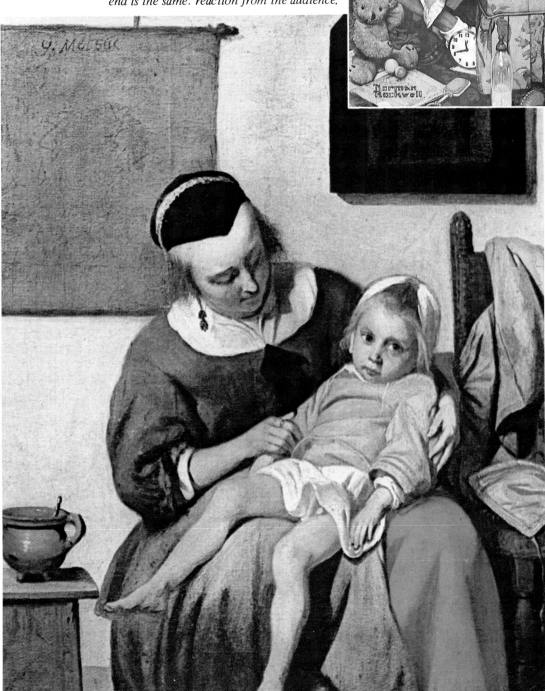

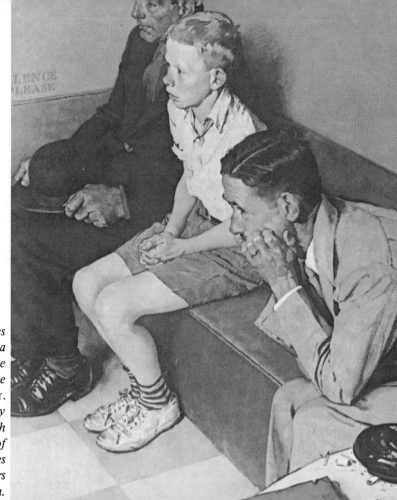

Rockwell physicians are kind men whose power comes from their intelligence. In this illustration of a doctor's waiting room (right), he emphasizes the part faith plays in healing. Dutch painters like Thomas de Keyser, whose Anatomy Lesson of Dr. Sebastiaen Egbertz (below) contrasts the frailty of the human form with the indomitable strength of the mind, praised the release by the Church of the body for experimental medicine. Rockwell shares the reverence of the seventeenth century masters for the inquisitiveness in man, his search for truth.

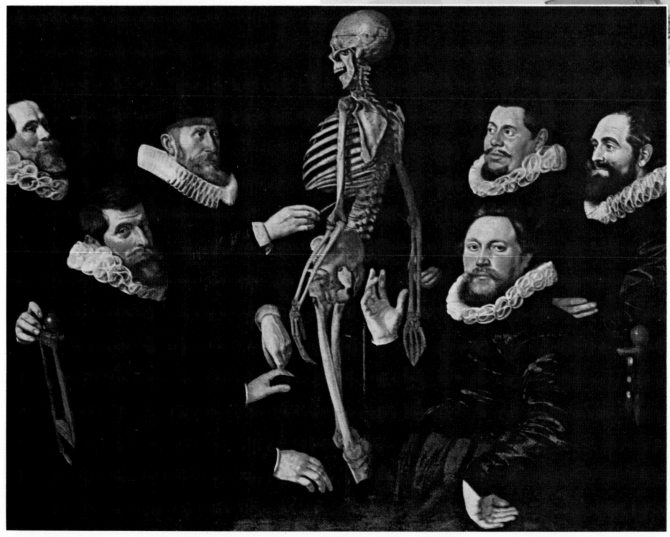

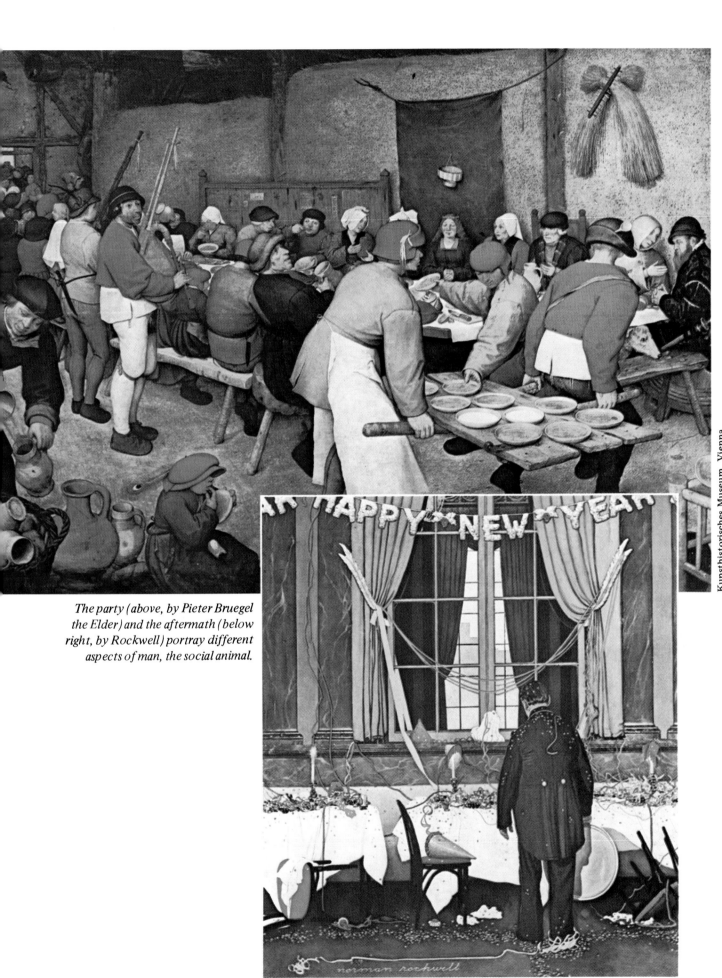

The party (above, by Pieter Bruegel the Elder) and the aftermath (below right, by Rockwell) portray different aspects of man, the social animal.

23

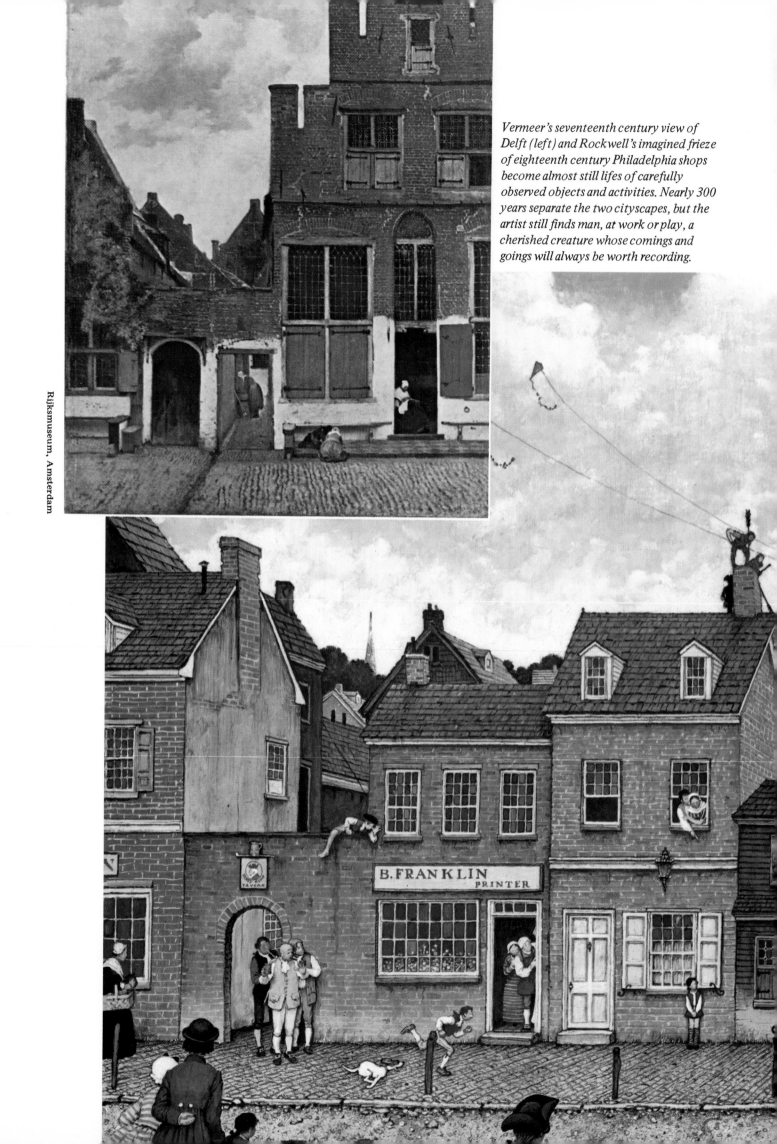

Vermeer's seventeenth century view of Delft (left) and Rockwell's imagined frieze of eighteenth century Philadelphia shops become almost still lifes of carefully observed objects and activities. Nearly 300 years separate the two cityscapes, but the artist still finds man, at work or play, a cherished creature whose comings and goings will always be worth recording.

B. FRANKLIN
PRINTER

derstand it either." And then he would change the paintings to accomodate public opinion.

Rockwell painted for the millions, a more difficult audience than the few. Giotto and early Italian Renaissance painters understood the value of a large audience. So did seventeenth century Dutch genre painters and the pre-Raphaelites. Commissions might come from anywhere. The more who saw and understood, the greater the artist's success as a narrator of the spirit and the earthly climate of his day. In that sense Rockwell has been an immense success. Worldly power counted for nothing with him, but he would've considered himself a failure had people not understood his observations, his duty to create positive values. Rockwell leaves historical documents of a people during the crises of depression and world war. He was aware of death, but for him, life was a stronger force.

Norman Rockwell Paints Norman Rockwell

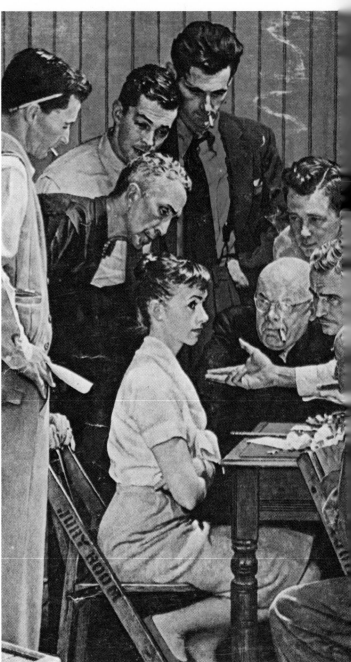

*"A man with the eyes of a poet but the neck of a chicken,"
said Adelaide Klenke in a 1916 interview, the first Norman
Rockwell ever granted. With honesty and humor his
Adam's apple and pigeon toes (he had worn corrective
shoes as a boy, torturous weights that kept him off the
playing field but pointed him to drawing as a way to gain
the approval of his peers) became symbols of accomplish-
ment to a doting public. (Above) He urges with 10 other
jurors the distaff to relent in a 1959 cover. (Top left and
left) Serious and frivolous self-portraits.*

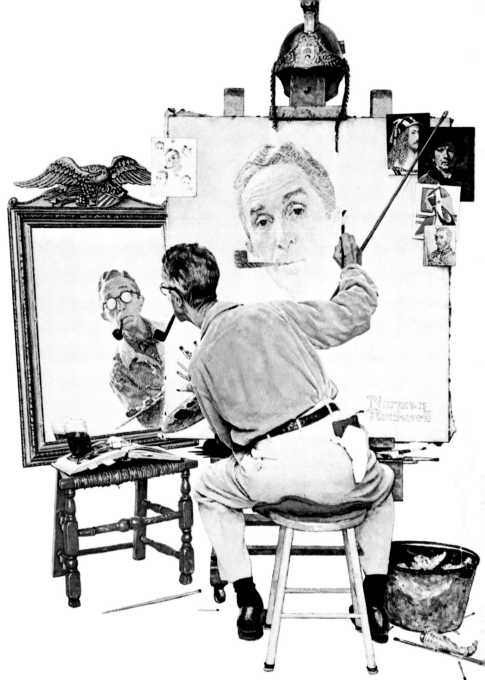

In the illustration for "Blacksmith's Boy, Heel and Toe" (above) the poetic eyes smile to bring the viewer into the contest. At the right, the artist pokes fun at himself in a 1960 Post cover Triple Self-Portrait. Below, the artist's face needs no exaggeration, but most of his models' teeth have to be bared to show happiness in a homecoming scene of the '40's.

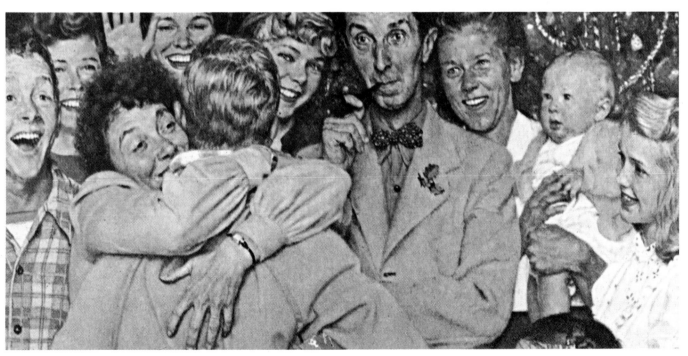

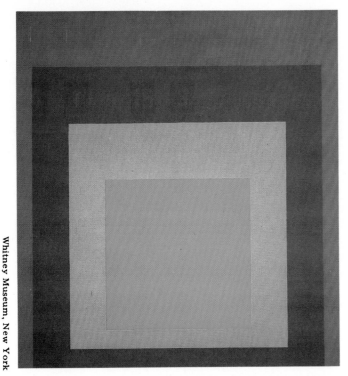

Joseph Albers, who painted Homage To The Square: Ascending *in 1953, had little graphically in common with Rockwell.*

Other Directions

While Rockwell Painted Home, Modern Artists Looked for Another Way

Painter Jackson Pollock was only 18 years younger than Norman Rockwell. Both attended the Art Students League. Pollock studied with Thomas Hart Benton, the regional Missouri myth-maker who was Truman's favorite artist. Benton had studied with artists who had much in common with Rockwell's teachers. Thomas Hart Benton and Norman Rockwell are close; Pollock, miles, centuries away it seems. Benton's portrait of America appears in public buildings, the WPA mural brought to its finest artistic possibility; Rockwell's work was public, too, the magazine cover seen by millions. Benton and Rockwell painted a portrait of the American. Pollock, influenced by the land (he had been a geological land surveyor in California and the Grand Canyon), painted America.

Frank Stella, the young artist whose shaped canvases are prisms of brilliant color, was a house painter for a time after leaving art school at Princeton. Andy Warhol chose as his canvas a cinematographic sweep, little frames of Elizabeth Taylor, Jackie Kennedy in the Zapruder film of the assassination, Marilyn Monroe, the Campbell soup can, multiplied by every housewife's nightmare/dream of supermarket power. Franz Kline captures an explosion, almost atomic in its suddenness, its vastness. All of these men are essentially landscape artists. They overwhelm size, capturing it within a frame, no matter how grand.

As these artists, oddly contemporary with the so-called anachronism of Norman Rockwell, were fascinated with the topography of the American earth, its expansive media, the view of it from the high point of the mind's eye, Rockwell was equally fascinated with the topography of the American face, the emotional range behind the face, its trivia, its magnificence, its possibilities. Rockwell was original only in the intensity of his belief in the positive. But Pollock, thrown out of the Manual Arts School in Los Angeles for

Frank Stella's Agbatana I *(near right) is an object in itself, not a painting of something else. Here colors have their own values, are not meant to imitate the tones and shades of subject matter. Color is color; form is form. If you don't like a painting right side up, try hanging it upside down. This "new" art brought tremendous freedom to painters of the twentieth century who threw off the shackles of representational art and painted what they felt rather than what they saw. Not Rockwell. He was comfortable within the strictures of the older tradition, and he went on painting what he saw.*

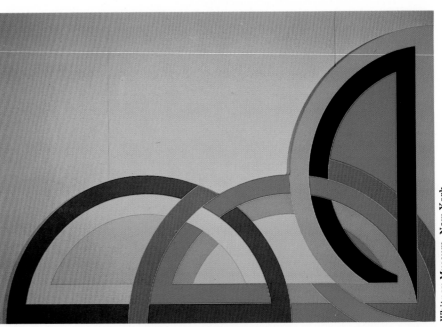

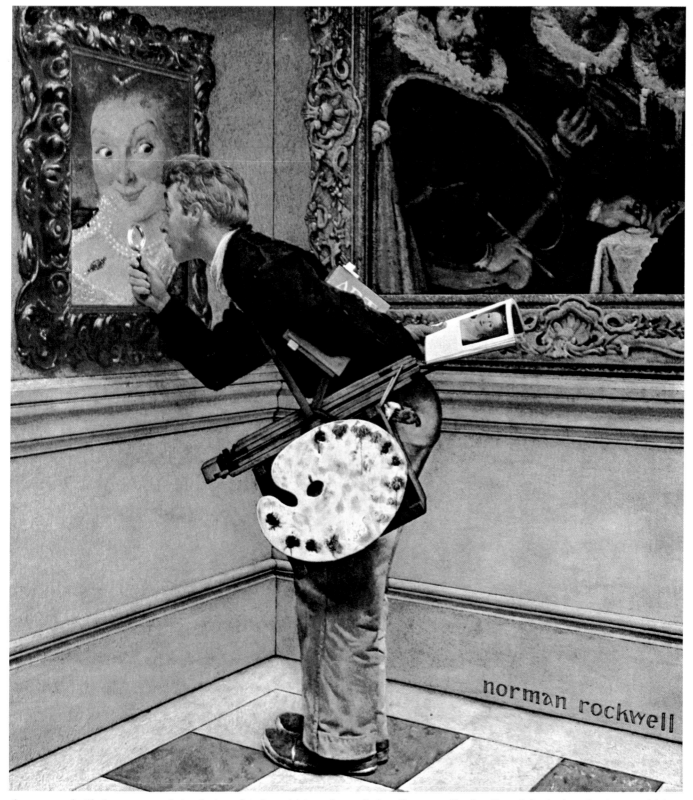

Art on art. As Shakespeare used the device of a play within a play to help tell a story, Rockwell used the device of a picture within a picture. He could, of course, paint ersatz Old Masters that looked more like Old Masters than the real thing, as for this 1945 Post *cover.*

publishing a newspaper demolishing the ideas of the average young American, was violently original, even to the point of his own destruction through alcoholism and a fatal car accident.

Another original technique was that of American-born Franz Kline, whose action-filled canvases ex-

plode with violent gesture and urban tension; a far cry from Rockwell in the '50's, his work hangs in the prestigious Whitney Museum in New York.

The public as a whole never took modern artists to its heart. There were, on the contrary, all sorts of jokes about explosions in a paint factory or pet mon-

Ornate picture frames intrigued Rockwell. This Post *cover was inspired by an unusual frame found in an antique shop.*

keys permitted to paint in private, using their tails as brushes, only to win great art awards for their owners when the results were revealed in museums.

Did Rockwell ever covet a place at their side?

Was he excluded because his commercial output was so prodigious? He did superb work for Ford, Interwoven Socks, Budweiser, Jello, Skippy Peanut Butter, Crest Toothpaste, Coca Cola, Fleischman's Yeast, Upjohn, Parker Pen, Pan American Airways, Del Monte Foods, Elgin Watch, Underwood Typewriter, Listerine, Fisk Tires, and dozens of other products. Some are now assimilated or out of the picture as trade names, and one gasps at the thought of board chairmen commanding, *"Get Rockwell,"* while art directors and agency executives skirmished to pay a higher fee than the next advertiser for the work of one small "illustrator" (to use his own term) whose genius never failed to put the message across. Some of that work has been brought back in this album.

Great artists of the past had done precisely what Rockwell was doing. The halls of the world's museums are hung with the works of artists who depended for a living on commissions from the rich and the royal. No doubt they would be painting "commercial" if they were living today.

Artists known today in the field of fine arts have also occasionally strayed into commercial ventures without

seemingly tarnishing their reputations. The roster of *Post* and *Country Gentleman* covers includes, for instance, such names as Grant Wood, Rockwell Kent, W.H.D. Koerner, John Falter, John Clymer, and the Wyeths (N.C. and Andrew). But then, they only touched once or twice upon the fringes of the huge mass of work Rockwell turned out with his prolific and indefatigable brush. Perhaps the multiplicity of his work as well as its commercial success are the causes of his never-to-be-realized ambition (albeit never loudly proclaimed) to be hung in the nation's leading art museums.

The issue, in the opinion of many, is still in doubt.

Rockwell worked to preserve a kind of painting that even his art teachers in Paris 50 years ago, in the school that trained the Leyendeckers at the end of the nineteenth century, said was 30 years behind. But within this outdated form he opened up a new vista of emotion, one great aspect of art sadly neglected by the modern masters. He made that a national happening. Dated he may have been, but that was his choice. He took on the challenge with a brush as facile as the best of them and with a mind and heart above any of his time. His rightful place in the history of art has not emerged as yet. But make no mistake about it, when that time comes, the name of Norman Rockwell will stand high.

In the hushed and respectful atmosphere of the art museum, as elsewhere, Rockwell poked fun at the pompous, the grandiose.

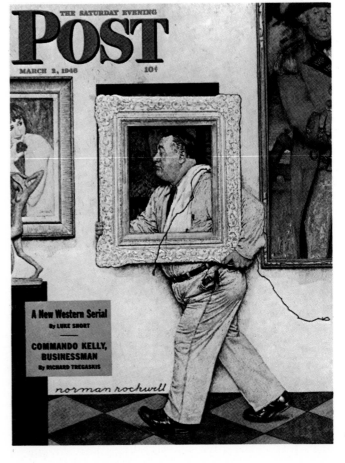

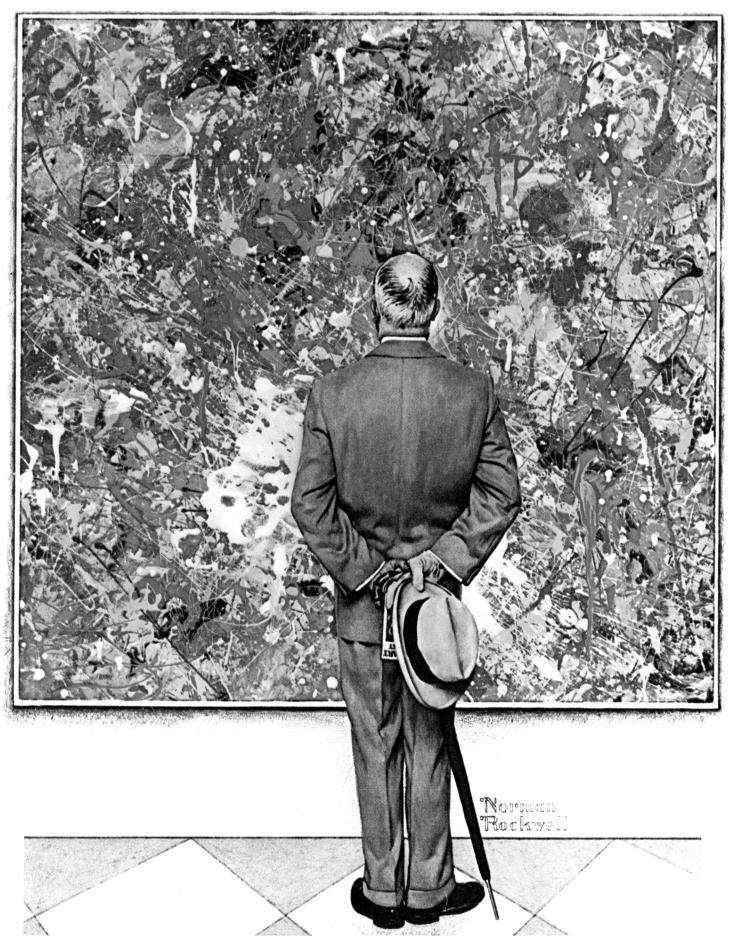

An American pioneer in the evolution of nonrepresentational painting, Jackson Pollock spread canvas on the floor and dribbled paint from above. So did Rockwell, when he created a very convincing imitation "Jackson Pollock" for this 1962 Post *cover.*

Norman Rockwell and the Post

He was born in New York City, the grandson of a professional artist, the son of an amateur artist. Rockwell was trained and disciplined in a trade. His education single-mindedly bore down on the talents he was born with and had already started to develop as a child. He entered the Chase Academy, and later the precision of his draftsmanship gained him a scholarship at the Art Students League.

At these schools, Rockwell took courses in illustration. He intended to become an illustrator. Illustration was a means of making a living and, of equal importance, a means of expressing emotion.

His linkup with the *Post* was significant. Many magazines were exploring photography and abstract ideas as cover art. But the *Post* nur-

tured a kind of sincerity in its contributors and readers that only representational art could make concrete. Serious entertainment, i.e., humor, was the business of the magazine, and Rockwell, hardened by city life and freshened by visits to the country, was a young man of perfect paradox, anecdotal, moral.

Rockwell embraced the magazine and all its philosophy. George Horace Lorimer, the *Post*'s famous editor, believed great literature ought to be wholly digestible. He was prepared to batter-dip his literary morsel in amusing and bright covers. He didn't care for names as long as the writers gave him a good story. And if authors had great names and turned in trash, back it went. He bragged that other magazines made up their copies from his rejections. "Mr. George Horace Lorimer," wrote Rockwell (who never mentioned Lorimer without the "Mr."), "had built the *Post* from a two-bit family journal with a circulation in the hundreds to an influential mass magazine with a circulation in the millions. He was *The Great Mr. George Horace Lorimer*, the baron of publishing. What

if he didn't like my work?" He did. And the rest is amusing history.

But Rockwell did his best work for editor Ben Hibbs, "the archetype of the easygoing, good-natured Midwesterner," according to Rockwell, but with "iron in his soul" and, something rarer, "integrity, absolute integrity," as editors who worked with him said.

Hibbs' method was to give Rockwell the freedom to choose his own topics and work them up within the new cover format. (The famous Guernsey Moore hand-lettered logo gave way in 1943 to the block-lettered POST.) Hibbs praised Rockwell, whereas Lorimer kept the artist on a tight lead, changing designs, making suggestions that often amounted to commands. Still, the two men had

enormous respect for each other. And Lorimer's discipline helped create Rockwell's climate of work, his devotion to duty and deadline.

Hibbs considered Rockwell the real victorious general of World War II. He felt *The Four Freedoms*, especially "Freedom of Worship" and "Freedom of Speech," which hung in his Philadelphia office, were great art. "They are a daily source of inspiration to me," he said, "in the same way that the

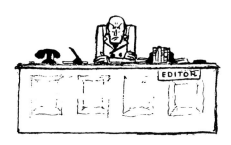

clock tower of old Independence Hall, which I can see from my office window, inspires me. If this is Fourth of July talk, so be it. . . . I regard [the pictures] as great art. Norman himself probably would disagree. He has always modestly labeled himself an 'illustrator' with no pretensions to fine art. I suspect art critics would say that those two pictures are excellent examples of an illustrator's work at its best, but not great art. I am no art critic, but I still disagree. To me they are great human documents in the form of paint and canvas. A great picture, I think, is one which moves and inspires millions of people. *The Four Freedoms* did—and do."

Rockwell's life was not always the happy life he painted.

He suffered through a divorce, a tragically ill wife, bouts when he felt he could not paint or that his work was no good. His solution to every difficulty was to go to his easel at eight every morning. He wrote several years ago, "I've got pains in my knees and my hair is almost white. I've developed a fondness for afternoon naps. I go to bed early almost every night. *But*, I get up early every morning. I'm at work by eight. I still play a fair game of badminton. I no longer believe that I'll bring back the golden age of illustration. I realized a long time ago that I'll never be as good as Rembrandt. *But*, I think my work is improving. I start each picture with high hopes, and if I never seem able to fulfill them, I still try my darndest. . . . The daisies do still look better from above

than from below. Somebody once asked Picasso, 'Of all the pictures you've done, which is your favorite?' 'The next one,' he replied."

Rockwell painted thousands of pictures. Museums and critics say Rockwell does not figure in the development of the history of art. The Rockwell in the Metropolitan's collection is lent out to decorate the office wall of a Borough president. Many collections do not even have a Rockwell. When the Met ask-

ed Rockwell for the painting in its collection 20 or so years ago, the then-director said it would be nice centuries from now for art critics "to see what people looked like" back in the twentieth century. Rockwell himself admitted "I could never be satisfied with just the approval of the critics, and, boy, I've certainly had to be satisfied without it." His works, though, stand as a sort of criticism of themselves. They exist within their own standard of excellence and popularity. No one can deny their importance or the importance of the witty, kind man who created them.

An early Rockwell illustration for a *Post* cover was sold in December 1978 for $43,000, and business magazines and art investors were pointing out at the time of Norman Rockwell's death that his

works were a good investment. Rockwell was paid $75 for that cover. But, as he himself said, two million people looked at a *Post* cover, probably more. "Two million subscribers, and then their wives, sons, daughters, aunts, uncles, friends."

"When I had added the *Post* cover to my portfolio the art directors of the other magazines began to give me assignments." His covers brought him five and six thousand dollars in the '40's and '50's, but more than that, they brought him the fame and freedom to dare a vision at which most illustrators would've quaked as one being pretentious and beyond the scope of illustrative art. Success, as they say, breeds success, and Rockwell's name and face were well known enough to cause readers to demand more than the merely good. Rockwell did not cringe at the challenge.

He worked like a horse. The assistants and models and photographers and art editors who worked with him recall his getting to the studio before 8:00 a.m., his waking people up in the middle of the night to have a stage built or a picture taken so he could start work early the next day. And he traveled and studied, both in the U.S. and in France, so that new ideas were constantly flowing through his old experiences. When his studio burned in 1943 he said he was glad in a way because "you get too tied to old pattern books, bits and pieces of costume." Few artists could've stood the calamity, but Rockwell went on to paint his greatest covers, laughing at an artist friend who'd said, "If the average person liked a painting of mine, I'd destroy it," and another who explained, "I think I'll take up fine arts. Commercial art is too difficult."

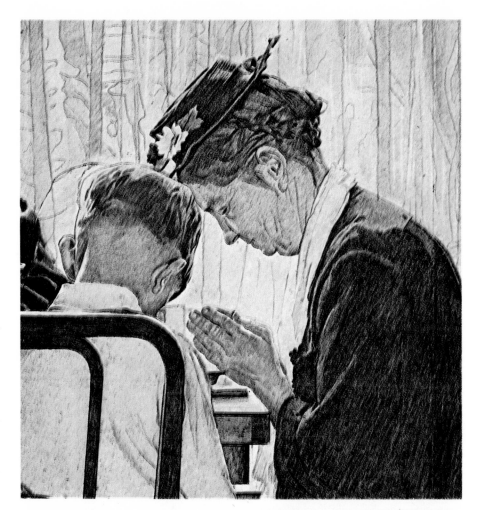

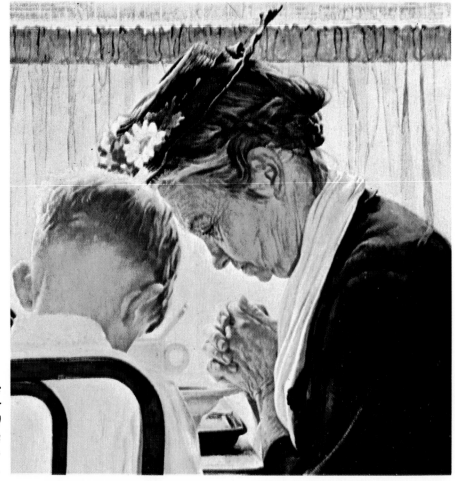

Small and subtle differences between the charcoal sketch for a Post *cover (above) and the finished painting (below) show Rockwell's painstaking attention to details that deepen and enrich characterization. Note woman's hands, hair.*

Favorite Themes

Rockwell's Wonderful Kids

The ineffable joys and sorrows of youth, the quick forgetting and the
moments of high discovery, never aged in the heart of the artist.

He began his career as a professional artist by drawing children, and his wonderful pictures of children recur, like grace notes, throughout the body of his work.

Pictures of children. But not *just* pictures of children, for they are very, very special. They are real children, with real problems and triumphs and emotions that trace life lines on their tender faces: astonishment at the discovery of a red Santa suit and beard in the bureau's bottom drawer; grief at the loss of a vacant-lot baseball diamond to the bulldozer; triumph when the girl beats the boys at their own game; wide-eyed wonder when a girl looks into the mirror and sees the future.

It is not at all surprising that Rockwell drew and painted children at the beginning of his professional life. Pictures of children were enormously popular in the early decades of this century; they were the stock-in-trade of all artists and photographers. Pictures of children appeared in advertisements, on calendars, on product labels and billboards, and, very regularly, on magazine covers. Artists drew and painted children because that's what buyers wanted to buy; that's where the money was.

But Rockwell's children were, from the very first, a little different from those other conventional prototypes. Not merely cunning, or merely cute, they were *real kids*. A little too fat, or too thin. Freckled. Cowlicked. They wore *real* clothes; their pants sagged a little, and so did their stockings. Here were imperfections enough to mimic nature without caricaturing it. Here was *character*.

The kids Rockwell painted were, of course, real kids, and we know their names: Billy Paine and Eddie Carson of New Rochelle, New York; Mary Whalen and Chuck Marsh, Jr., of Arlington, Vermont; Kenneth and Scott Ingram and Eddie Locke of Stockbridge, Massachusetts. All were flesh-and-blood

"Kids—I wonder how many kids I've painted. . . . Thousands, I guess," Rockwell wrote in 1959. "And I still enjoy it. I got a kick out of painting Billy Paine in 1915 and another out of painting the kids today." On this page, children from Rockwell Post covers dated 1936 and 1952.

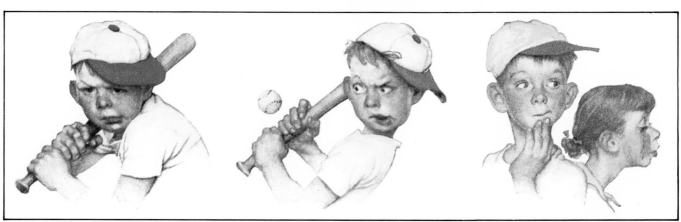

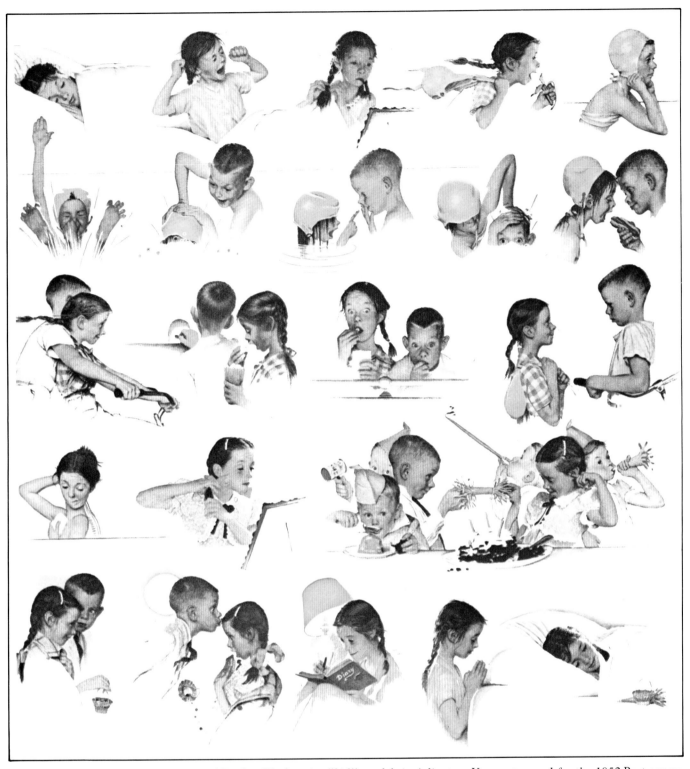

Chuck Marsh and Mary Whalen, two of Rockwell's favorite "kid" models in Arlington, Vermont, posed for the 1952 Post *covers entitled* A Day in the Life of a Boy *(excerpts on opposite page) and* A Day in the Life of a Girl *(above).*

children who earned nickels and quarters and dollars by posing for a pleasant, whimsical, slightly eccentric gentleman who lived down the street from them.

All the children have happy memories of their modeling sessions in the painter's studio; it was a special place where a special kind of game was played. Rockwell would explain the situation he had in mind, then act out all the parts. He would shout, pound the floor, jump up and down. When he saw on the child's face the expression he was seeking, there would be a joyful burst of laughter.

At least one of those models—Billy Paine—is dead. The others are grown up, and some are married and have children of their own. But they are also children still, and will be always. Their pigtails, their bandaged knees, and their black eyes have achieved immortality. For, indeed, Rockwell's children are everybody's children.

The Ups and Downs

The elderly—contributors to the present, links to the past.

by Jacquelyn S. Sibert

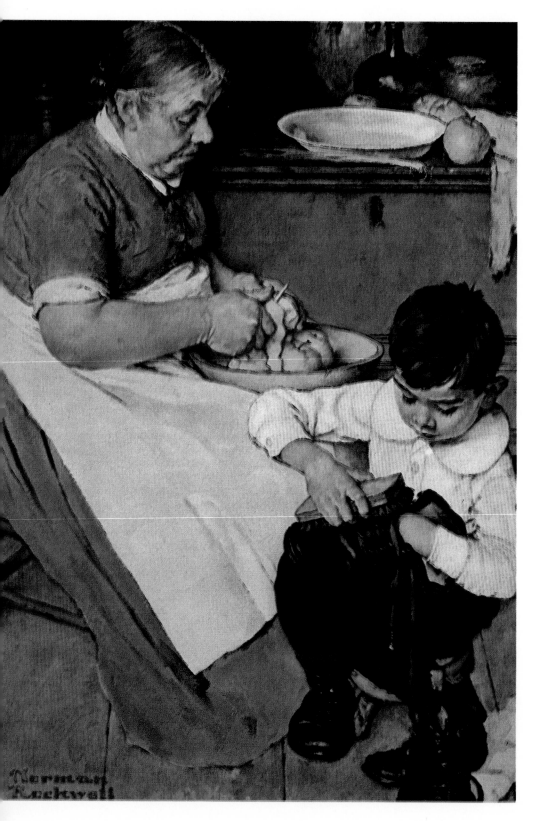

Memories of Saturday nights in Grandma's kitchen inspired this scene (left) from a Post *article by Kenneth Roberts.*

For Rockwell, the faces of the aged—gnarled and wrinkled by failures and disappointments, strengthened and smoothed by wisdom and contentment—had a special kind of beauty. "They show their lives in their faces," he says in his autobiography, "the ups and downs and turn-arounds, the knocks and pushes."

James K. Van Brunt was an elderly model Rockwell used over and over during the '20's. A tiny old man with a knobby nose and sad, dog eyes, Van Brunt would suggest a cover idea almost every time Rockwell saw him. His most distinguishing feature was a magnificent mustache—measuring eight inches from tip to tip. One day he had strutted unannounced into Rockwell's studio and declared, "I have fought the Confederate Army at Antietam, Fredericksburg, and in the Wilderness. I have battled the nations of the Sioux under Dull Knife, Crazy Horse, and Sitting Bull and fought the Spaniards in Cuba." Rockwell proceeded to paint him that day and used him for numerous *Post* covers thereafter.

For Rockwell, Van Brunt's face was more than just comic. For him, Antietam, Fredericksburg, and the Wilderness were all there in it. He painted a cover of Van Brunt carrying a violin under his arm and reading a sign attached to a saxophone that said, *"Jazz it up with a sax."* With this cover, Rockwell incorporated the contrasting elements of comedy and tragedy necessary for impact. The face and baggy trousers and the idea of the old man "jazzing it up with a sax" are comic; the thought that changing fashions make an old man feel useless is tragic.

Another old model, Joshua Biengraber, once asked Rockwell, "Were you ever *really* hungry?"

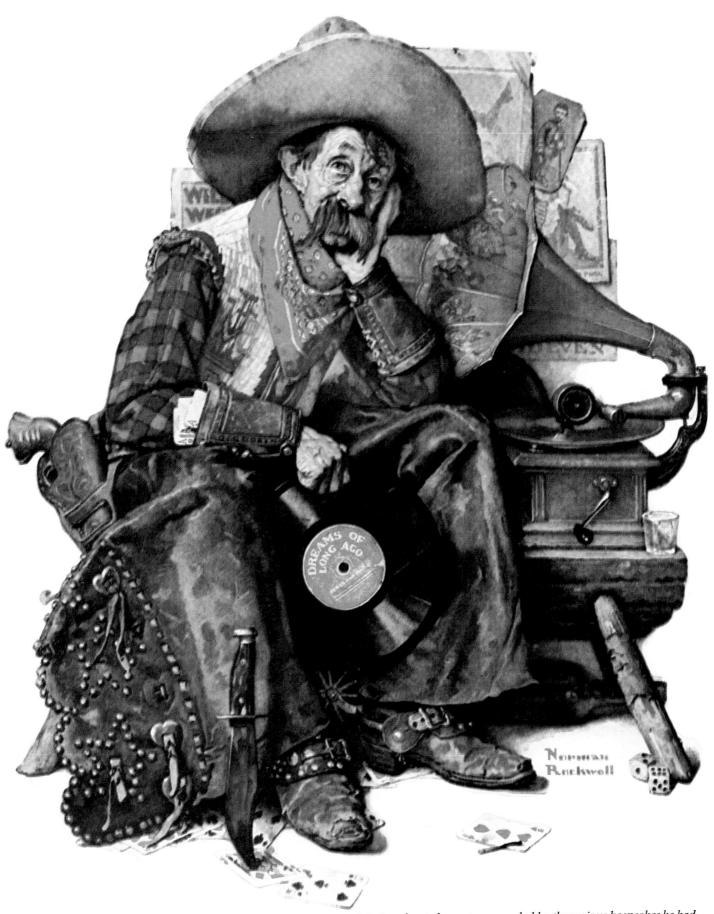

Rockwell found model Van Brunt sitting alone one evening, reminiscing about the past, surrounded by the various keepsakes he had accumulated during his long life. Here Rockwell captured the face and mood of that encounter. (1927)

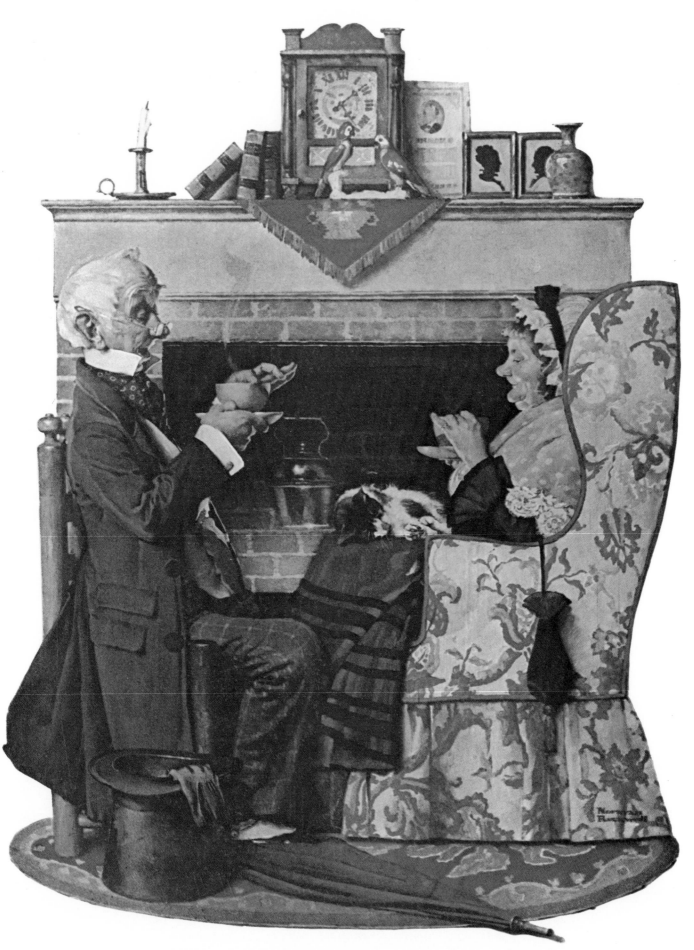

Tea and tranquillity. Typical of the time (1927) was this view of old age as a time for quiet comfort by the fireside, cat in lap and cup in hand. Fortunately, Rockwell also portrayed oldsters as busy, active, involved with the world's affairs.

As an artist, Rockwell could see and capture that experience in Joshua's face.

Rockwell's eccentric Uncle Gil was another influence on his work. A stout old gentleman with round pink cheeks and a bald head, Uncle Gil was always jovial and had a habit of getting his holidays mixed up. He faithfully brought presents (though inappropriate ones) for each occasion and went to great lengths to hide them. Watching Norman and his brother search for them gave him great pleasure. The popular 1936 *Post* cover depicting the small boy digging into his grandfather's coat pocket in search of presents is, Rockwell tells us, a tribute to his Uncle Gil.

The old teaching the young was an effective and favorite Rockwell theme, particularly during the '20's and early '30's. Often, in magazine ads and story illustrations, on magazine covers and for calendars, he portrayed elderly person and youth in the same setting—providing not only a contrast, but also a picture-story of ongoing interaction.

Anthropologist Margaret Mead has written of the important part grandparents used to play in a child's education. A child's own grandparents might be dead or live far away, but in a small town there were always other people's grandmothers and grandfathers. One good grandmother, Mead says, could go a long way with her old-fashioned stories, songs, and oatmeal cookies. For the children of small towns, the presence of the older generation meant acquiring a sense of the past. Dates became real instead of numbers in a history book.

Perhaps it is this sense of the past that Rockwell hoped to convey in his portrayal of the elderly. The old people he knew had lived from horse-and-buggy days to the jet age; they had seen more change than any other generation in the history of the world. They were not only living repositories of tradition, but also living evidence that human beings can adjust to enormous change.

In his autobiography, Rockwell said of his work, "I can't handle world-shattering subjects. They're beyond me, above me. . . . I do ordinary people in everyday situations, and that's about all I can do. . . . "

Yet the aging faces he painted express an accumulation of earth-shaking experiences. Through them he reveals a history, a sense of origin, a perspective. Each line in a face tells of one moment in one life—one human's interpretation of the "ups and downs and turn-arounds"—of the old confronted with the new.

Black and white, man or woman, the old and the young—"Each according to the dictates of his own conscience."

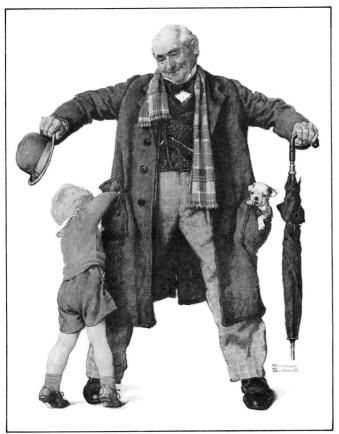

"You're getting warm," the smile on the face of the kindly old gent seems to be saying in a popular 1936 Post *cover (above). A salute to the art of gift-giving. . .and receiving.*

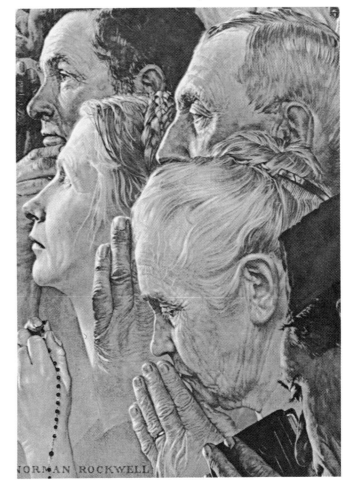

NORMAN ROCKWELL

April is the Foolingest Month

How many mistakes and incongruities can you find? Possibly more than the artist intended. Rockwell said he painted 45 errors into the first of the April Fool's Day covers he painted for relaxation between serious projects; one man wrote saying he found 120.

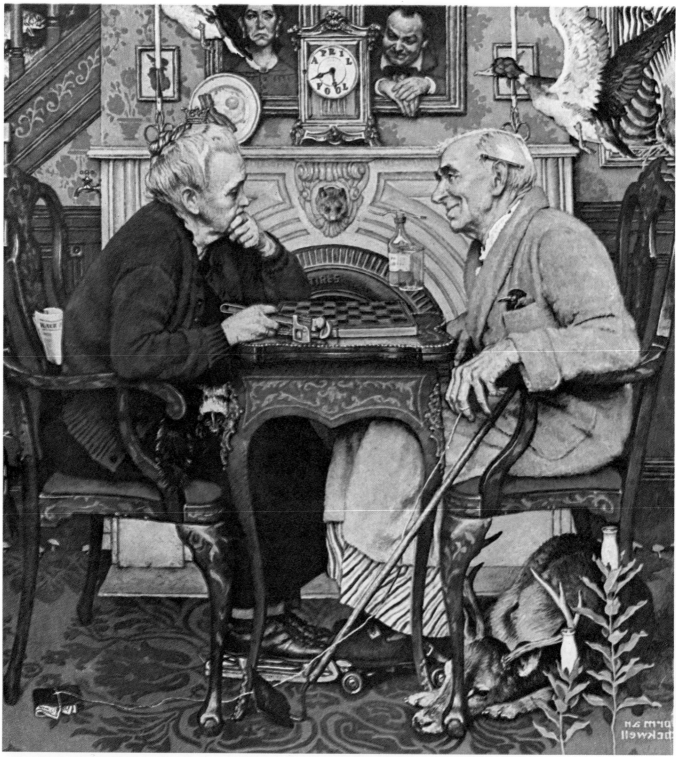

Rockwell bought furniture for his house with an eye for using it later in illustrations. Here his house beautiful and his career in advertising, his Fisk tire and his fireplace, struggle for ascendancy while the medicine bottle achieves it.

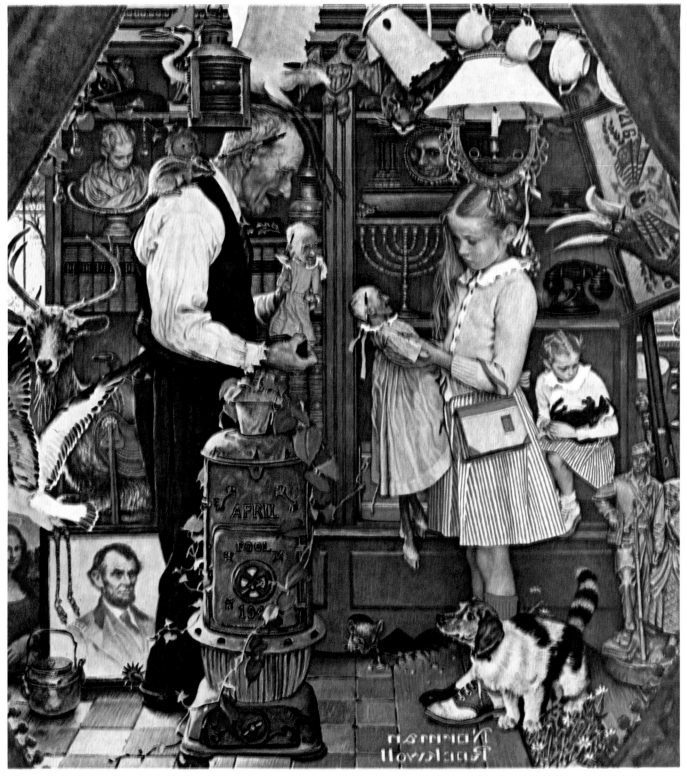

Alice in Wonderland might feel at home in this old curiosity shop, but Lincoln in Lee's uniform decidedly does not, and the typically Rockwellian dog blending into a typically Rockwellian cat may be puzzled when it tries to bite its tail.

Before the acceptance of the Gregorian calendar, New Year's Day fell on March 21, the vernal equinox when the length of the day equals that of the night and spring bursts upon the world. Priests were unhappy, though, with the proximity of Easter and New Year's, festivals of gravity and frivolity. So New Year's was postponed to April 1, and, with the new calendar, moved in 1549 to January 1.

But custom dies hard. Friends still gave presents on April first, made visits, played jokes. Often they would put trinkets in grand boxes to make them look like something expensive and laugh when friends opened the box—"April Fool!"

Ancient legend connects April with the kidnapping of the lovely Persephone by Hades, god of the underworld. Her mother, Demeter, the goddess of growing

43

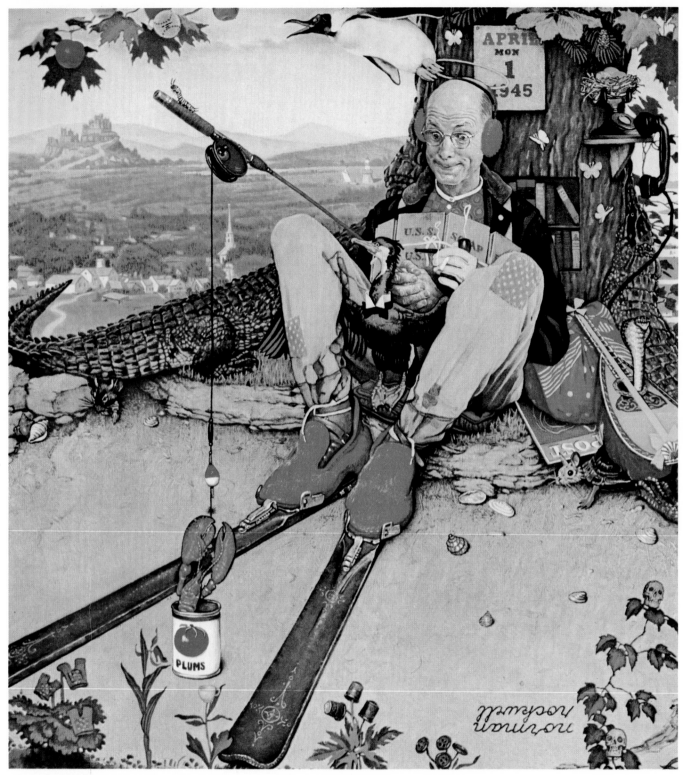

Warbling native woodnotes wild bring the cobra out of its mandolin, the squirrel out of its shell, buttons and thimbles out of the ground, apples out of oak leaves, and the lobster out of his plums.

things, grieved for Persephone and the earth turned brown. Hades, at Zeus' command, gave up his beautiful captive, but only for part of the year. She came, her hair wreathed in flowers, just at spring, and all the earth rejoiced, exploding with life, turning green and fertile.

Rockwell's April Fool's covers are celebrations of the innate desire of creatures to play.

Dutch and Flemish painters delighted in upsetting the eye, mixing man and beast, marrying the strange with the known in their pictures. One senses the same attitude of enjoyment in the Rockwell puzzle-paintings. They were a sort of answer to people who complained about mistakes in his serious covers. But more, they were an expression of fun and love for the absurdity of man and his possessions.

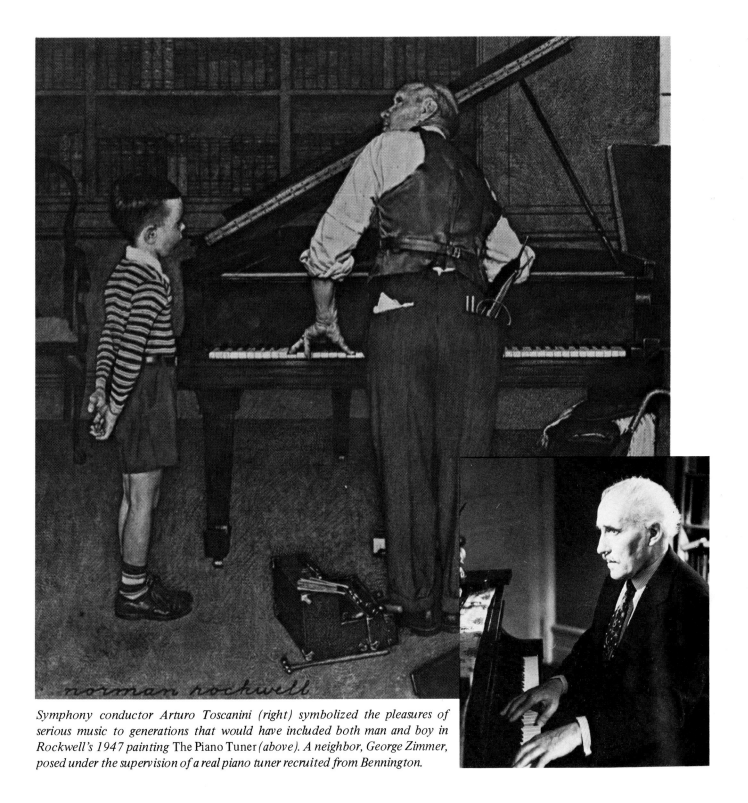

Symphony conductor Arturo Toscanini (right) symbolized the pleasures of serious music to generations that would have included both man and boy in Rockwell's 1947 painting The Piano Tuner *(above). A neighbor, George Zimmer, posed under the supervision of a real piano tuner recruited from Bennington.*

The Pleasures of Music by Aaron Copland

We musicians don't ask for much. All we want is to have one investigator tell us why this young fellow seated in row A is firmly held by the musical sounds he hears, while his girlfriend gets little or nothing out of them, or vice versa. Think how many millions of useless practice hours might have been saved if some alert professor of genetics had developed a test for musical sensibility. . . .

If music has impact for the mere listener, it follows that it will have much greater impact for those who sing it or play it themselves with some degree of proficiency. Any educated person in Elizabethan times was expected to be able to read musical notation and take his or her part in a madrigal sing. Pas-

sive listeners, numbered in the millions, are a comparatively recent innovation. Even in my own youth, loving music meant that you either made it yourself or were forced out of the house to go hear it where it was being made, at considerable cost and some inconvenience. Nowadays all that has changed. Music has become so very accessible that it is almost impossible to avoid it.

Perhaps you don't mind cashing a check at the local bank to the strains of a Brahms symphony, but I do. Actually, I think I spend as much time avoiding great works as others spend in seeking them out. The reason is simple: Meaningful music demands one's undivided attention, and I can give it that only when I am in a receptive mood. . . .

Very often our "serious" music

is serious, sometimes deadly serious, but it can also be witty, humorous, sarcastic, sardonic, grotesque, and a great many other things besides. It is, indeed, the emotional range covered which makes it serious and, in part, influences our judgment as to its artistic stature.

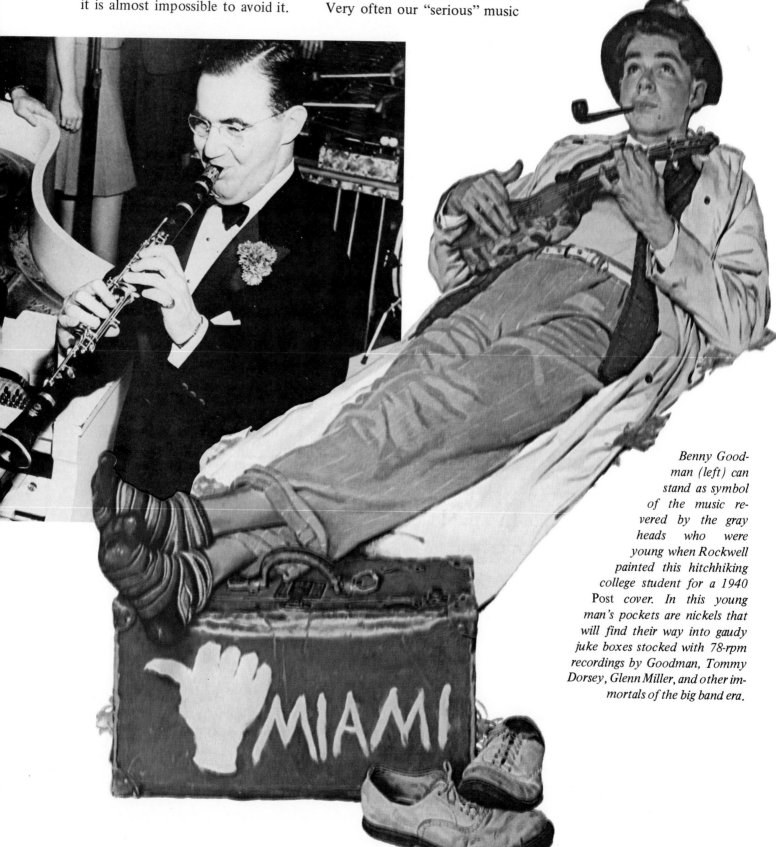

Benny Goodman (left) can stand as symbol of the music revered by the gray heads who were young when Rockwell painted this hitchhiking college student for a 1940 Post *cover. In this young man's pockets are nickels that will find their way into gaudy juke boxes stocked with 78-rpm recordings by Goodman, Tommy Dorsey, Glenn Miller, and other immortals of the big band era.*

Everyone is aware that so-called serious music has made great strides in general public acceptance in recent years, but the term itself still connotes something forbidding and hermetic to the mass audience. They attribute to the professional musician a kind of initiation into secrets that are forever hidden from the outsider. . . . But, in all honesty, we musicians know that in the main we listen basically as others do, because music hits us with an immediacy that we recognize in the reactions of the most simple-minded of music listeners. . . .

No discussion of musical pleasures can be concluded without mentioning that ritualistic word "jazz." But, someone is sure to ask,

is jazz music serious? I'm afraid it is too late to bother with the question, since jazz, serious or not, is very much here, and it obviously provides pleasure. The confusion comes, I believe, from attempting to make the jazz idiom cover broader expressive areas than naturally belong to it. Jazz does not do what serious music does either in its range of emotional expression or in its depth of feeling or in its universality of language—though it does have universality of appeal, which is not the same thing. On the other hand, jazz does do what serious music cannot do—namely, suggest a colloquialism of musical speech that is indigenously delightful, a kind of here-and-now feeling,

less enduring than classical music, perhaps, but with an immediacy and vibrancy that audiences throughout the world find exhilarating.

Personally, I like my jazz free and untrammeled, as far removed from the regular commercial product as possible. Fortunately, the more progressive jazz men seem to be less and less restrained by the conventionalities of their idiom, so little restrained that they appear in fact to be headed our way. By that I mean that harmonic and structural freedoms of recent serious music have had so considerable an influence on the younger jazz composers that it becomes increasingly difficult to keep the categories of jazz and nonjazz clearly divided. A new kind of cross-fertilization of our two worlds is developing that promises an unusual synthesis for the future.

Thus, the varieties of musical pleasure that await the attentive listener are broadly inclusive. The art of music, without specific subject matter and little specific meaning, is nonetheless a balm for the human spirit; not a refuge or escape from the realities of existence, but a haven wherein one makes contact with the essence of human experience. It is an inexhaustible font from which all of us can be replenished.

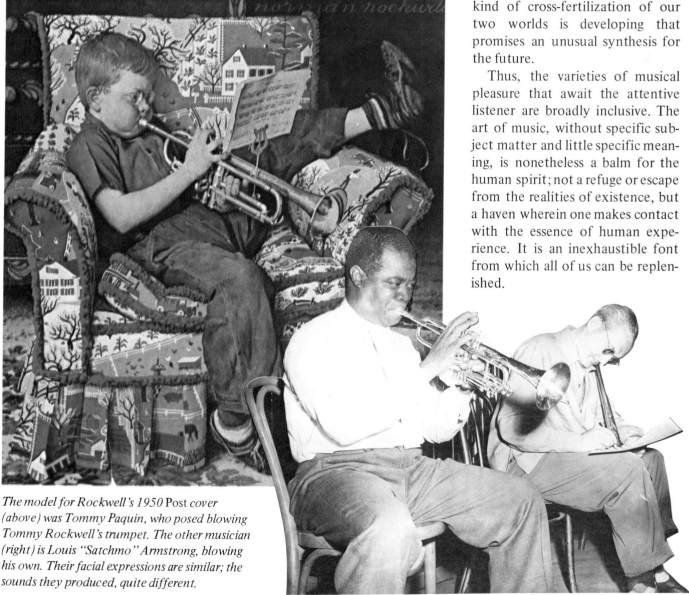

The model for Rockwell's 1950 Post *cover (above) was Tommy Paquin, who posed blowing Tommy Rockwell's trumpet. The other musician (right) is Louis "Satchmo" Armstrong, blowing his own. Their facial expressions are similar; the sounds they produced, quite different.*

Blissful Summers

Freckles shaded by frayed straw hats; patched-up overalls stopping just short of sun-browned toes; clean air; green fields; and frogs and kids alike leaping in and out of ponds. That's what Rockwell country summers are made of. That and layer upon layer of memory projected onto the canvas.

Life in the country, particularly the life of boys in summer in the country, was a dominant theme in Rockwell's early work that resurfaced from time to time throughout his career. Over half a century his focus expanded somewhat to include adults and other seasons, but rarely did it include city streets.

Though a city boy, Rockwell spent his summers till the age of nine or ten in the country at various farms that took in boarders. Of "those blissful summers" in the country, Rockwell says in his autobiography:

"I remember the farm horses . . . as they drank . . . after a day in the hayfields. The horse would raise his head for a moment, snorting and shifting his great hoofs, then drop it again to the water so suddenly that I'd slide right down his neck, kerplunk, into the stream, the horse stopping his drinking to look calmly at this sudden apparition splashing in the shallows . . . I remember wrestling and tumbling in the mow until we collapsed, exhausted, in the warm fragrant hay . . . throwing off my shoes and socks to wiggle my bare toes in the cool green grass on our first day in the country, then running off gingerly . . . to the river for our first swim . . . [I remember] hunting bullfrogs . . . [and] the turtles and frogs we carried back to the city in the fall, snuffling and crying on the train because summer was over and we had to leave the country. I remember we'd put the frogs and turtles in a bowl of water and feed them religiously every day. But invariably, two months later, we'd find them floating, dead, in the bowl. And then the summer was dead too."

It is easy to see the source of Rockwell's "Cousin Reginald" series, done for *The Country Gentleman*. It is also easy to see what inspired the *Post* covers *Springtime, Summertime,* and *Contentment*.

Four seasons make up the conventional calendar year but in the World of Rockwell there are generally only two—spring and summer—plus the midwinter holidays.

Spring is the time the country boy escapes from the schoolroom that has become his prison as the days grow longer and warmer. Free at last, he runs and jumps like a spring colt. He tosses away the books he won't look at again until September. Shoes are forgotten.

Rockwell's country boy has just

In this homecoming, a sad young camper attempts to hold back the summer's exodus with jar lids and string.

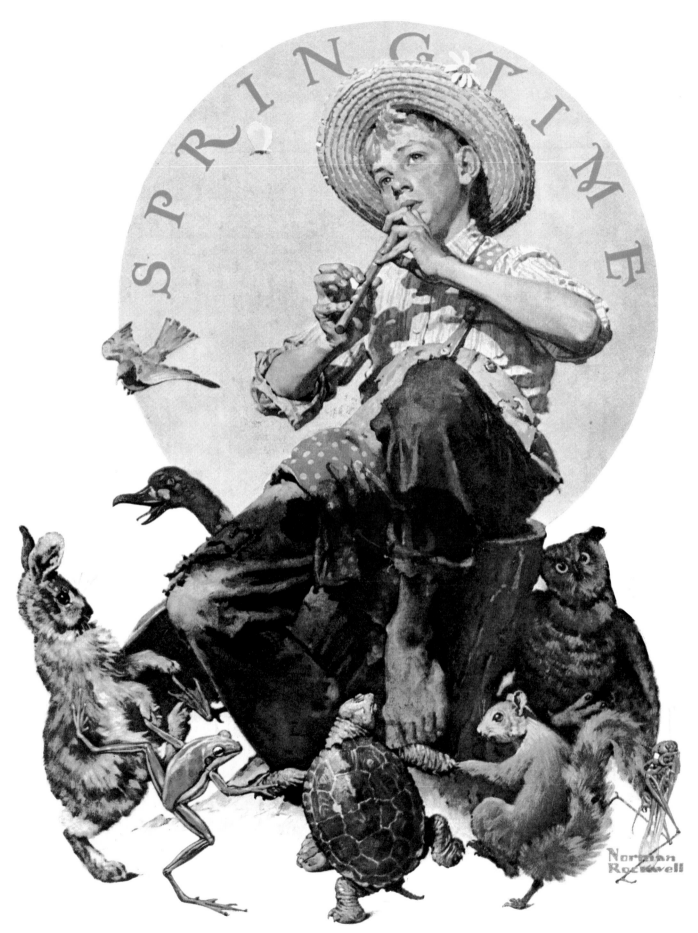

Rockwell tells of acting out his cover ideas for the Post's *Mr. Lorimer: "I'd say, 'It's spring. The sun is warm. . . . And little animals are dancing in a ring . . . a rabbit, a duck, a frog'–[and] I'd kick up my heels and dance around the chair. . . . "*

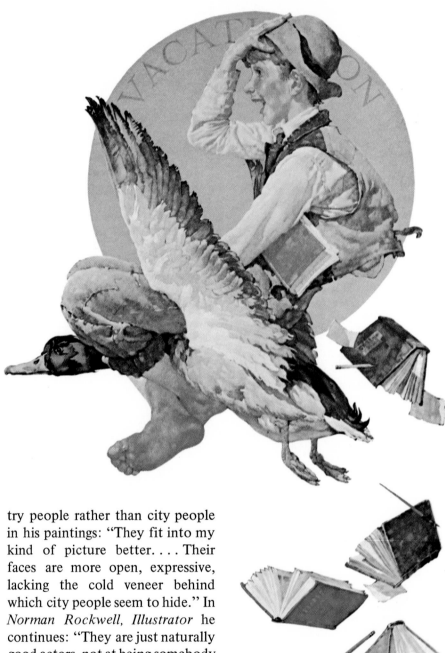

one set of clothing—straw hat, faded shirt, denim jeans rolled well above the ankle. He needs no other wardrobe, since he knows only warm weather. We have to imagine the hand-knitted cap and mittens he would wear in winter, trudging off to a one-room country school.

Summer lingers long in this magic world—and it is a magic world—mermaids and nymphs live there, and animals dance. It is a joyful world of song and laughter.

As a kid on the farm, young Rockwell had done everything the country boys did—everything, that is, but complain about the drudgery and boredom. Rockwell admits that if he had grown up as a farm boy, he probably would not have idealized rural life as an artist. Yet he believed those summers spent in the country as a child had a lot to do with what he painted later on. For, as he said, "The artist paints to fulfill himself and his life . . . I wasn't a country boy and didn't really live that kind of life . . . except later on in my paintings. Those summers, as I look back on them now more than fifty years later, have become a collection of random impressions—sights, sounds, smells—outside time, not connected with a specific place or event and all together creating an image of sheer blissfulness, one long radiant summer."

Since he was not a bona fide country boy, then, Rockwell was able to share with Americans his nostalgia for the clean, simple life through his numerous and varied portrayals of "those blissful summers."

In *My Life as an Illustrator* Rockwell explains his use of coun-

try people rather than city people in his paintings: "They fit into my kind of picture better. . . . Their faces are more open, expressive, lacking the cold veneer behind which city people seem to hide." In *Norman Rockwell, Illustrator* he continues: "They are just naturally good actors, not at being somebody else—they wouldn't be that—but at being themselves. These people have worked hard and their understanding of the fundamentals of life is reflected in their faces. That is what I like to paint. The more trouble they have had, the more interesting their faces."

Thomas Fogarty, who taught illustration to Rockwell in his art school days, always said that in order to paint a good illustration "you have to feel it. . . . Live in the picture; step over the frame. [It's] like throwing a ball against a wall. Throw it hard, and the ball comes back. Feel a picture hard, and the public feels it the same way."

Rockwell followed this advice throughout his career. The story of his life was really the story of his pictures and how he made them. As he puts it, " . . . in one way or another, everything I have ever seen or done has gone into my pictures." And, as Huck Finn says of Mark Twain in *The Adventures of Huckleberry Finn*, " . . . he told the truth, mainly. There was things which he stretched, but mainly he told the truth."

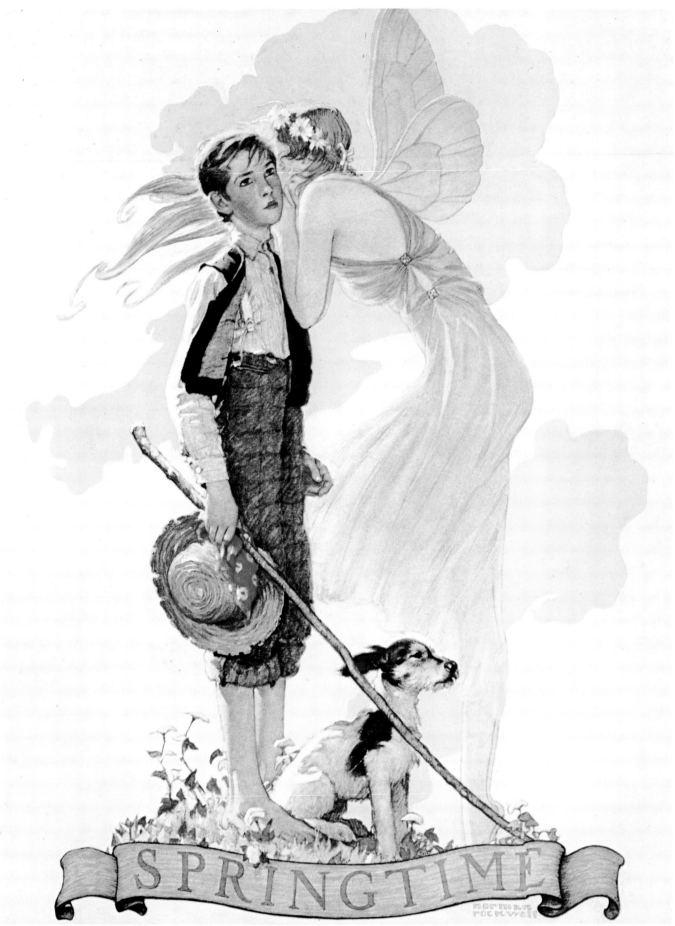

SPRINGTIME

It is significant that when Rockwell painted a dream world it is a country world. Rather than a knight in shining armor, the hero of his fairytale is a freckle-faced, barefoot farm boy. Rather than crag and castle, the setting for his fantasy is blossoming meadow and sun-dappled pond. The siren's song heard here is the rustle of new leaves in a spring breeze.

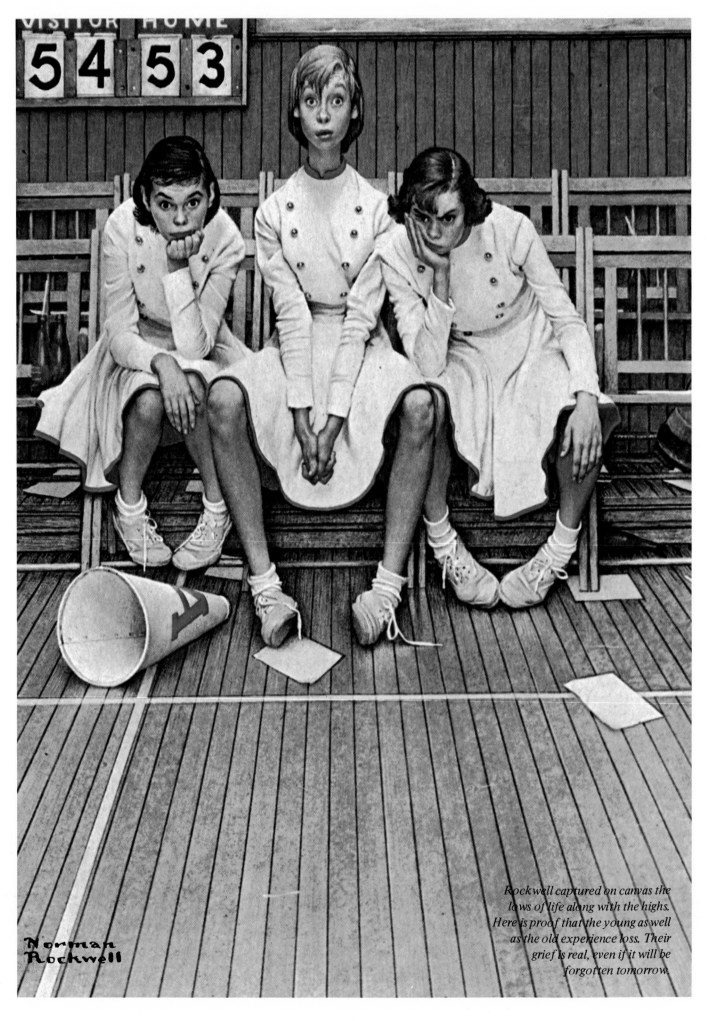

Rockwell captured on canvas the lows of life along with the highs. Here is proof that the young as well as the old experience loss. Their grief is real, even if it will be forgotten tomorrow.

Rockwell Loved A Loser

By John Alexander

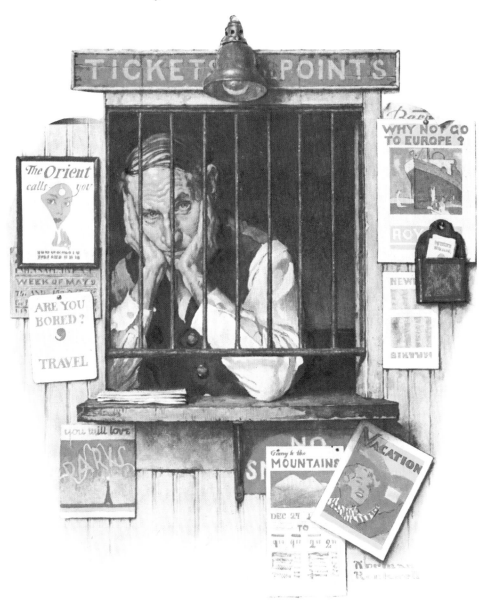

When everything has been said—*what a great draftsman Rockwell was, what an eye for detail he had, wasn't he the droll one, and my! couldn't he see clear through the foibles and pomposities of mankind?*—perhaps in the end why America took him to its heart was his pure humanity.

When one adds up all his works, it is the span of emotions Rockwell could orchestrate like a symphony conductor which is so impressive. When he tuned in on themes like *The Four Freedoms* he could strike chords in the human heart like a Beethoven or a Brahms. His old duffers, his feisty old ladies, the Romeo-and-Juliet quality of his young lovers are a virtuoso performance in the interpretation of the hu-

man condition. Each one is a variation in a new key.

But what a heart that little artist had in his small frame! Frail as he was in stature, he had a godlike view of what life could do to its losers, and he tried his level best through his art to even things up for them, if only in imagination.

It happens time after time with Rockwell. Sometimes the happy ending can never be, only a poignancy so touching the beholder would like to jump in there and help—as when the little old violinist reads his sad fate in the wail of the newfangled saxophone.

Occasionally, the loser smashes through to his great beyond, to the joy of all concerned.

Rockwell was the artistic embodiment of Abraham

Lincoln's remark that God must have loved the common people because he made so many of them. Time and again we visit charwomen mimicking the *haut monde*, humble ticket sellers yearning to journey to far Cathay, bums preparing a tin can dinner as insouciantly as Charlie Chaplin ever could, a pair of begrimed workmen plumbing the mysteries of milady's *parfumerie*. Less often we see youngsters in tragic moments that are none the less poignant for all their transiency. Rockwell sees humor in these situations but his portraits are sketched with a sympathetic hand. If there is a message here it is a simple one: We all win sometimes, lose sometimes. We are all one.

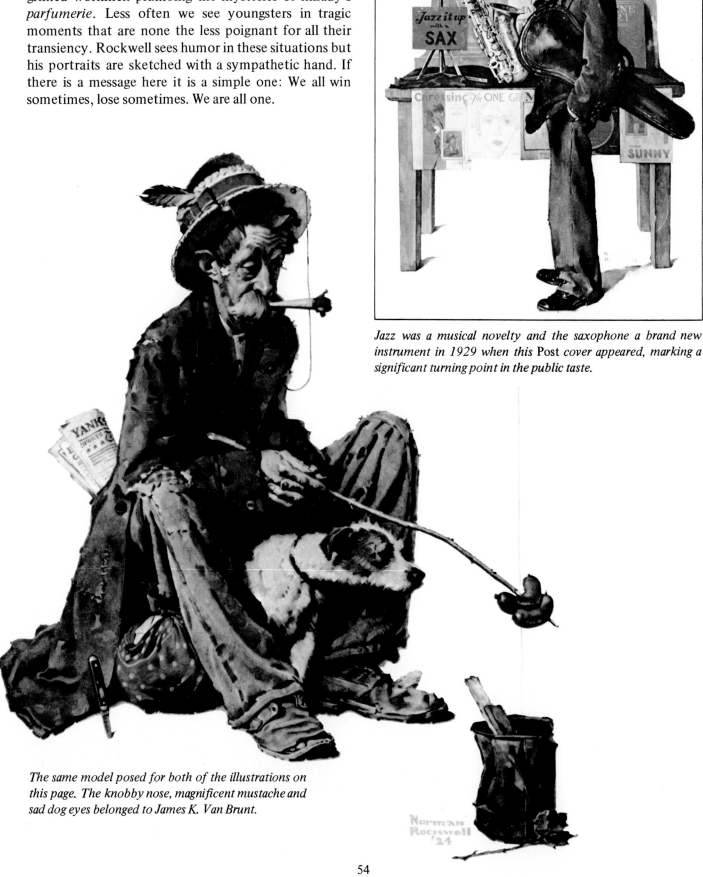

Jazz was a musical novelty and the saxophone a brand new instrument in 1929 when this Post *cover appeared, marking a significant turning point in the public taste.*

The same model posed for both of the illustrations on this page. The knobby nose, magnificent mustache and sad dog eyes belonged to James K. Van Brunt.

54

Love & Marriage

They Go Together, In the Artist's World

Norman Rockwell, a romanticist to the core, saw no harm whatsoever in portraying true love as one of this world's delights and marriage its inevitable finale. Thus, through some of his most charming paintings runs the theme of bittersweet young dreams and trials, with the happy ending just around the corner. Starchy little misses and prickly tomboys inevitably

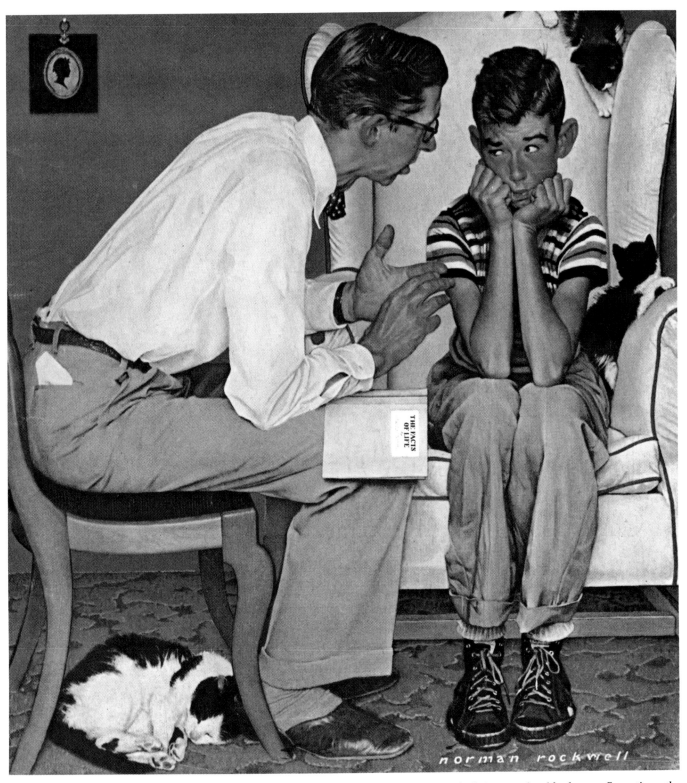

Courtship, marriage, family life—these are the realities that provide magazine artists with their most durable themes. Sometimes the treatment is frankly sentimental; sometimes it is humorous. The Facts of Life (above) belongs to the latter classification. It is obviously too late to lecture the cat—one of many cats that doze or frolic in Rockwell paintings.

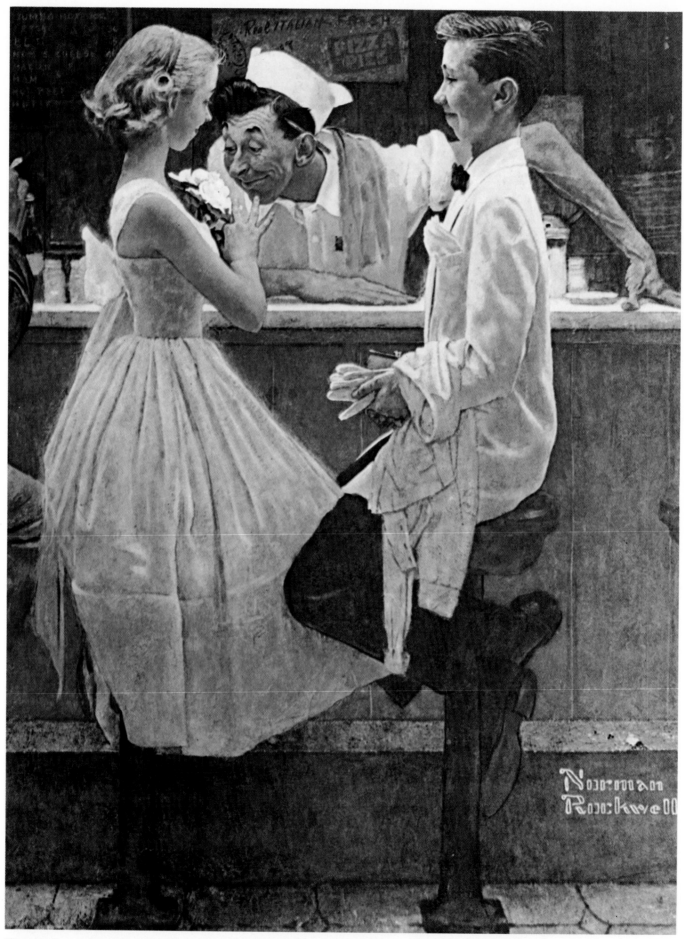

Rituals of courtship still existed in 1958. For him: ordering flowers, arriving early enough to spend five minutes with her father in the living room, promising he'd drive carefully and bring her home—after a stop at the soda fountain—by midnight.

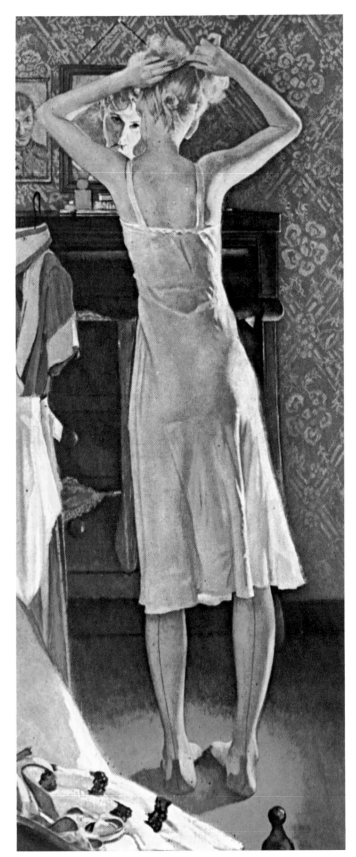
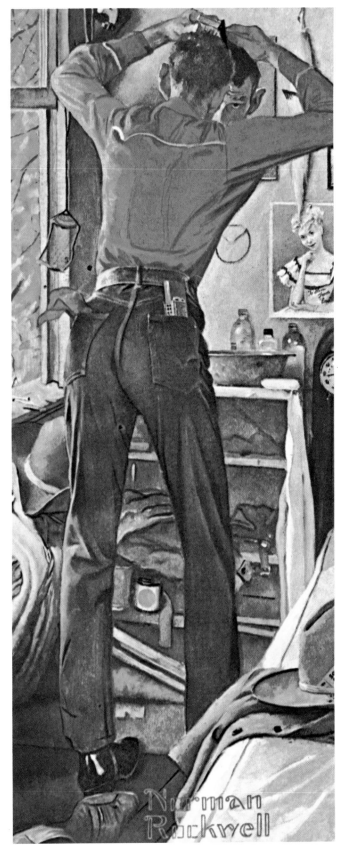

As anyone who's ever been on a date knows, a large part of "going out" is preparation. Getting the hair just right is paramount.

blossomed into shy young things demurely bussed under the mistletoe by gawky young giants, half boy, half man. Wedding bells chime softly offstage—see next week's cover for the bemusement and bliss of young married life. Was there a harsher world beyond? Of course, Uncle Norman knew that well. The coil and clamor of reality would be upon them, all too roughly, all too soon. So, he just smiled with that gentle, far-away look in his eyes, and seemed to say: Let them be for now, let them be happy.

All in a Day's Work

Of the many artists whose paintings appeared on the cover of *The Saturday Evening Post*, Norman Rockwell stands out as the one who most often portrayed workers at work.

The checkroom attendant staggering under a load of coats and hats, the optometrist placing glasses on a little boy's snub nose, the flagpole painter gilding the eagle for July Fourth—each is shown at the work he does to earn a living. Nearly all of the "work" pictures make a whimsical statement about the occupation: The railroad ticket agent dreams of the faraway places he sees only in travel posters; the zookeeper is so nonchalant about the lion's nearness that he may lose

his sandwich; the stained-glass worker seems to be receiving a blessing from angels in the church window he is repairing.

Rockwell's contemporaries John Falter, Stevan Dohanos, and John Clymer concentrated mostly on humorous family situations: Tots "helping" Mom by preparing dinner in her absence; Father giving the baby the 2:00 a.m. bottle; the backyard barbecue; the birthday celebration.

On other *Post* covers Thornton Utz, Dick Sargent, and George Hughes immortalized vacation and leisure-time scenes: the family struggling to erect a tent in a national park campground; travelers ordering French delicacies at a side-

walk cafe in Paris; teen-age boys happily eviscerating their jalopy on a shady summer lawn.

For the most part, these artists left it to Rockwell to find humor in work. Who else wanted to paint charwomen, plumbers, and window washers?

Sometimes the model Rockwell used was the real thing—as when Eddie Arcaro posed for him as a jockey weighing in before the big race. The doctor preparing a "shot" for the boy who drops his pants while inspecting the doctor's diploma was Rockwell's own physician, Dr. Donald A. Campbell of Stockbridge. Umpires Larry Goetz, Beans Reardon, and Lou Jorda, plus Dodgers coach Slyde Sukeforth and Pirates manager Bill Meyer, all posed for a baseball cover in 1949.

But sometimes the models were not at all what they seemed. Two well-to-do lady neighbors of the Rockwells in Arlington donned cheap cotton dresses and ruined their hairdos to pose as the dowdy cleaning women pausing in theater seats to read last night's playbill.

Sometimes members of the profession were delighted with the way Rockwell portrayed them and the picture became, over the years, almost a symbol for the group. One example is *The Pharmacist*—it hangs, framed, in many American drugstores and it appeared on a U. S. postage stamp honoring pharmacy. Many physicians hang *The Doctor and the Doll* in their offices, and *The Optometrist* was chosen in 1972 to appear on the cover of *The Journal of the American Optometric Association.*

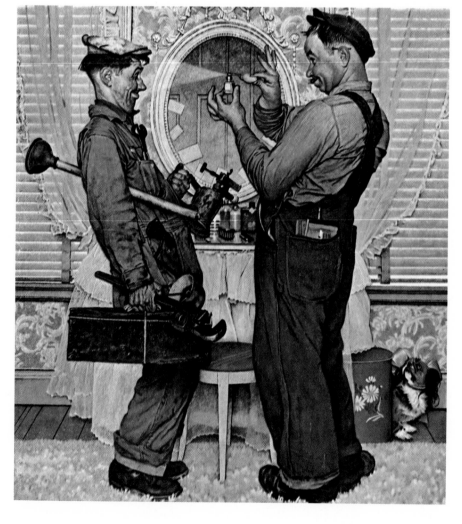

Rockwell laughed with the worker, not at him. Here, plumbers enjoy a moment of fantasy in a world of extravagance.

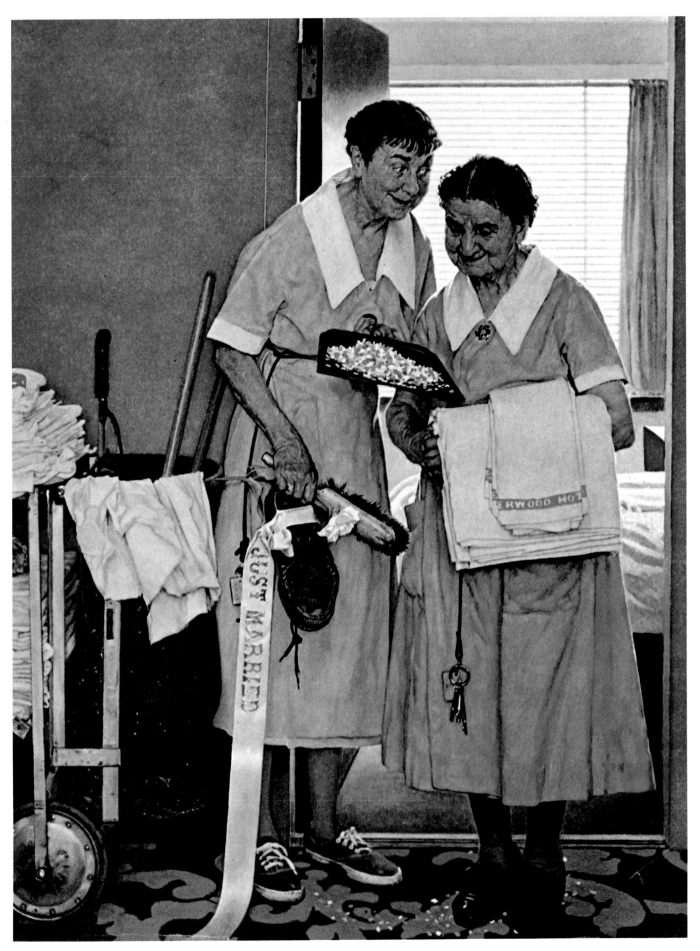

Who but Norman Rockwell could capture so well a moment of gentle humor in the average working day? Here two motel maids pause by their carts to exclaim over the dustpan-full of confetti found in 209—the honeymoon suite.

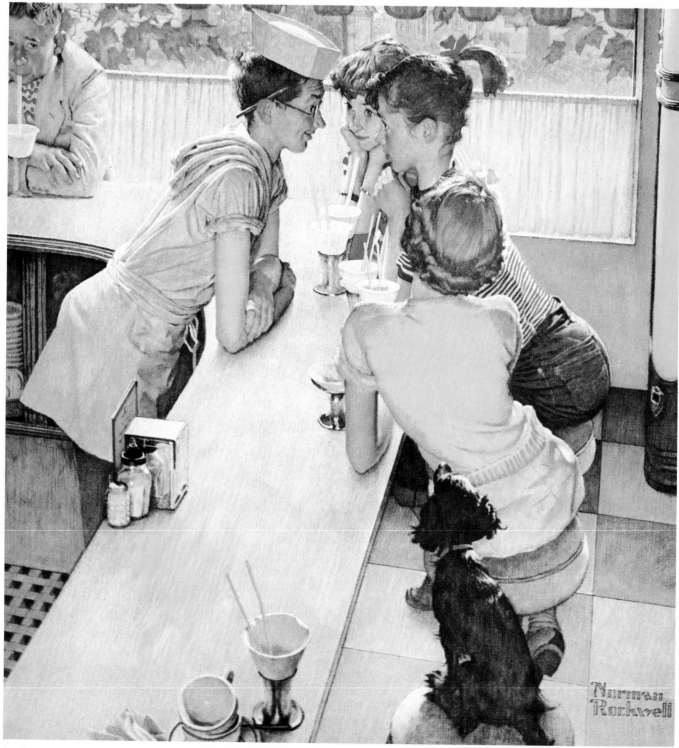

In the days when saddle shoes jitterbugged to the "Bop-Bop-Bops" of juke boxes and wheels thumped over bumps to the beat of "Blueberry Hill," the soda counter was the place to be and, as the picture above testifies, not a bad place to work, either.

Not so with schoolteachers. A 1935 cover showing a teacher in 1870's garb and the 1956 cover, *Happy Birthday, Miss Jones*, both drew letters complaining about the teachers looking dowdy or just plain ugly.

(As a matter of fact, one can find immortalized by Rockwell on the cover of a 1917 *Post* a very pert and pretty schoolmarm complete with beau. So Norman Rockwell, painter of teachers—as well as doctors, pharmacists, optometrists, and umpires—is exonerated.)

Since Rockwell's job descriptions were, of necessity, wordless, he paid particular attention to the workman's garb and the workman's tools.

As one might expect, Rockwell left starch out of their clothing. The wrinkled state of the traditionally crisp uniform of a "nanny" pays tribute to the task of quieting a screaming baby. There is character in the uneven roll of a painter's trouser cuffs, and in the shapeless hat on the belligerent head of the sheriff who mans the Elmville

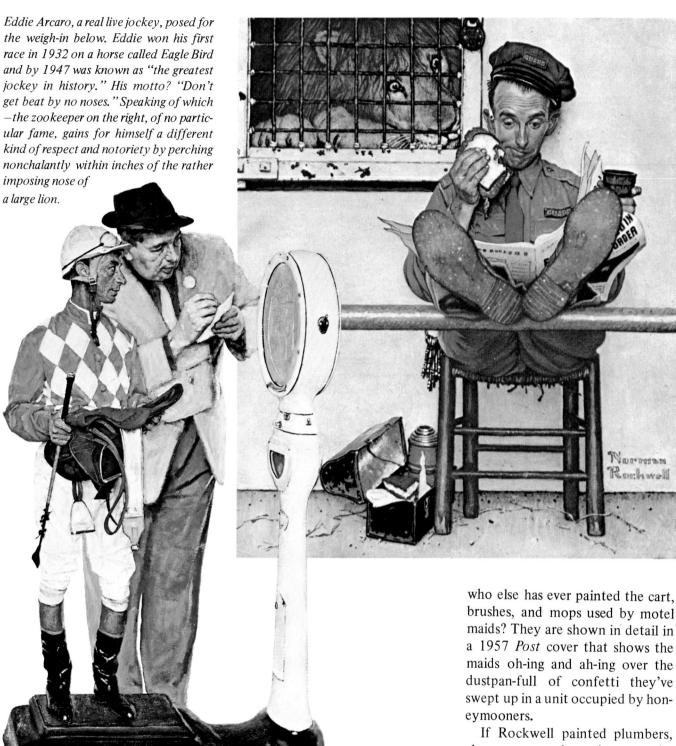

speed trap. The Yankee lobsterman who catches a mermaid (that 1955 cover brought a spate of mail from people who felt the "topless" catch was too sexy for the staid *Post*) wears clothing that is properly weatherbeaten, and the soda jerk's apron is soiled just enough. Each garment is perfectly detailed and authentically rumpled.

The plumbers in one famous *Post* cover are easily identified by the wrenches and plunger they carry, tools that take on comic dimensions when compared to a diminutive bottle of perfume. Whimsy turns slapstick when one plumber squirts scent at the other. Authentic are the tools of the window washer and the sign painter. And

who else has ever painted the cart, brushes, and mops used by motel maids? They are shown in detail in a 1957 *Post* cover that shows the maids oh-ing and ah-ing over the dustpan-full of confetti they've swept up in a unit occupied by honeymooners.

If Rockwell painted plumbers, charwomen, and moving men, he also painted men and women who earned a living in more unusual—even esoteric—ways. A tattoo artist. An Army chef. The guard in an art museum. The repairman who clambers to the top of Miss Liberty's torch. The "work" pictures are varied, but they also have certain things in common. Always there is gentle humor in the situation portrayed. And always, too, there is respect for the worker and the job he does.

Famous Faces

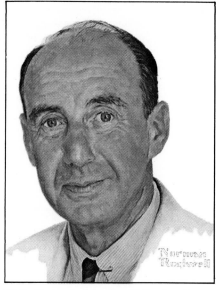

H e painted the great as well as the humble—Presidents and potentates along with newsboys and bums, glamorous actresses and First Ladies as well as charwomen and little girls with skinned knees.

Among those who sat for Rockwell portraits: Ethel Barrymore and Jennifer Jones, Bob Hope, Bing Crosby, Gary Cooper, Frank Sinatra, Arnold Palmer, Stan Musial, Joe Garagiola, four Presidents, a half-dozen unsuccessful candidates for that office (and their wives), plus assorted astronauts and a few foreign heads-of-state.

Was he awed by all these persons of prominence and power?

Always, said Norman Rockwell in his autobiography. He insists that he suffered from a kind of stage fright when confronted with a famous face. The truth is, some of the important people who sat for their portraits were very much in awe of Norman Rockwell, who was, by the late '50's, an American institution.

N.R. first dipped his paintbrush into the political scene in 1952, when the *Post* sent him to Denver to paint newly nominated Presidential candidate Dwight D. Eisenhower.

"Likable and charming," Rockwell said of Adlai Stevenson, Eisenhower's opponent in the Presidential election of 1956. In an attempt to be impartial the Post *ran Rockwell portraits of the two candidates on consecutive issues just before Americans went to the polls.*

Funnyman Jack Benny (below) looks characteristically wise, witty, and everlastingly 39 in the portrait Rockwell painted for a 1963 Post *cover. As a matter of fact the comedian, famous for jokes about his age and his money, was 69 at the time.*

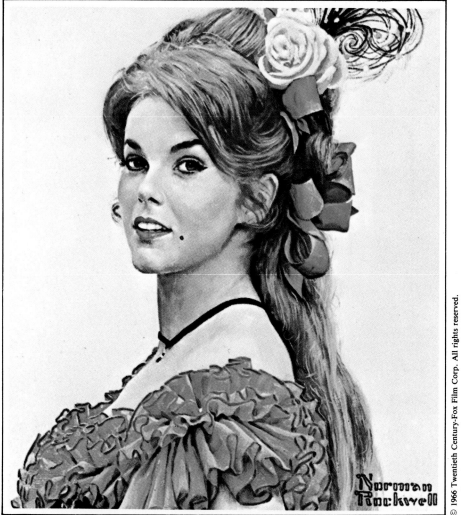

Actress Ann-Margret's portrait was part of the promotion for the 1966 movie Stagecoach. *Rockwell ended up playing a small part in the film himself.*

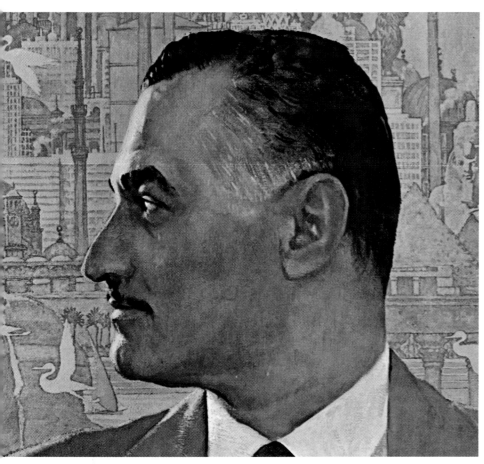

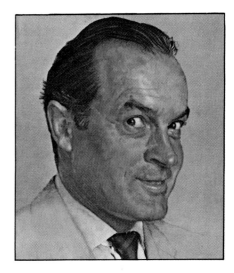

(Above) "I wanted a profile shot of Nasser," Rockwell said. "But he kept giving me that handsome wide-toothed grin." Bodyguards didn't help make the posing session any easier. Finally, the skinny artist jumped up and bodily turned Egypt's husky President sideways. Bob Hope's ski-slope nose, his wisecracking eyes almost spit out snappy one-liners in the 1954 portrait at right. Nehru, (below) agreed to wear his white linen hat though it was winter when Rockwell flew to New Delhi. The Nasser and Nehru portraits appeared on the Post in 1963.

Ike asked Rockwell's advice about his own painting, and at the end of the sitting they were good friends.

Four years later Rockwell painted Ike again, and he also painted Democratic candidate Adlai Stevenson.

"Painting both candidates didn't exactly clarify my political views because, as it turned out, Governor Stevenson was very likable and charming, too."

You would have to believe, from their Rockwell portraits, that all famous people are "likable and charming."

There is, of course, an explanation.

Rockwell saw the best in the people he painted, and he painted that "best"—the warmth, the

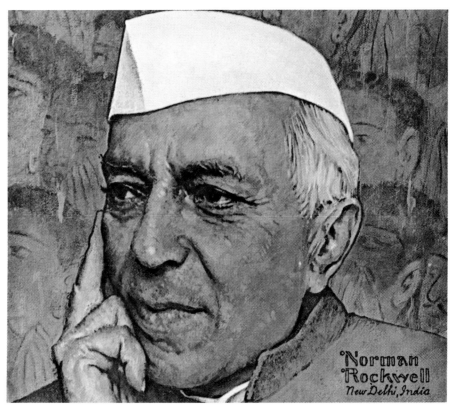

Norman
Rockwell
New Delhi, India

63

humor; the smile lines and the twinkle in the eye; the modesty and wisdom.

Rockwell liked the people he painted, and they liked him, and this mutual respect and affection adds a very special quality to these portraits of Presidents, statesmen, political figures, and show biz personalities.

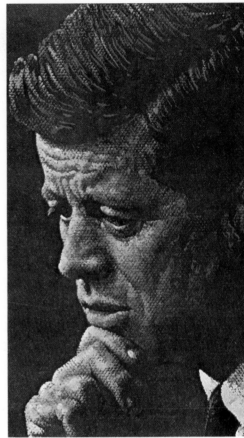

Bing Crosby's portrait (below) shows him as the grizzled, drunken doctor in Stagecoach. *The genial music man who made hits of countless song-and-dance epics was also a competent character actor. To the right and below, two from the series of Presidential portraits Rockwell painted for the* Post. *Most pictures of John F. Kennedy emphasize the man's youth and vigor rather than the intellectual qualities inherent in the Rockwell portrait that appeared on the magazine cover in April 1963. Dwight Eisenhower was the first President Rockwell painted for the* Post. *"It's his range of expression that's so appealing," Rockwell wrote, explaining why he called Ike one of his favorite models; "his wide, mobile mouth and expressive eyes."*

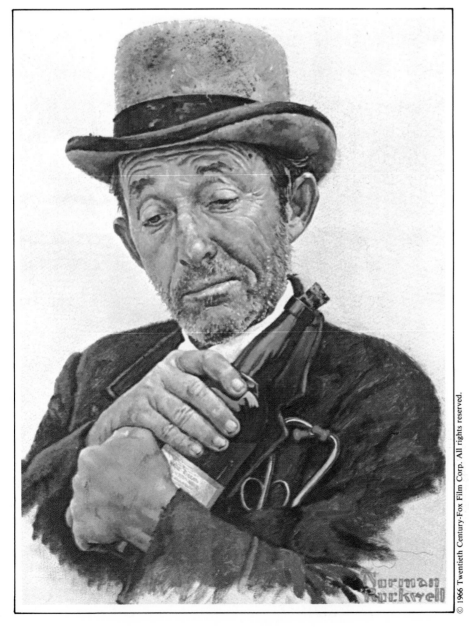

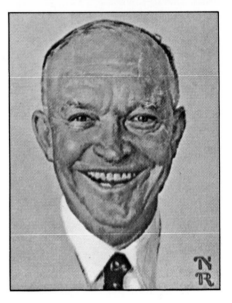

Norman Rockwell: Reporter

The Rockwell "visits" comprise a very special genre within the body of the man's work—they are his most literal depictions of American life.

Everything in these pictures is what it appears to be. The teacher is a real teacher; the editor is a real editor. The nervous men waiting outside the maternity ward? They were all real fathers by the time their pictures appeared in the *Post*. On shoes, the patina of actual wear; on umbrellas, evidence of actual weather. The backgrounds show the places where flesh-and-blood people went about their daily tasks—real places furnished with real calendars and real telephones that could connect you with a place called "Central" when you lifted the receiver.

The paintings and drawings in this series were done on assignment for the *Post* between 1944 and 1948. The home front of World War II and the postwar years as America neared the midpoint of the century—here are glimpses of that world, preserved for a later generation's scrutiny.

These worthy citizens determined who was entitled to extra quantities of such war-scarce commodities as gasoline and sugar.

Rockwell Visits a Ration Board

Spring was on the land, and the benignant Vermont sun, having penetrated every other nook and cranny in the town of Manchester, presently made its way into a certain quiet room where six men and one woman sat around a long, plain table. Then, in the following order, came: the song of birds, the fragrance of flowers, and—Norman Rockwell.

The last of these three, it developed, wanted something. The ration board, never having had a visitor who didn't, evinced no surprise. In Rockwell's case, however, the desideratum was none of the things that the rest of us try to wheedle out of our ration boards.

"What I would like," said America's favorite artist, "is the privilege of painting pictures of all you board members."

Could it have been a glow of pleasure, the stirring of some long-suppressed vanity, that seemed momentarily to illumine the seven faces? After all, New Englanders are human. And when Rockwell paints you, the world sees you. At any rate, the board members consulted one another, reached a decision, and in unison nodded to the artist.

"But make us look good, now."

In a flash, Rockwell saw his advantage. Living in New

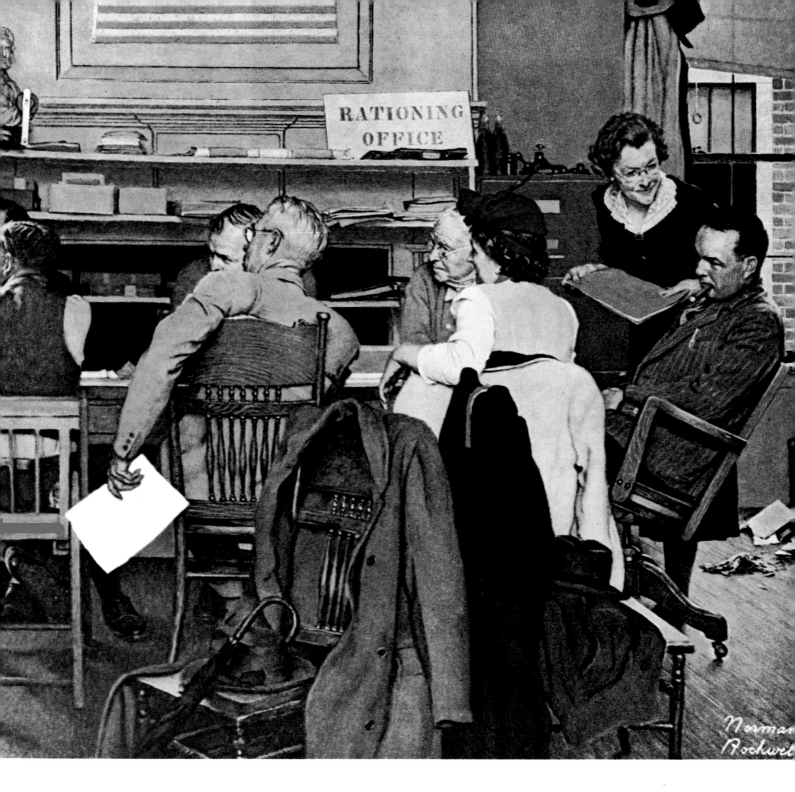

England sharpens a man, brings out the trader in him.

"If I do," he bargained, "will you give me a B card?"

"No, but if you don't," they said, "we'll take away your A card."

In a flash, Rockwell took a back seat (the same one you see him occupying) and, his favorite pipe in his mouth, spent all day—a day of sunshine and showers—watching America parade by.

It was a parade that has been and still is going on all over the Union; a parade which differs from all other parades in this: Everybody marches in it. That is why it interested Rockwell. It is an integral part of the American scene—now. There was no such thing a few years ago, and who can say how soon our ration boards will disband and this unique parade vanish forever? But no matter; for Rockwell has recorded the scene—the ration board at work and the importunate citizens who appear before it.

That record, reproduced here, is the newest chapter of a book which has been in the making for 28 consecutive years. The book might well be entitled *Norman Rockwell's History of the U.S.A.* It contains no text, and needs none. To leaf through its pages is to know America as it was—how its people looked and acted, how they dreamed and mourned and grinned—between the years 1915 and 1944.

Other chapters will be added to this record from time to time. Many of them, we trust. (1944)

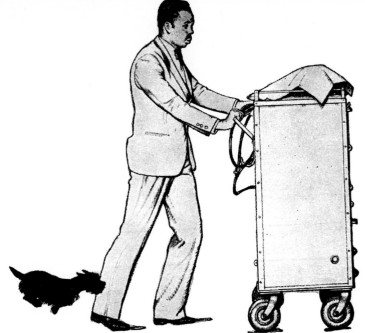

Fala pursues as President Franklin D. Roosevelt's lunch is wheeled into his office.

White House correspondents interviewing a visiting Navy hero.

So You Want to See the President

Sometimes it seems to the busy White House staff as if everybody on this good, green hemisphere wants to see the President of the United States personally. With a small segment of our population this is a chronic disease; with most Americans it is simply an expression of honest curiosity and interest. It was with this understandable interest in mind that White House authorities recently permitted *Post* artist Norman Rockwell to roam the Executive Wing and make a visual report on what the process of getting in to see the President is like. As the drawings and paintings show, Rockwell found the wing a fascinating antechamber of democracy, and he says he

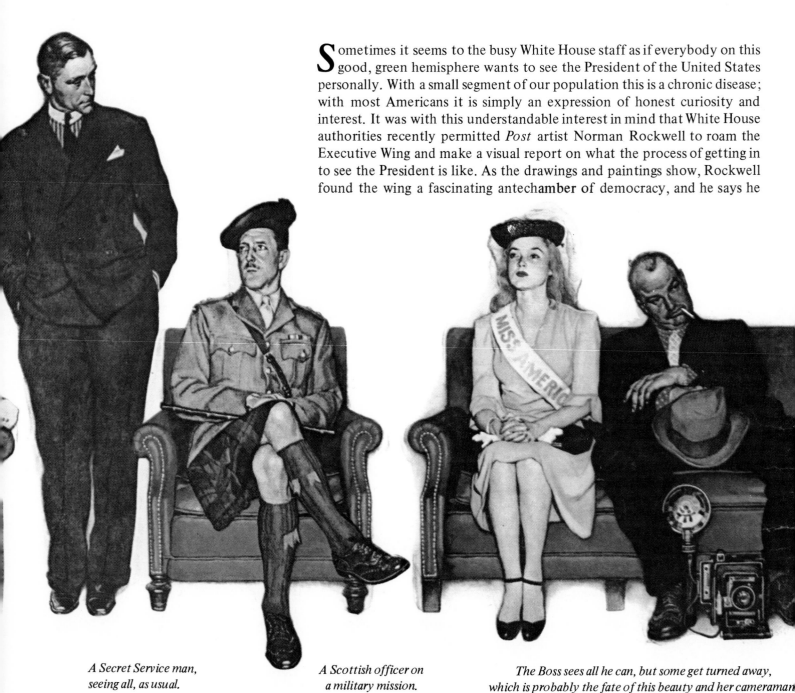

A Secret Service man, seeing all, as usual.

A Scottish officer on a military mission.

The Boss sees all he can, but some get turned away, which is probably the fate of this beauty and her cameraman.

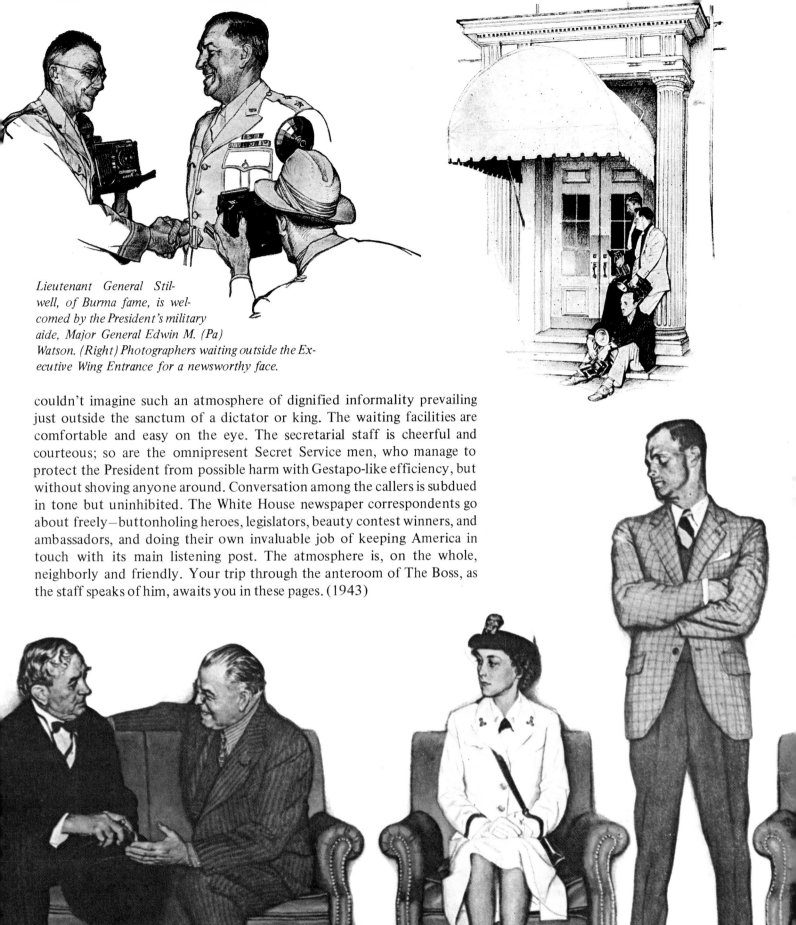

*Lieutenant General Stil-
well, of Burma fame, is wel-
comed by the President's military
aide, Major General Edwin M. (Pa)
Watson. (Right) Photographers waiting outside the Ex-
ecutive Wing Entrance for a newsworthy face.*

couldn't imagine such an atmosphere of dignified informality prevailing just outside the sanctum of a dictator or king. The waiting facilities are comfortable and easy on the eye. The secretarial staff is cheerful and courteous; so are the omnipresent Secret Service men, who manage to protect the President from possible harm with Gestapo-like efficiency, but without shoving anyone around. Conversation among the callers is subdued in tone but uninhibited. The White House newspaper correspondents go about freely—buttonholing heroes, legislators, beauty contest winners, and ambassadors, and doing their own invaluable job of keeping America in touch with its main listening post. The atmosphere is, on the whole, neighborly and friendly. Your trip through the anteroom of The Boss, as the staff speaks of him, awaits you in these pages. (1943)

*Senators Connally (D., Texas) and
Austin (R., Vermont) and briefcase.*

*What has Miss America got that
Wave Ensign Eloise English hasn't got?*

*Another Secret Service man
keeping both eyes peeled.*

America at the Polls

It would be hard to name anything more thoroughly American than the grand and glorious event which takes place on a certain Tuesday of every fourth November. To portray this national phenomenon, to capture its traditional spirit, we could think of no living artist better equipped with native understanding than Norman Rockwell.

In his search for a truly representative background, Rockwell went straight to the heart of America; specifically, to Cedar Rapids, Iowa. By the time his pictorial preview was completed, he had created a new character: the human, likable citizen who adorns these pages. We have christened him Junius P. Wimple.

It was the picture in the lower right-hand corner that gave the *Post* editors a bright idea. Rockwell, we reasoned, always knows his characters through and through. As Wimple's creator, he knows how Wimple thinks, feels—*and votes*. Therefore, why not trick the artist into revealing Wimple's secret, and thus learn the outcome of the election before it takes place? So we wired Rockwell: "Which one is Wimple voting for?"

Promptly, the guileless artist answered by wire, collect: "For the winner." (1944)

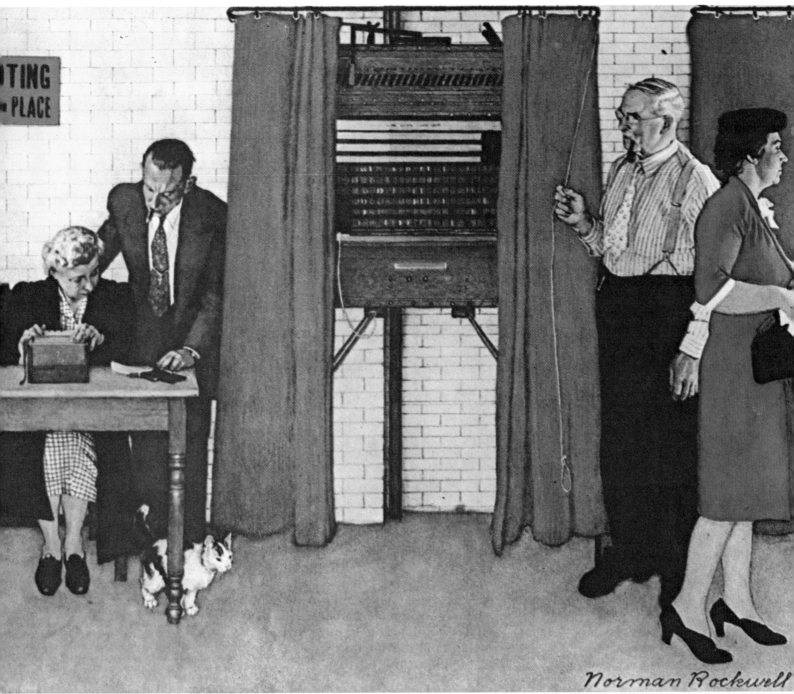

"Now, dad, you listen to us!"

"Have a cigar, Junius. Now. . ."

"Hurray! My man won!"

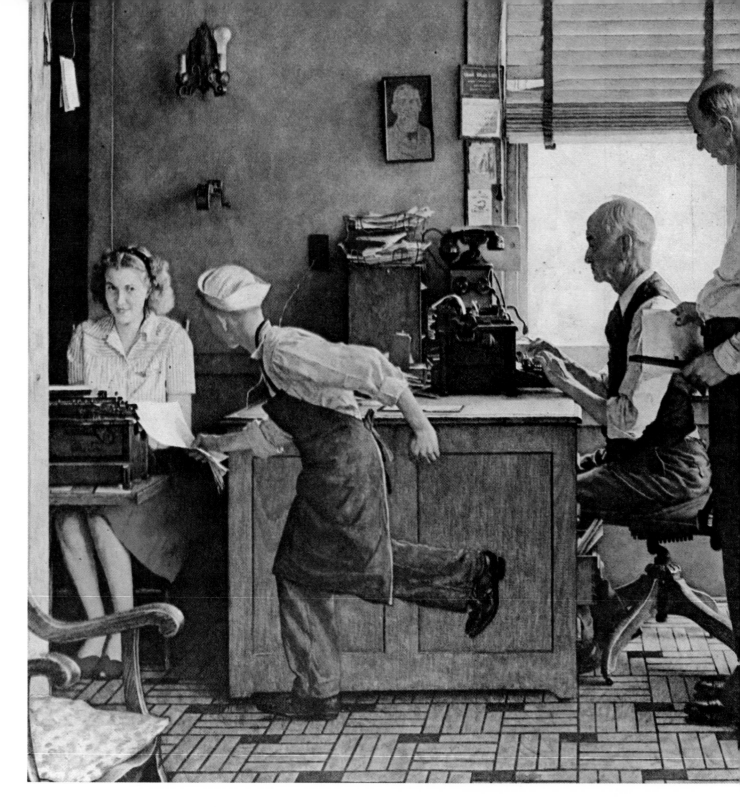

Rockwell Visits a Country Editor

When artist Norman Rockwell set out from his Vermont studio to look for a typical old-style country editor, he was fated to find his way to the weekly newspaper office of Jack Blanton in Paris, Missouri. Anyway, that is what the painting herewith testifies—and that's our man bursting in at the door.

Blanton is perhaps the best known country editor in the United States. By the force of his personality and convictions, he has done for his paper, the *Monroe County Appeal*, what the late William Allen White did on a larger scale for his Emporia, Kansas, *Gazette*. He struggles, as White did, for the civic soul of his community and the political soul of his state. Blanton is 76 and has been editor of the *Appeal* for 53 years.

Monroe County is in the center of a strip of Missouri that is known as Little Dixie. Its inhabitants incline toward religious fundamentalism and the Democratic Party. Blanton, a devout Baptist, is widely known as an expert at praying for rain. During a drought in 1942 he

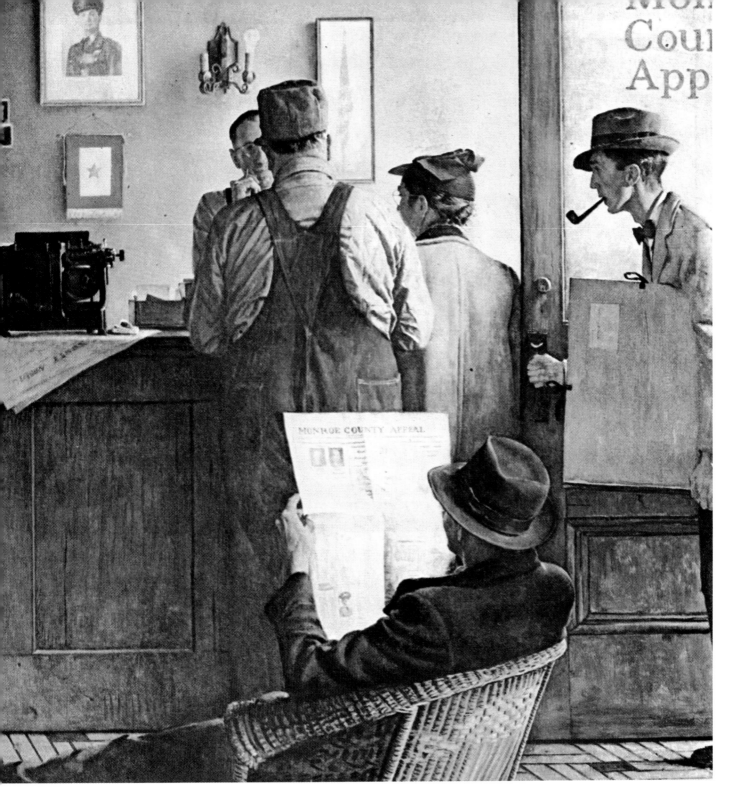

published a banner headline which read: *Lord, we confess our sins, we ask for forgiveness, we pray for rain.* Rain fell an hour after the *Appeal* was off the press.

The painting above shows the *Appeal* office on a typical Thursday just before the paper—circulation 3,000—goes to press. Blanton is shown batting out a last-minute editorial. That picture above his desk is one of his father, who founded the *Appeal*. The gold-star service flag hangs beneath a picture of a grandson of Blanton's, who would have succeeded him as editor if he hadn't lost his life in the Army Air Forces. Peering over Blanton's shoulder is the *Appeal*'s printer, Paul Nipps, whose experienced eye is gauging the number of printed lines the editorial will take up. At right, Malcolm Higgins, combination city editor and reporter, is talking over subscriptions with a couple of customers. The man in the wicker chair just dropped in to read a back number.

Rockwell hung around the place for days sketching the staff and an occasional visitor, and he couldn't resist the temptation to make himself part of the scene.

At left, typing, is Secretary Fernelle (Blondie) Wood. Dashing past her, Dickie Wyatt, the printer's devil, is headed for the pressroom where the faithful old press will soon begin to roll. (1946)

73

The Maternity Waiting Room

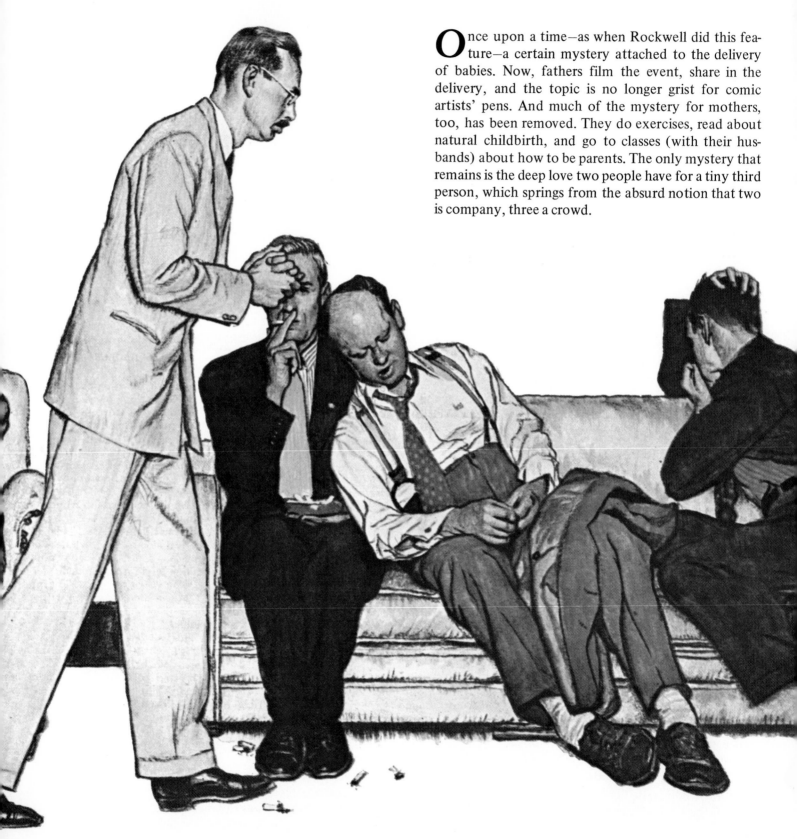

Once upon a time—as when Rockwell did this feature—a certain mystery attached to the delivery of babies. Now, fathers film the event, share in the delivery, and the topic is no longer grist for comic artists' pens. And much of the mystery for mothers, too, has been removed. They do exercises, read about natural childbirth, and go to classes (with their husbands) about how to be parents. The only mystery that remains is the deep love two people have for a tiny third person, which springs from the absurd notion that two is company, three a crowd.

Distraught
Executive

Chain
Smoker

Father-of-Eight Type

Trag

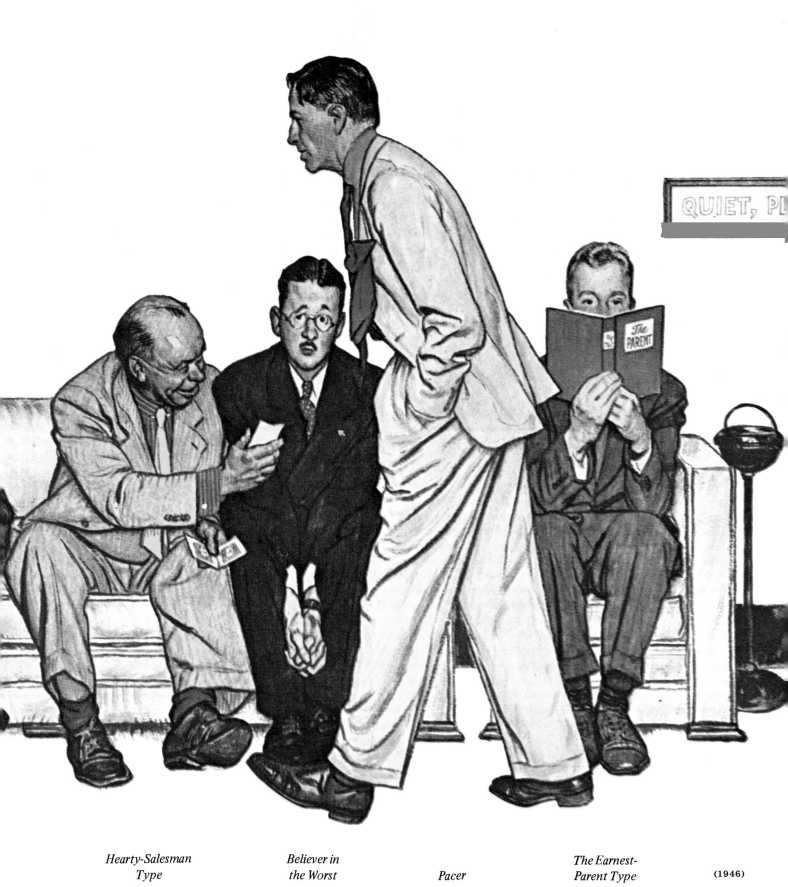

Hearty-Salesman
Type

Believer in
the Worst

Pacer

The Earnest-
Parent Type

(1946)

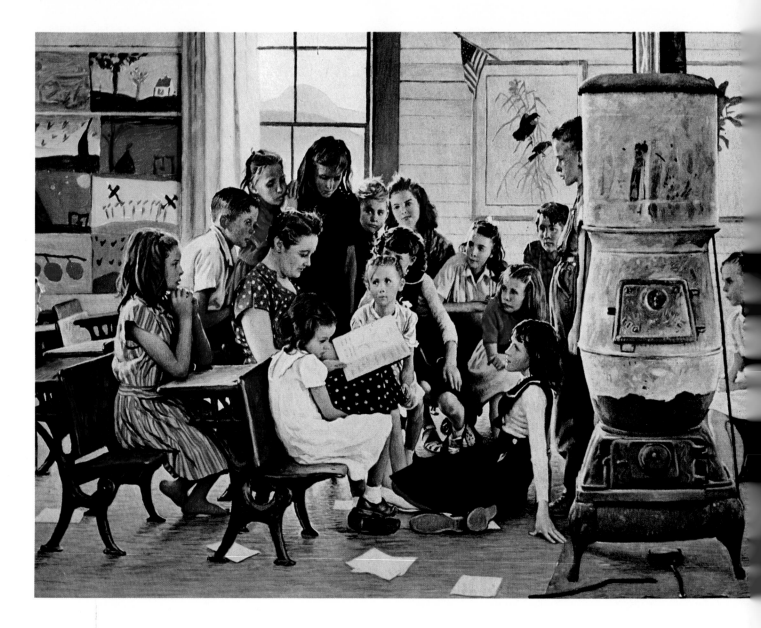

Rockwell Visits a Country School

*I*n the three pictures on these pages, one of our pupils, Norman Rockwell, will recite on his visit to a one room country school. The class will please put away its books and papers and quit copying the arithmetic answers from that smart girl across the aisle. First, can anyone tell why the one room country school is famous? That's right, it is where millions of Americans had their first brush with education; where they first had to learn that Montana is west of the Mississippi, that 9 times 9 is 81, and that words that end in *ible* invariably double-cross you and end in *able*. And what else? Yes, because it was to schools like this that some of our most successful citizens trudged heroic distances through snow piling higher every time they tell it.

The children listening raptly above—all except one Miss Barbara Gilley, who likes to choose her own books—are students in Oak Mountain School, which

sits atop a tall clay hill in Carroll County, Georgia. Rockwell visited it in a "small year" when there were only 40 pupils; some years there are 75. The school was suggested to him by leading educators who think the teacher, Mrs. Effie McGuire, does an exceedingly good job of teaching these rural youngsters.

Mrs. McGuire teaches all grades. Oak Mountain used to have two teachers. When it was cut to one, the county superintendent suggested that sixth and seventh grades move to the next school. The pupils wouldn't hear of it. "I was teaching children, not grades, so they stayed," says Mrs. McGuire. Rockwell's explanation is simpler: "The kids are crazy about her."

The wife of a farmer, Mrs. McGuire lives a mile from school. With no children of her own, she has devoted ten years to teaching all the small fry of the community—the Gilleys, the Drivers, the Meigs, the Calhouns,

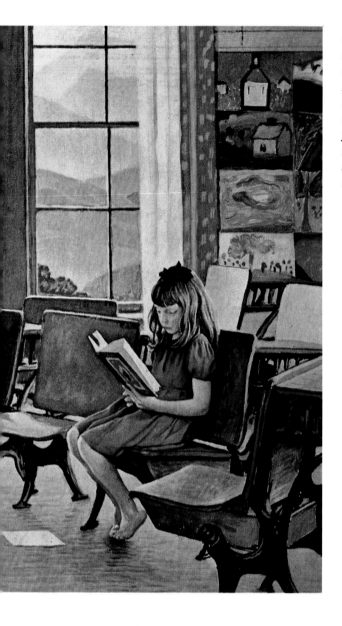

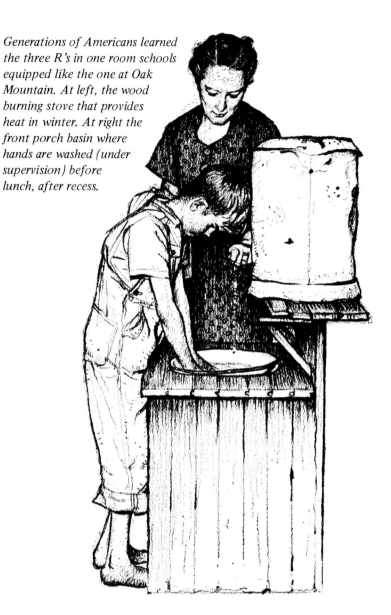

*Recess finds teacher and pupils out on
a playground equipped with space
and fresh air—and not much else.*

the Barneses, the Wallaces, and the Thomases.

In a time of great unrest among teachers, when many have given up being "the candle which lights others while consuming itself," she is a rarity—an enthusiast. "Smiley" Duffey's daughter decided to be a teacher when she was a barefoot girl of six attending a school very much like this. It is perhaps a good thing that she does love the work, for this weather-beaten clapboard schoolhouse may be a fortification of the republic, but it has all the shortcomings of its kind. The plumbing is outdoors, the washbowl is on the porch, someone has to tote coal for Big Joe, the stove. The pay is thin soup; it has been as low as $420 a year, and even now is only $878.

"She's an unusual teacher," said a Georgia educator. "She's no great intellectual. She's just able, through kindness, a quiet voice, and a love of children, to free their minds so they can learn."

This simplest form of one-celled school is being overtaken by evolution. More and more of today's 12,000,000 rural school pupils catch the school bus to a bigger school, made by consolidation. (1946)

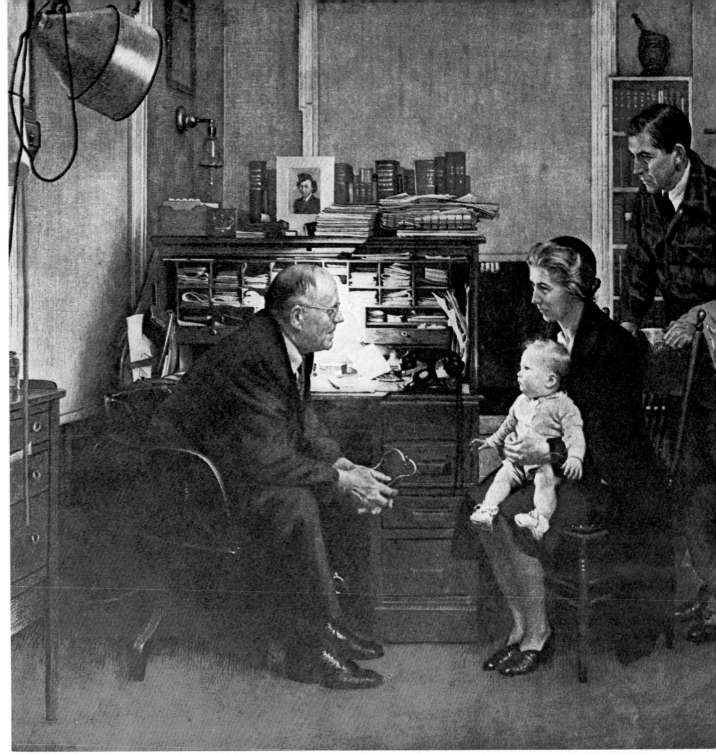

Dr. Russell's comfortably cluttered office and the adjoining waiting room are part of his residence, a fine old colonial house on Arlington's main street. The decor includes various objects from the doctor's extensive collection of Vermont historical materials.

Rockwell Visits a Family Doctor

A young doctor who had opened his first office in Northern Vermont had to journey to Poughkeepsie, New York, in 1911. Overnight he stopped in Arlington, Vermont, putting up in a pre-Revolutionary inn. It was an old town flourishing long before Ethan Allen's Green Mountain Boys were born, as Early American as pewter. The traveler liked the looks of the place so well that he resolved to stay there. He has become an all but indispensable citizen, a leading physician and a wheelhorse in town affairs. His hard-used car has answered many calls to Norman Rockwell's house, for this town of 1,200 is the artist's home, and now the famous artist pays a professional call on the doctor with paint and pencil. For in Rockwell's opinion, Dr. George A. Russell, M.D., personifies a whole band of hard-working men—the family doctors.

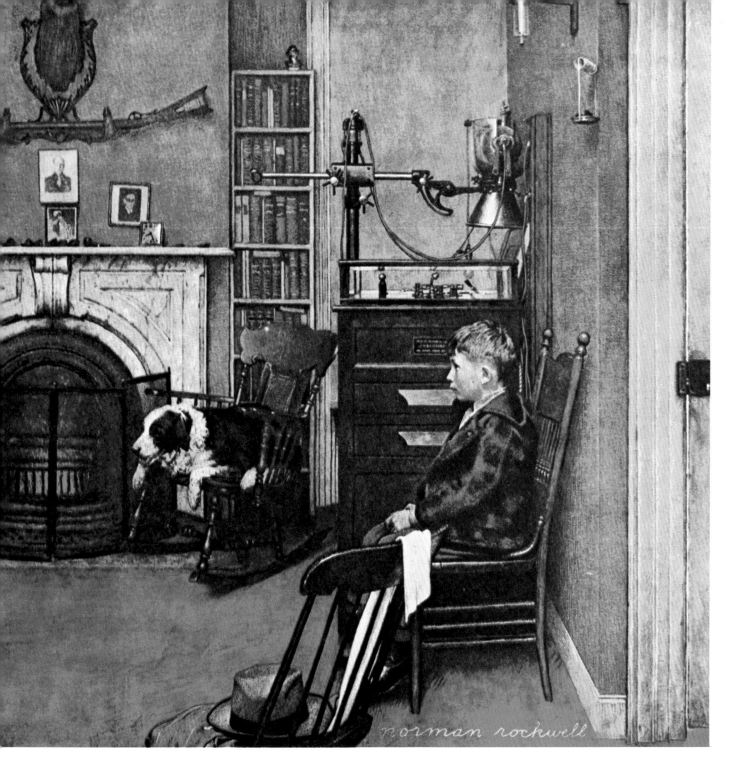

Their fame is not horizontal and national, but vertical and local. In an age of specialists, here are "generalists," expected to battle everything from appendicitis to zonulitis, which, along with being a handy example of an ailment beginning with *z*, is an eye trouble affecting the "zone of Zinn." "Worth many another man to any community" was the value the great Sir William Osler set on the "well-trained sensible family physician." Arlington puts it like this: "We couldn't do without Doctor Russell. He's one man the town couldn't spare." For thirty-three years—he spent three overseas in World War I—he has dosed, bandaged and splinted them, put the accident victims together, delivered the babies, treated the measles and mumps, and stitched up the town's cuts. (When they were logging the woods, bloody accidents were common.) He is the school doctor, the railroad doctor, and in his consulting room has treated almost everyone in town and the countryside around.

On the cluttered desk stands a portrait of his daughter, an Army nurse; near by hangs the diploma he won from the University of Vermont, paying his way by running a streetcar in Boston of summers; his dog Bozo usually is around. In this room he has heard a quarter century of troubles; doctors like this know everything about everyone, and it is fortunate that they are not easily scandalized and are professionally silent.

Illness doesn't wait because roads are sheathed with ice, and a doctor called to treat pneumonia often risks getting it on the way. (1947)

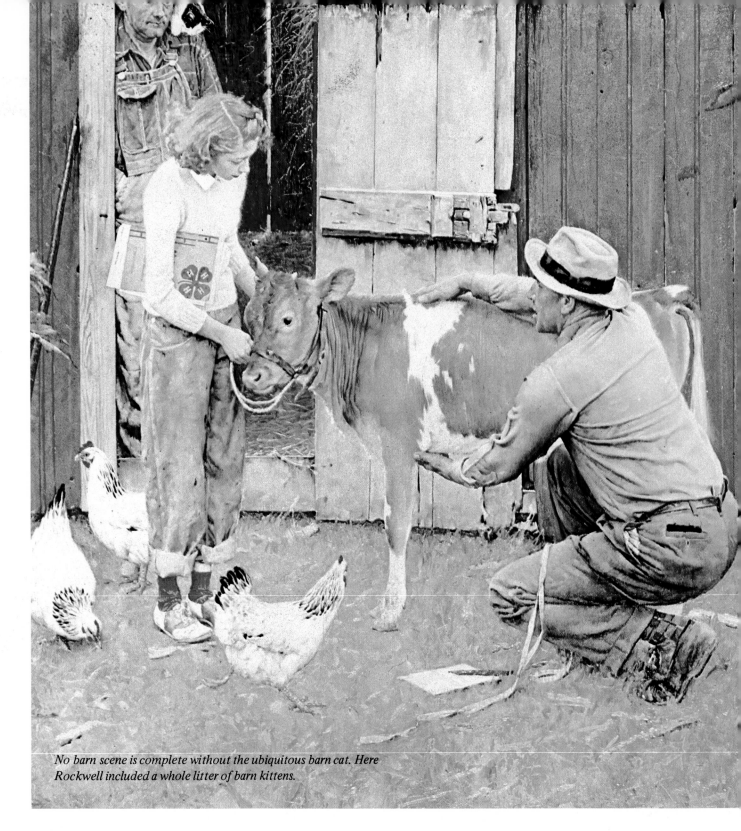

No barn scene is complete without the ubiquitous barn cat. Here Rockwell included a whole litter of barn kittens.

Rockwell Visits a County Agent

Sketching a grass-roots report of that uniquely American institution, the county agricultural agent, was a strenuous assignment for Norman Rockwell. After trailing County Agent Herald K. Rippey around Jay County, Indiana, for several days, Rockwell

was worn to a nubbin, but chock-full of farm cooking, tips on how to cull chickens, and warm admiration for his subject. "An agent has to be all man," he told us. "A farm expert, educator, organizer, diplomat, and trouble-shooter"—a busy fellow.

The Rockwell-Rippey team found the scene above on the 167-acre farm of Donald W. Steeds, whose 14-year-old daughter, Jama Sue, had bought a Guernsey calf with some money earned in 4-H Club projects. "That's the way many herds are started," noted Rippey, who thinks youth work is one of his most rewarding duties. In the barn door is quiet Don Steed, who is

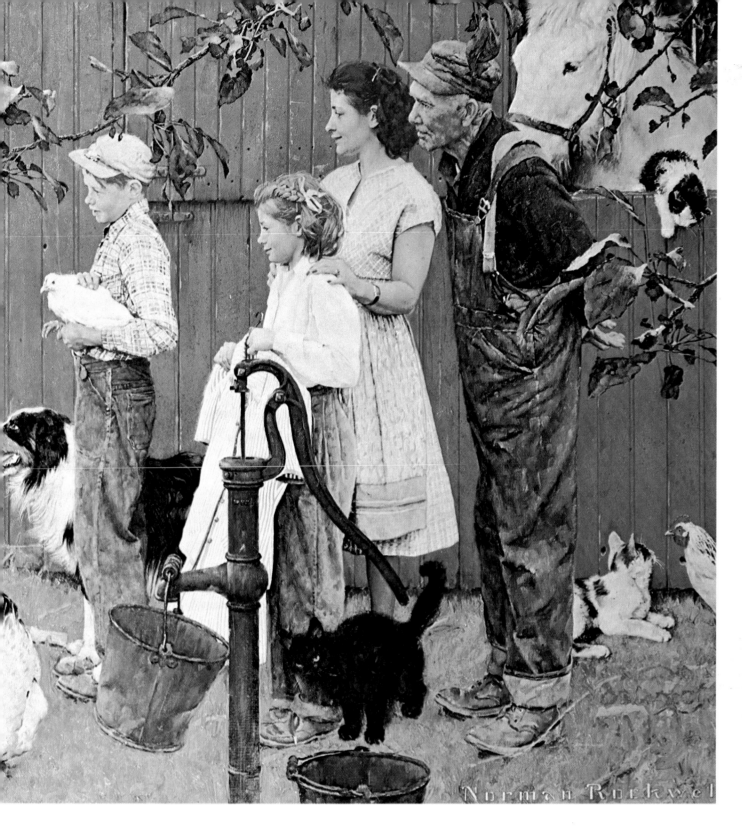

active in Jay County farm and school organizations. Waiting for the county agent to examine their 4-H tasks are Larry and Sharon Lea. At 13, Larry can run the tractor and milk the cows, and hopes to have a farm "with a white board fence all around it." Ten-year-old Sharon Lea has projects in sewing, dairying, and gardening. Despite her many household duties, Mrs. Steed attends Farm Bureau and PTA meetings. The elderly gentleman is Arlie Champ, neighborhood handyman.

No one county agent is "typical," but Herald Rippey is an authentic sample of the 3,000 who serve the rural United States. He is 44–about average. Like most, he grew up on a farm and studied agriculture in college; he has a degree from Purdue University. His salary comes from the U.S. Department of Agriculture, Jay County, and Purdue's Agricultural Extension Department.

Last year Rippey drove 20,000 miles, visited 800 farms, gave advice to 3,800 farmers, and attended 369 meetings, as many as three in one evening.

He does wish for more time for his family and fishing and hunting. But when his wife once suggested that he find a job with more pay and fewer hours, he replied, "I'll change–if you can name one where I'll be as well satisfied." The subject hasn't come up since. (1948)

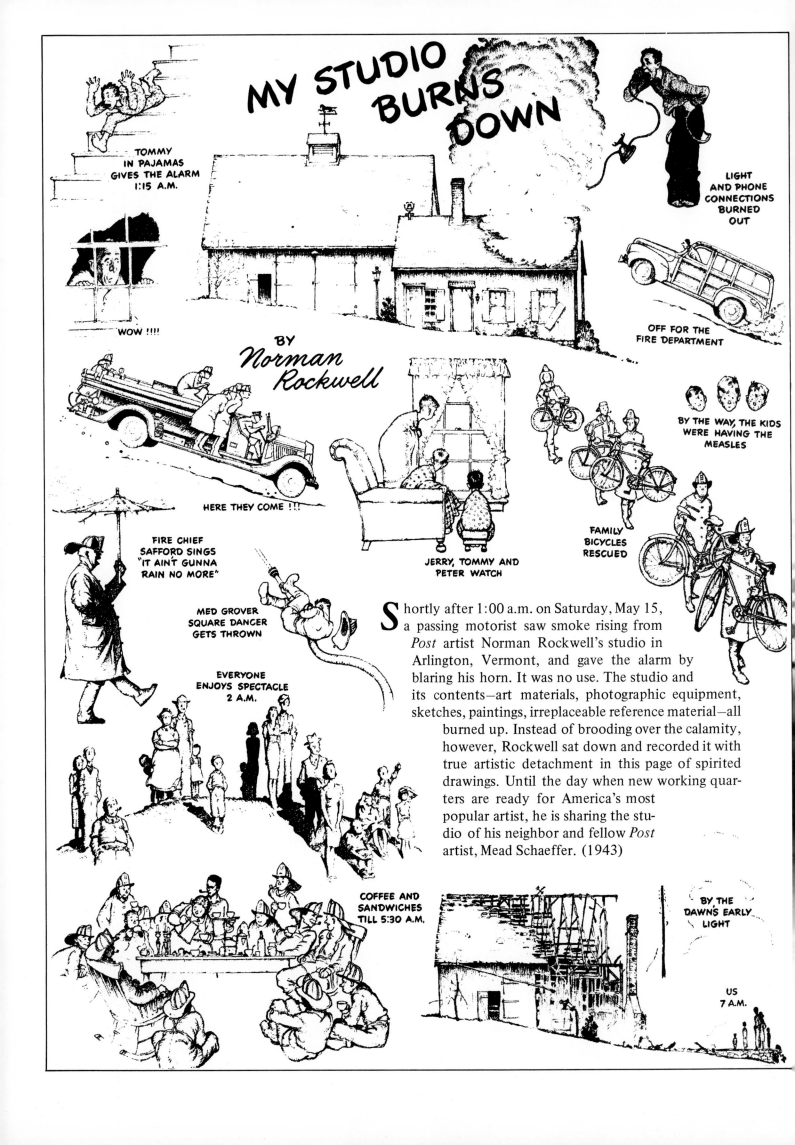

MY STUDIO BURNS DOWN

BY Norman Rockwell

TOMMY IN PAJAMAS GIVES THE ALARM 1:15 A.M.

WOW !!!!

LIGHT AND PHONE CONNECTIONS BURNED OUT

OFF FOR THE FIRE DEPARTMENT

HERE THEY COME !!!

JERRY, TOMMY AND PETER WATCH

BY THE WAY, THE KIDS WERE HAVING THE MEASLES

FAMILY BICYCLES RESCUED

FIRE CHIEF SAFFORD SINGS "IT AIN'T GUNNA RAIN NO MORE"

MED GROVER SQUARE DANCER GETS THROWN

EVERYONE ENJOYS SPECTACLE 2 A.M.

Shortly after 1:00 a.m. on Saturday, May 15, a passing motorist saw smoke rising from *Post* artist Norman Rockwell's studio in Arlington, Vermont, and gave the alarm by blaring his horn. It was no use. The studio and its contents—art materials, photographic equipment, sketches, paintings, irreplaceable reference material—all burned up. Instead of brooding over the calamity, however, Rockwell sat down and recorded it with true artistic detachment in this page of spirited drawings. Until the day when new working quarters are ready for America's most popular artist, he is sharing the studio of his neighbor and fellow *Post* artist, Mead Schaeffer. (1943)

COFFEE AND SANDWICHES TILL 5:30 A.M.

BY THE DAWN'S EARLY LIGHT

US 7 A.M.

Stories
to Read

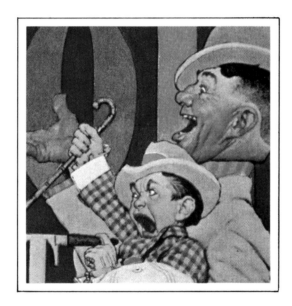

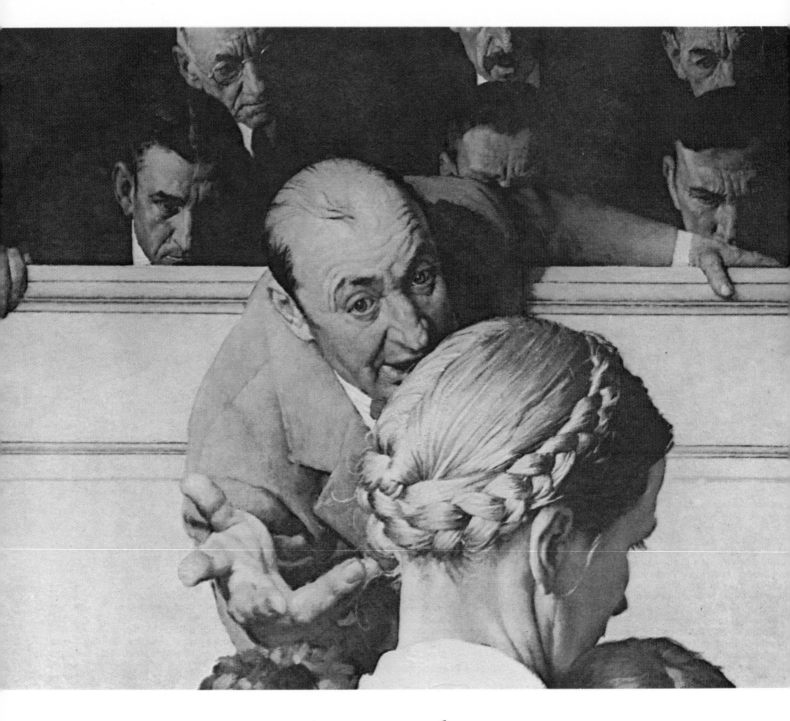

The Inside Story

A magazine story illustration has a very special function—it is supposed to catch the attention of the leafer-through and make him want to read the story.

The story illustration is, therefore, intriguing and incomplete.

Unlike the magazine cover, which includes all the information needed to understand what has transpired, the story illustration poses questions without answering them. Why is the mother brushing her daughter's hair with such grim determination? Why is the old man looking down a hole, and what does he see there? In the courtroom scene, why does the woman look away from the spellbinding attorney?

The picture asks the question; you have to read the story to learn the answer to the question.

Perhaps because they ask questions Norman Rockwell's story illustrations contain more empty space than his magazine covers. In most there is tension and suspense, but there is also spaciousness, for the elements of the composition stand a little apart from each other.

The magazine cover format poses rigid strictures on the artist—

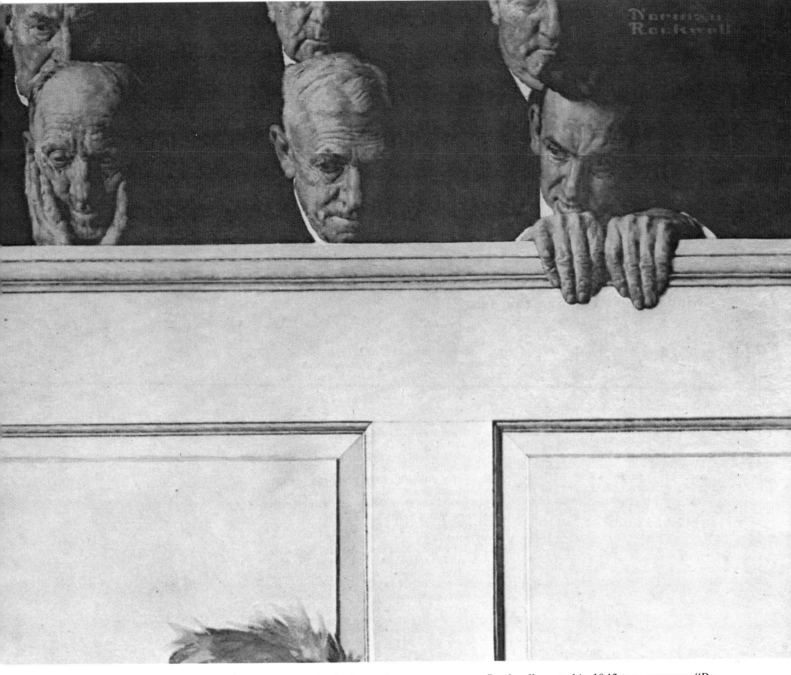

The man who is on trial for murder does not appear in the dramatic courtroom scene Rockwell created in 1942 to accompany "Do You Know a Better Man?" by Helen Friedel Mosier. Instead, one sees the man's wife clinging to three young sons. The model was Rose Hoyt, who also appears in Freedom of Worship *and in the* Golden Rule *cover.*

his painting must be vertical and rectangular, it must allow space for the logo and a suggestion of the magazine's contents, etc. Not so the magazine story illustration. It can be any shape the artist fancies.

Rockwell obviously enjoyed the freedom allowed him when he illustrated stories, particularly the freedom to create horizontal compositions. These include the forging contest scene (an illustration for "Blacksmith's Boy—Heel and Toe"

by Edward W. O'Brien), the courtroom scene reproduced here, and the striking illustration for Carl D. Lane's "River Pilot" which appears on pages 88 and 89 of this book. In each case the horizontal composition can be divided near the center to form two nearly square pictures, each one able to stand alone.

Norman Rockwell illustrated different types of stories for the *Post*, so it is not surprising that he made use of different styles and

techniques even in paintings done at about the same time. His illustrations for James Thurber's amusing baseball story, "You Could Look It Up," are cartoon-like; the illustration for Stephen Vincent Benét's legend, "Daniel Webster and the Ides of March," is mystical and mysterious; the illustrations for two Depression-era tales of poverty and deprivation, "Johanna's Christmas Star" and "Do You Know a Better Man?" are poignant, and

they have the dimmed, almost blurry quality of scenes viewed through a mist of tears.

The first Rockwell story illustrations in the *Post* appeared in 1916. Very similar to his earliest cover paintings, they are lively and attractive—but unremarkable—pictures of children at play. There are no more story illustrations for two decades. The illustration that appears then, in 1937, is a beautifully composed and freely brushed study of two men and a boy waiting apprehensively in a doctor's office. This, and the other illustrations that appeared in the '40's and '50's, are vintage Rockwells, some of the master's finest work. The last to appear, in 1962, shows a young Lincoln speaking before a jury. Appropriately, it is one of the most "modern" of all Rockwell's paintings in its free, almost impressionistic, splashing of color.

The greater part of Rockwell's work was made up of magazine covers and commerical assignments for advertisements and calendars—but his story illustrations included some of the most fresh and original and unusual of his paintings.

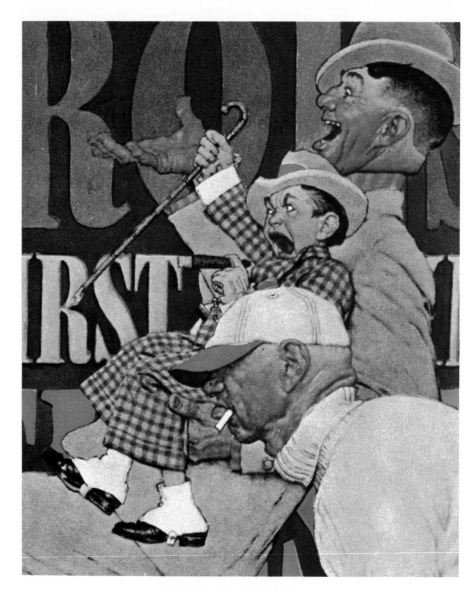

Rockwell's first story illustrations for the Post *(below) appeared in 1916. A quarter of a century later, the comic cartoon-like characters (above) in Thurber's "You Could Look It Up" contrast with the real flesh-and-blood figures (right) in the story "The Handkerchief."*

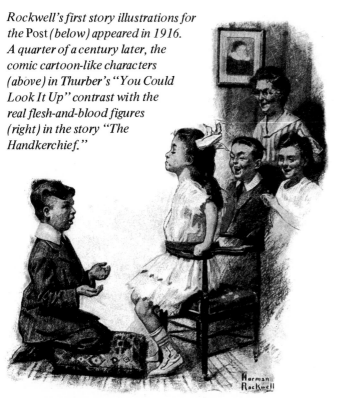

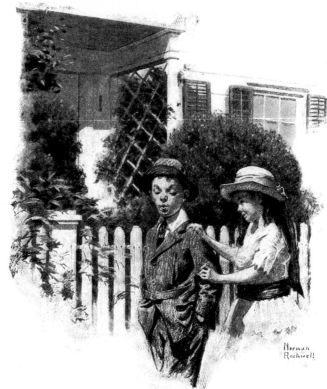

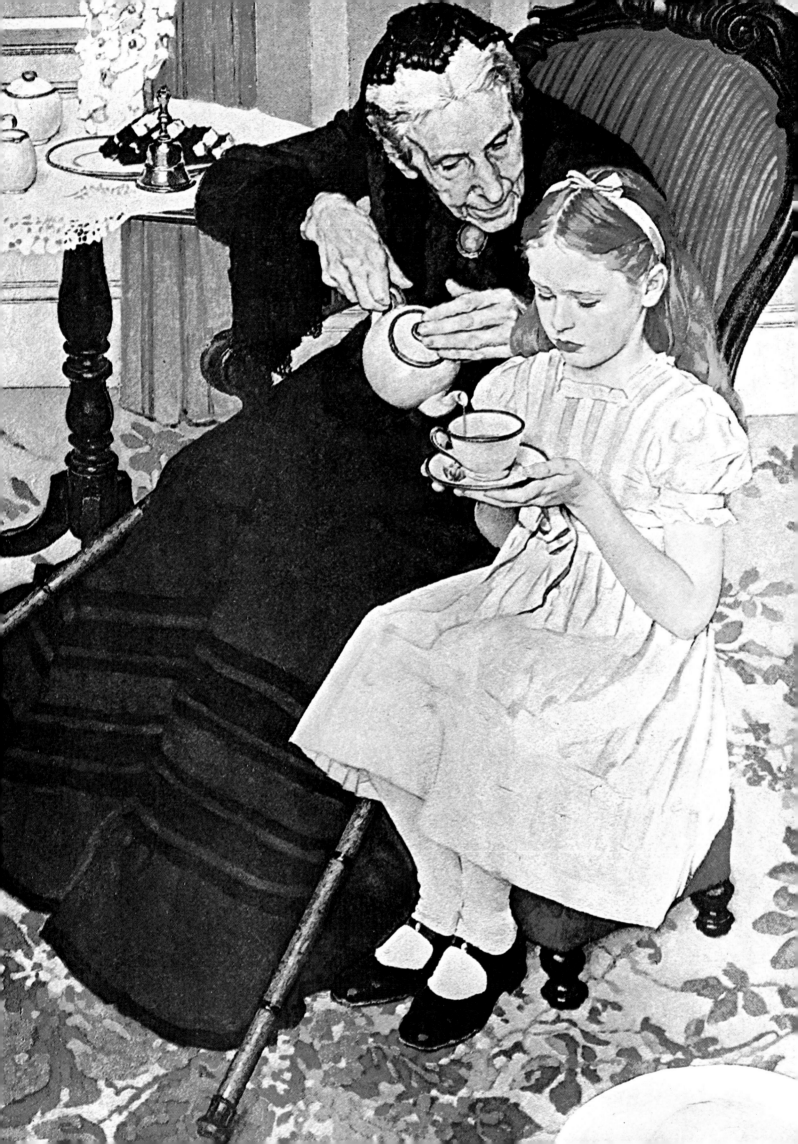

River Pilot

A Story by Carl D. Lane

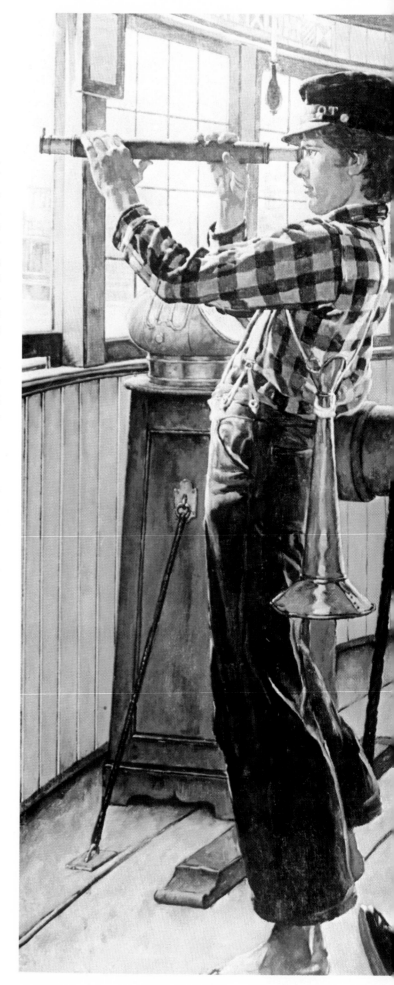

Jem Bates tried to sleep, as was both necessary and proper before a man tackled the upriver run. He lay on his narrow berth in the cabin marked *Pilot*, trying to close out the sounds beyond the packet's shuttered window. He could hear the heavy thud of chunks chuted into the fuel bunkers and the quarter-hourly clang of the boiler door as the watchman kept up the steam for a quick morning start. Far off, from the coastal marshes beyond the darkly flowing river, a train whistled, calling the river ferry. The train was from the East, from Boston, and it wasn't the one that Jem was waiting for.

All that night, it seemed to Jem, he stared through boat sounds. But he was too young and too lusty not to sleep at all. He thought he hadn't closed his eyes but five minutes when the Saybrook Point agent was banging on his door.

"New York train's comin'," Mr. Barley croaked. "I've give yer engineer orders to steam up."

Jem sat up, his eyes still closed. He wanted to yell; screech like an apprentice when Hartford bore on the bow and liberty was promised. This was the day. This was the day he'd dreamed of for years; since he was a mite of a youngster, wading the backwashes of the upper river, knowing every steamer that hooted for Butter Island out channel and went sweeping grandly on to ports Jem had never seen.

"Pilots," sniffed Mr. Barley, "is gettin' almighty young. How old you now, boy?"

"Twenty even," Jem said, pulling on his britches. "I was born on the river."

"It ain't what's on the river licks pilots," said Mr. Barley gloomily; "it's what's under it."

"Reckon so," Jem said. His cabin lamp was lighted, throwing a sooty column against the smoke bell and filling the cubby with the sweetish stench of burning sperm oil.

Looking around, as he dressed, it was still hard for Jem to realize that he'd slept in the same cabin that the great pilots of the Connecticut had; Andy Towell and Skipper Orphan Slaney and Old Man Eldridge. They were respected names along the river, names that held records. It was something for a man to live up to.

With practiced rakishness, Jem perched his new pilot's cap on his head. *Pilot, S.S. River Bird*, the gold letters on the foreband spelled. Until today, those words had been only a dream.

"Sometimes," the agent said, looking over his spec-

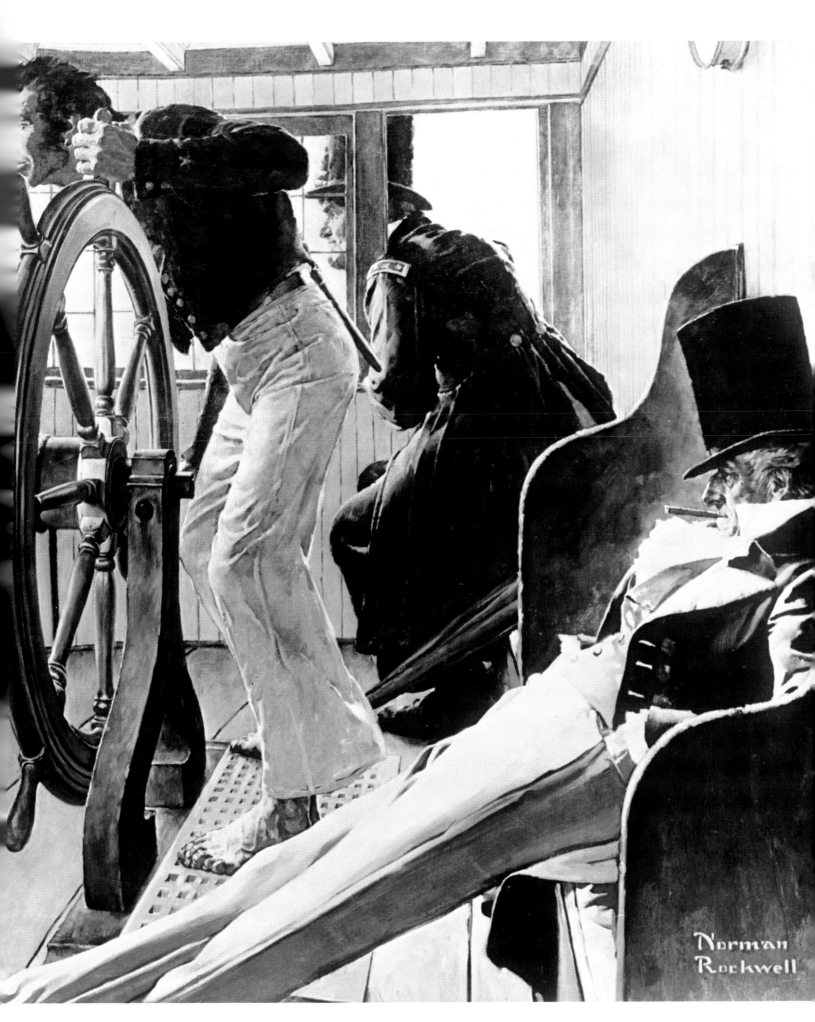

tacles, "pilots don't even last till the letterin' gets tarnished."

Jem went out on the hurricane deck, damp with dew and cold to his bare feet. He'd buy shoes, come payday. Shoes weren't as important as a cap, and he'd bought that first. The sky was graying in the east and the gulls were beginning their impatient complaining, hurrying the light so they could see the smelt schools.

The old man's sourness didn't touch Jem. Not on this day. Jem was full-rated and licensed and his pay was twice what he'd gotten as quartermaster. That was something to make a man proud; something to turn over and suck on, like a bit of sugar candy that's extra toothy. Jem guessed that maybe, upriver, Delly Eldridge would be stirring; peeking out from her covers—though Jem had never even dared guess what the inside of her bedroom might be like—and taking the time to be proud, too.

Old Man Eldridge, and Ma, too, might be thinking of him. They'd made Delly wait for this day. They weren't having their daughter married to a man until he'd shown he was worth something.

"Look at Pa," was the way Ma Eldridge had put it. "He started out to be a pilot, too. I married him whilst he was still on deck and it took me eight years of driving to make him start climbing again. Marrying nigh stopped him. You and Delly'll have to wait before you're likely to get my blessing."

Old Man Eldridge was Haddam-Hartford pilot, relief for Jem on his run from the salt ports. He'd nodded his graying head and rubbed his knees and agreed with Ma. Most folks always agreed with Ma.

Jem took the steep ladder to the boiler deck with studied nonchalance. Pilots, by tradition, were disdainful of things that annoyed ordinary mortals. He paid no heed to the men who loaded the eternal chunks which fired the single boiler between the two iron-studded paddle wheels.

He stepped into the white-wainscoted dining saloon. At first, the real china and silver service and the black boy's attentions kind of embarrassed him. It was a far cry to the wooden kid and belt knife which had been Jem's eating tools on river boats since he was 13.

Jem sat opposite the captain's chair. It was empty now. The real captain on a river boat is the pilot, and Jason Butts would sleep long as he felt like. It suited Jem fine. In command of the *River Bird*, fastest of the paddlers, pilot to Haddam with express and freight. Jem pitched into the meat pudding, swishing it down with coffee that had stood behind the boiler all night.

Mr. Barley regarded him balefully. "I see it in yer eye," he announced. "I seen it hun'erts o' times. But for you, boy, the river's too high. She's been rainin' back country for a week."

"Well," said Jem, "a man's bound to try. It's nacherel."

"Ain't no records been broke on the Haddam run in seven year," the agent said. "Ain't never been one broke agin the spring current."

"The crest is way upriver yet," Jem said, arguing for his dream. "I'll easy make Haddam before the drift stuff comes down. There's nothing but current to bother. Henny Laidlaw's puttin' on extra chunks and if he drops his gauge below 40, I'll log him."

"Hunh!" growled Mr. Barley, "Henny's old 'nough to be your grantha; he'll take no loggin' from you. You're like 'em all, first time. Churn into Haddam, whistle cord tied down, a girl to kiss and strut at the opery tonight!"

But still, a fast run would be a mighty good thing, though Mr. Barley got no thrill contemplating the dash upriver, cutting bars, chancing snags and gravel shoals. The express contracts were up again and there was talk of them going to a screw-driven boat. Some even predicted the railroad would someday branch to Hartford and carry freight without a transfer. "Train's in," he said and left the cabin.

Across the river on the Lyme side, Jem could see the *Amos Pruitt*. Black pine-knot smoke belched from her single Neptune-crown stack. The *Amos Pruitt* was screw-propelled and pretty swift, too. But she was deeper than the *River Bird* because of the screw and couldn't cut the bars. Their time worked out about the same; though it was speed and not cutting bars that counted when the railroad contracts were given out.

Jem gulped his coffee, stowing some muffins in his reefer pocket. The New York train had sighed to a stop, breaking the train for the ferry across the river and her baggage car was being unloaded onto the steamer. Jem stood for a moment at the dock gangway.

"Tumble 'em on any way for now, boys," he said. "Stow 'em later. We're movin' right off."

The loading gang grinned, understanding. Mr. Barley came on board, his manifests fluttering. The freight thumped faster. Volunteers stood at the spring lines. Jem went aloft to the wheelhouse. Across the river, the *Amos Pruitt* whistled arrogantly.

"I'm out for a record, Li," Jem said to the quartermaster, trying to keep his voice calm.

"Cain't," Li said, spitting into the river. "Current."

"Five dollars I do," Jem said. "When I get paid."

"Cain't," Li said. "Married. You'll find out."

Mr. Barley checked his waybills with maddening deliberation.

"Hurry up," Jem said; "the *Amos Pruitt*'s moving."

"Don't itch so, boy!" the agent growled. "You're not likely to pass her anyways. Delly Eldridge'll keep, I allow. Record or no record, she's yourn, boy."

Jem didn't take the time to think of the pleasantness of that. He and Delly were privately spoken, but it would make it extra binding to come up with a record hung, against the current and on his first trip. Sam

Friars, the Haddam agent, would certify his time with a whoop. So would Old Man Eldridge. And Ma would be impatient to make public announcement. And then maybe he and Delly could kiss without feeling it was stolenlike.

Mr. Barley was finished at last. He rose ponderously from the shipping-desk stool. Above him the smoke curled thick and pitchy from the thwartship stacks. The cook's breakfast bell rang. The early risers on the wharf watched Jem anxiously.

"Stops to deliver at Essex, Deep River, and Chester," Mr. Barley said. "Hartford express goes right through, no matter what. There ain't nothin' more important than the express."

"Get ashore, please," Jem begged. The *Amos Pruitt* was already halfway up the Reach channel, licking it. If he got right along to doing it, Jem knew places where he could pass her.

"You got to acknowledge them orders, boy," the agent said.

"Essex, Deep River, Chester," Jem cried. "Now, step ashore——"

"All of it," Mr. Barley insisted.

"Oh," Jem said, "Express. Nothin' more important. Now——"

"Drat you," the agent snorted, "yer so all-fired impatient, you'll sail agin an empty time card!"

Jem colored; guessing maybe he was pretty raw, pretty green, letting the excitement of it strike him dumb like that. He gave over his card and Mr. Barley took out his watch and marked down the time and signed it.

"Now," he said, "for cat's sake, wait till I get ashore, will you!"

Flames joined the *River Bird*'s smoke. The hawsers came singing aboard. Larboard paddle was churning the river, fighting the bow into the current. Jem stood at the wheelhouse sash. His heart was pounding and he felt his neck grow hot and damp. He had nothing to do but use his brains, his knowledge of the river to beat all time northward. But even more he had to use his knowledge of what was under the river.

"Haddam," Jem whispered, "here comes Jem Bates, pilot. Delly, here comes your true love."

Jem was fair in the Reach before he knew he was up against a snorter of a current. It came muddy and brown and slick from the swollen headwaters, presaging the 12-foot crest that was coming. There'd be stumps and saw-mill cuttings and sometimes bridges and house tops in the crest; things no paddle steamer would want to meet. Jem called the ranges, carelesslike and easy, in the tradition.

"Starb'd!" he conned her. "Starb'd, full. . . . Keel-line 'er! . . . Steady for the naked butternut, Li. . . Now—full a-larb'd!"

The *River Bird* swept grandly upriver, straight for

shoals that only at the last moment revealed themselves cleft by a channel; straight for broken water that only Jem knew was deep. The Connecticut shores were full green in daylight now. In fields, beyond the unnatural banks, plow teams crawled over tobacco and corn rows.

Jem allowed it was the grandest moment he had ever lived. He whistled to farmers and to current-borne flatboats passing in the shallows.

They didn't know him yet. But they would. And, Delly, too. Ma Eldridge was known from Saybrook Bar to Windsor Locks because of Pa. Partly so, anyway. Only Delly would be prettier and more femininelike.

Ma had helped carve the wilderness, and the marks were still rough on her. Delly would be a fine lady; wife of Pilot Jem Bates, him that held the Haddam record. Jem would borrow shoes and take her to the traveling opera tonight, sure enough.

At Essex the river was up on the dock cribbing. They sent the freight downhill, making quick work of it.

"She's raisin' the bad un above," the agent said. "Tide's all that's holdin' it back. You look out, Jem."

"Sign my card, please," Jem said. "I figure I gained some, eh?"

"A mite," the agent said, "but you'll need it."

The *Amos Pruitt* showed at a bend, four miles above; legging it, but staying carefully in the deep center channel. To catch her, lick her, Jem thought, would be a mighty thing to do; no paddle steamer ever had on the lower river. Beyond Haddam, where the river was shallow, a paddler, cutting the channels, could shake her, two out of three times. Jem jingle-belled for full steam. At Hamburg Cove, Jem cut the beacon which the Hessian settlers had erected, and saved a mile. Henny Laidlaw was sure afraid of a logging, at that. The *River Bird* quivered with the thump of his steam.

"We're eight minutes ahead," Jem said. He had to talk, forgetting that pilots aren't talkative.

"I need help at this dom wheel," Li said. "She's buckin' like a Quaker at a cockfight."

The river rolled brown and earthy against them. Docks on either hand were awash. People stood in groups alongshore, watching the flood. They were seeing history being made, Jem told himself. He had always planned on being known as a friendly pilot, so he whistled to them.

"I've seen records lost from wastin' steam," Li said.

After that Jem didn't whistle any more. They were close to the *Amos Pruitt* now, cutting into her wake. Jem knew that was some going for a paddler. That screw boat was long-legged as all get-out for the river, but she sure was swift. And she'd be pretty handy in drift stuff. Jem thought of his paddles, grinding into wreckage. If he hit that crest before Haddam he was licked. And maybe drowned.

He was so far ahead of his time at Deep River that he had to send a man ashore to ring the pierhead fog bell to

91

announce his arrival. They came running then: bug-eyed and looking over their shoulders at the steeple clock. Jem Bates sure had made the *River Bird* hum. Jem Bates was going to be a crack pilot; holding a screw boat like that.

The Deep River company agent brought a stranger to Jem's wheelhouse. He was a cold middle-aged man, with sideburns and a New Haven drawl.

"Name of Telfer," he said, nodding to Jem. "Railroad inspector."

Mr. Telfer lit a long thin seegar, like the ones Philadelphia skipppers smoked when they came to transship whale oil. He made himself comfortable on the wheelhouse settee.

"I'll make the run with you," he announced. "The *Amos Pruitt*'s bidding on the express contract and my line's asking for reports. You're making good time, Mr. Bates."

"Record," said Jem. "Record run, so far."

"The *Amos Pruitt*"—Mr. Telfer looked upstream, where the screw boat was just closing with the Anastasia Island range—"has the steam on you, though."

"She can only run fast to Haddam," Jem said. "Besides, I'm making the regular railroad stops."

Jem knew that more than ever he'd have to make a record; hold the time he'd made. The current was rolling oilily against him. The paddle spray, as it dried on deck, left little deposits of sand. He'd have to take some short cuts. Even Henny Laidlaw, as good an engineer as ever held a river ticket, could make a boat go only so fast. It was the short cuts, the pilot's knowledge of the river bottom, that made records and kept a line carrying express.

Jem took Two Horse Channel behind Anastasia; then the Drowned Man beyond. He was nosing the *Amos Pruitt* again in the Snake o' Sand, breathing in her smoke. The river was spotted with drift and Jem guessed the crest wasn't much above Haddam; perhaps an hour off. Then he'd have to be tied up someplace; no paddle wheeler had ever bucked the full crest.

Mr. Telfer chatted with Captain Butts, on deck now. The captain wore an old flannel gown and sipped coffee inconspicuously as if he knew there wasn't much use competing with a pilot.

"Your pilot's a pusher, captain," Mr. Telfer observed.

"Jem's got a girl," Jason Butts said; then added with belated cunning, "He's got express on, too."

The Chester dock was two feet under water and Jem couldn't make a safe tie-up. But he found a back eddy over a deep hole off the dock and held the *River Bird* there while they sent the two express packets ashore on an overhead line stretched from the hurricane deck to the loft window of the dock house. It seemed to please Mr. Telfer. He stood watching, puffing his seegar fast.

"Jem," the agent hollered, "you can't go upriver,

you danged idiot. The tide's swang and you'll ketch that crest full in the Haddam Channel. You aim to bust the *Bird* to kindlin'?"

"I got express on," Jem shouted back.

"You got a record on," the agent barked.

But Jem flaunted his taffrail to Chester and drove on. "Record!" Jem snorted. "I'll say to tarnation I have!" But in a way, the express was part of the record; it was the reason for pushing, for fighting for every minute the river would yield him. Wouldn't be no sense licking time without a purpose, would there? Making Henny Laidlaw's black gang sweat? Making the *River Bird* shiver to her horn timber?

No purpose except Delly Eldrige. Delly favored a real-to-heaven pilot, and Delly was worth any fight a man could put up for her. She was the liveliest, prettiest girl in the whole valley, clear to the Vermont mountains. And she showed a lot of sense, making him prove himself. Jem reckoned that in an hour he'd be taking noonday meal with her, touching her knee with his knee while he talked to Old Man Eldridge about the river, being careful not to give away his courses. After, he'd coax her into the grape arbor under the side hill and kiss her and they'd make their plans.

"You're 21 minutes to the good, boy," Captain Butts said loudly. "You're as good as I ever had in my wheelhouse. Twenty-one minutes ought to count for something in places a man could mention."

Mr. Telfer puffed his third seegar politely and watched the *Amos Pruitt*.

The two boats held their own, smoke billowing from each, shearing the swift current of the Gorge. They raced so for an hour; Jem's piloting matching the screw boat's superior speed.

The Haddam Channel opened up before him, like a brown lake, set in the low green hills. Jem, taking his depths, knew the crest was close upon him. Minutes, only, away. Already the river was dotted with drift large enough to stove the *River Bird* if it ever jammed between paddle and planking. Jem steered around the biggest of the drifts and that cost him distance. The *Amos Pruitt*, her screw safely below the floating trees and rail fences, plowed the short center channel.

"She's a-comin'," Li said. "Andy Towell, even, would be tailin' it downriver by now, boy!"

"Hold steady," Jem said quietly.

Jem could see the crest now beyond Haddam wharf. His spyglass showed the churning wreckage, racing downriver in a seething mass, filling the river from shore to shore. He'd have to beat it to the wharf and double hawsers. No paddler could hope to fight it.

"You want me to ring her down?" Li whispered.

"No," Jem said. "Mountain Water bar's ahead. Steady as she is."

"Power o' prayer!" Li cried. "On'y four feet on the Mountain Water!"

92

"Twelve today," Jem said evenly. "Over we go. It's the only chance we got to beat the crest."

Jem knew he was losing time now; cutting into the record he'd made in the lower, quieter water. But it wasn't the record a man must think of now. Once, as a boy on Butter Island, Jem had seen a steamer caught in

the crest. Her people had jumped; and some hadn't ever come up again.

A good spitter like Li could have reached the shore easy. Trees, stump-washed and leaning, brushed the rail and the boat davits.

Jem felt the lift of the *River Bird* as she struggled uphill over the water bulk as the river poured over the bar. Her safety hissed. Both paddles bit deeply; gaining slowly, like a man running on ooze. The river snarled at the boat, reaching to add her to the wreckage.

The *River Bird* touched once; dead center of the Mountain Water. The shiver of it quivered through her; she hesitated, then slid smoothly into the slack water of Mooney's Pool. Jem's hands wouldn't uncurl from the grab rail, so tightly had he gripped it. Li sweated, letting it run in wet trickles down his neck; holding his wheel with both hands.

"Son," Li said, with respect, "that was pilotin'." Coming from river-knowing Li, it meant more to Jem than anything he'd ever been told.

Jem rang her down for Haddam wharf then. The *Amos Pruitt*, cutting in from middle river, was heading over too. The dock was crowded with folks. Jem could see Sam Friars, waving him madly on. Delly would be there, too, sure enough. Jem leaned from his sash, trying to feel calm, to ignore the whoops of the crowd.

"Stop engine!" Jem called. "Slow astern! Bowman, pass your line."

The *River Bird*'s heaving line went singing to the dock. Willing hands grabbed for it. But in mid-air, another line crossed it. The *Amos Pruitt* snuggled to the wharf a length ahead of Jem.

They hauled wildly on the lines, drawing in the hawsers. Sam Friars yelped, fighting at the bollard. But it was the *Amos Pruitt*'s hawser which circled the bollard. Officially, the *Amos Pruitt* had come in first.

But Jem didn't really care. He still had his record; what was left of it. He perched his pilot's cap jauntily on his head. Then he took his waybills and his log and stepped ashore. He sure would have liked to lick that screw boat.

"Andy Towell's best was four minutes more," an old skipper croaked. "Youngster, ye've made river lore this day."

"Come to get your girl, Jem Bates?" a woman giggled at him.

It pleased Jem mightily. It made him feel heady and light, like a sudden draught of rum on a winter's day. He wished he'd see Delly. The agent signed his time card with a flourish, sharing, in signing, Jem's record.

"He and Delly were privately spoken, but it would make it extra binding to come up with a record hung, against the current and on his first trip. . . . And then maybe he and Delly could kiss without feeling it was stolenlike."

Jeff Raleigh's Piano Solo

A Story by Edmund Ware

The year Jeff Raleigh sold the fleet of trucks to the Northerst Sand, Cement & Gravel Company, he decided he could afford to give his wife a piano for her birthday. The decision, not without reason, gave him a bad case of stage fright. It was essential to Jeff's plan, and to his ego, that the gift come as a spectacular surprise. Obviously, therefore, he could not invite Alice herself to select the instrument she wanted. Which meant that he, Thomas Jefferson Raleigh, whose musical experience consisted of accidental barbershop harmony, was faced with the task of choosing a piano whose tone, touch, and action would suit his wife perfectly. But far more deadly to the cause than Jeff's musical ignorance was Alice's musical comprehension.

Even to those who really knew, Alice Ross Raleigh's training in music was considerable. To Jeff, it was downright awesome. In a dignified black frame above the out-of-tune, rented upright which Alice had long since refused to touch, hung a parchment, reading as follows: *Praeses Sodalesque Conlegi Radcliviani Baccalaureae in Artibus Magna Cum Laude, Alicia Ross, Quae Praeterea in Musica Adepta est Magnos Honores——*

The document, roughly translated, certified that Alice Ross had been awarded a bachelor of arts degree by Radcliffe College, with high honors for her accomplishment in the study of music. Subsequently, Alice had given a piano recital in Town Hall. Somewhere in the family archives was a cluster of yellowed press notices starry with such phrases as "creditable musicianship," "promising talent," and

"at times almost professional."

Jeff often brooded that Alice had forsaken a brilliant career for him, for children, and for home. She made it clear to him that her choice was happy, but that if there were to be music in the home, it must be good. Her standards automatically snuffed out Jeff's sole musical delight—singing bass in a quartet with his cronies, Pat Morgan, Val Williams, and Shorty Cornwall. Once, Alice had accompanied them on the piano, but only once. Jeff had been lost in transports of harmonic bliss until after his cronies departed. When the door closed upon their hulking backs, Alice had clapped hands to her ears, and wailed: "Oh! Men howling at the moon! Deliver me!"

Gazing at her strickenly, Jeff had fished for a small crumb of appreciation: "But didn't you like my bass in the cornfield song?"

"You ended on a dominant—every single time." There had been such contempt in the word that Jeff hadn't even asked for a definition. He gathered that a dominant was a note first coined in the barrooms of hell. He had turned and stalked upstairs, saying inwardly in his grief: "My voice is stilled forever." Thenceforth, he sang only on spring mornings, when the roar of the shower bath drowned the richness of his paean.

The day Jeff decided to present Alice with a piano, her birthday was a month in the future. The possibility of his selecting the wrong instrument for one who could play Beethoven's 101st by heart did not at once occur to him. Neither did the consequences. For a time, his heart soared with the

sentiment and dramatic appeal of his idea. The piano, besides being an impressive item of furniture weighing more than half a ton, would bridge the one gulf between Alice and himself. Fifteen hundred dollars' worth of evidence that he honored her talent might also convince her that he, Thomas Jefferson Raleigh, had music in his soul.

Jeff kept his secret to himself for three whole days before the temptation to share it overpowered him. He called Pat Morgan on the phone, but Pat was out of town. Jeff decided it was just as well. He had a suspicion that Pat would suggest a new radio. That night Alice went to the movies with her neighbor, Mrs. C. B. Applegate, and Jeff stayed home with the children. James, thirteen, and Joan, eight, Jeff felt, would be the perfect confidants. The secret would be of special interest to James, who was taking piano lessons; and it might make Joan momentarily forget horses.

Charles, the baby, was asleep in his crib, but James and Joan were in the living room in characteristic pursuits—James reading *Treasure Island*, and Joan, with chairs and blankets, constructing stalls for imaginary horses, of which she was one.

Neither of the children reacted favorably to Jeff's initial, throat-clearing bid for attention. He hesitated a moment, and announced: "The seventh of August is Mother's birthday."

James gradually withdrew his in-

Dramatic angles create tension and excitement in the illustration Rockwell created for this 1939 story. The models posed for him in a real piano warehouse.

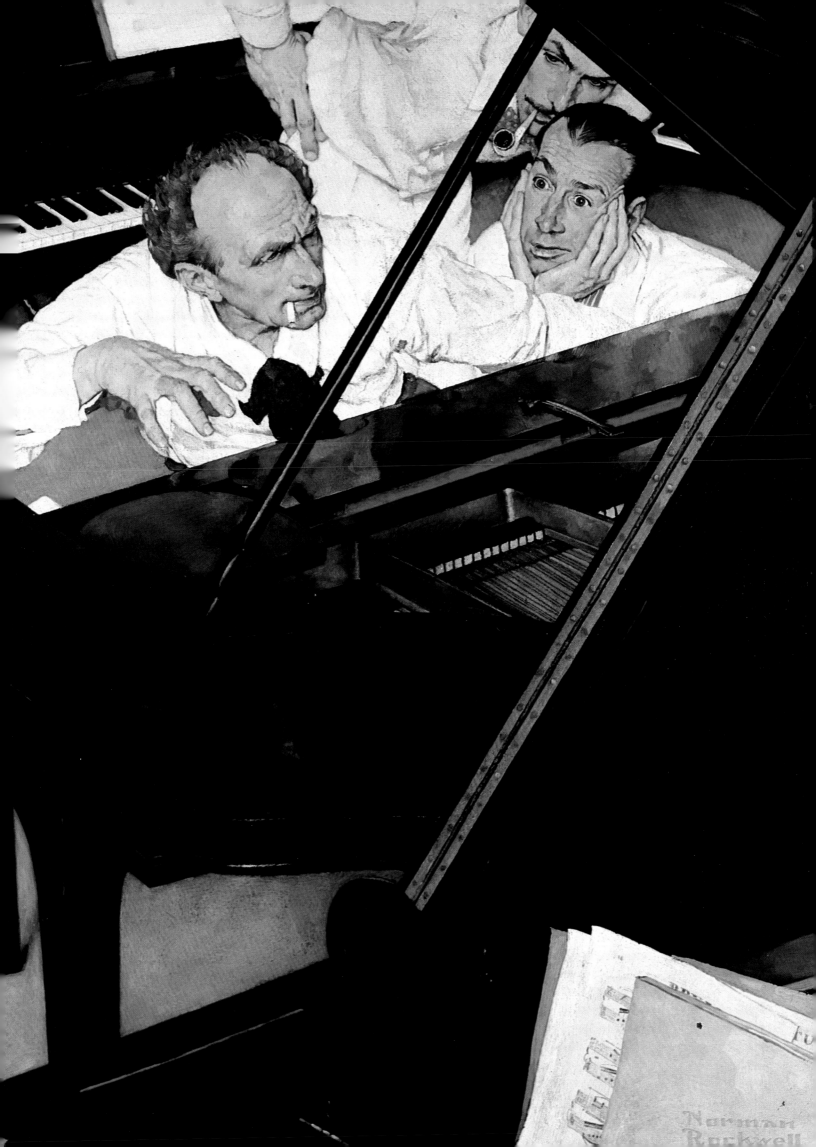

terest from *Treasure Island*'s magic, and said: "That a fact?"

"Steady, there," Joan admonished herself, as she backed into a chair-and-blanket stall. "Steady, Blazer. There. Whoa."

"It's less than a month off," continued Jeff, "and I'm going to let you in on a secret. Can you keep a secret?"

"Sure. What you going to get her, Dad?" asked James.

Joan, or the horse, Blazer, emerged from the stall and reared to her hind legs. Assured that he had won his audience, Jeff told them: "I'm going to give her a piano—a really good one, so she'll play again, the way she used to."

"Boy, oh, boy! Swell!" commented James, possibly thinking of his piano lessons.

Joan gave a heartbroken nod, and sighed: "I would pru-fer if you got her a horse."

"Baloney!" James said, under his breath.

"Now, Joan," said Jeff, appealing to the reason of his mysterious, brown-eyed girl child, "what would Mother do with a horse?"

"Ride it," Joan answered. "And that is what she could not do with a piano."

"Oh, go on to bed," James suggested to his sister. Then, turning to his father: "D'you get the piano yet?"

"Not yet. Tomorrow, maybe."

James thought long and intently. "If I were you, Dad," he said cautiously, "I think I'd let Mother pick it out herself."

"Nonsense. Be no surprise at all if she did." With a slightly nervous laugh, Jeff added, "Don't you think I'm capable of buying a piano?"

"O.K., Dad," said James, and went back to *Treasure Island*.

The next afternoon, when Jeff made his first attempt at selection, he was all but stunned by the range and power of his own ignorance. After consulting the telephone directory, classified section, he proceeded to a basement containing nine pianos and a redheaded lady with mother-of-pearl fingernails and an air of disdain. Jeff stated his mission.

Gazing at him as if he were a plumber arrived by mistake, the lady said: "Grand or upright?"

"Grand," muttered Jeff, and realized that this was precisely everything he knew about Alice's taste.

The lady stalked majestically among the instruments. "Heah's a mah-velous one," she said, pausing. "Sit down and try the tone."

"Me?" gulped Jeff. "Me try it? I can't play. It's for my wife."

"Then she'd better come in person."

"No. It's—I mean—want to surprise her. Can't play myself, but I like music. Like to hear you play."

The lady tried seven of the pianos, and to Jeff's ear they all sounded exactly alike.

His gloom lasted a solid week, then lifted briefly as he dreamed of giving up the whole piano idea and offering Alice a nice trip somewhere, say fishing in Canada. But the clouds lowered again to zero-zero on the evening of July twenty-fourth, shortly after the local paper was delivered.

"Oh, Jeff!" exclaimed Alice, as she glanced at the front page.

"What's the matter?" asked Jeff, startled.

"Sabinsky's giving two summer recitals in Hartford. And he's going to play Bartok!"

Jeff had heard of Ivan Sabinsky, the great Russian pianist. Who hadn't? But for all he knew, Bartok might have been a gambling game or an airport in Syria. In fact, his interest in modern composers had expired the night Alice lured him to hear Stravinsky's *Le Sacre du Printemps*. Trained to the rustic harmonies of "Sweet Adeline," Jeff's ears rebelled against dissonance.

Now, turning to Alice, he said: "That's fine. You could go down to Hartford for both concerts."

"Yes—yes, I suppose I could," sighed Alice, looking wretchedly at the disused upright. "But every time I hear Sabinsky, I simply yearn to begin practicing again—and this piano is impossible. I hate the sight of it."

From the corner of his eye, Jeff caught the triumphant, knowing look on James' face, and in Joan's huge eyes the bulge of secrecy. Jeff flashed them a glance of warning—and the black mystery of piano buying reinvaded his soul.

A few nights later, lying scared and awake in his bed, Jeff had a ghastly inspiration. But even while it flamed in him, he knew it honestly for a mere night thought—one which the logic of dawn would ridicule. Vague as to how the contact came about, Jeff imagined himself in personal conversation with Ivan Sabinsky. Jeff imagined the master as bearded, gaunt, and approximately seven feet tall. In the fantasy, Jeff approached Sabinsky and, with great dignity, said unto him: "Look, Mr. Sabinsky, I am just an automobile man, see? Raleigh Agency, Third 'n' Main, City. But I—uh—uh——"

There the happy part ended. The fact was that Jeff had lived so long with a musically superior wife that he could not even dream himself into equality with Sabinsky. The flight of fancy took its inevitably tragic turn.

Sabinsky drew himself to his full seven feet and rumbled: "Who are you? I do not know you. I do not like automobiles. They go so fast. They smell so bad. They get you nowhere."

Jeff then let his imagination run wild. "Well, Sabinsky, they're my life, see! I sold enough trucks last June to buy my wife a piano for her birthday. A really good one, get me? You—you, Sabinsky, are going to select it personally. Understand?"

But Sabinsky wouldn't be humbled. "A piano?" he said, hissing in

his beard. "For the wife of an auto-mobile salesman? It is absurd. What would she do with a piano? Place vases on it? Serve cocktails from it?"

"I want you to know Mrs. Raleigh doesn't drink! She won't even let me drink. And she got a *magna cum laude* in music, and——"

The smile that Jeff now imagined on Sabinsky's face all but shriveled him in his bed. "*Magna cum laude?*" sneered the master. "It is the mere beginning—a trifle. That is all."

Frustrated even in his dream, Jeff kicked off a blanket, turned over, and groaned aloud.

"What's the matter?" asked Alice, drowsily. "Why are you awake?"

"Can't sleep," Jeff snapped.

"Why?"

Jeff writhed, rumpled his pillow, and whined: "I—I—I feel old. I'm burnt out!"

"Old?" she said soothingly. "Why, you silly! I've got a birthday coming pretty soon. Nearly as old as you, too—but I feel young."

Jeff rose to his elbows, saying bitterly: "Now look, Alice. I know when your birthday is. You needn't remind me. I won't forget it!"

"Well——" Alice hesitated.

"Well, what?"

"Don't do anything extravagant, dear—please. We've got to start thinking of the children's college education pretty soon."

"Oh, give me credit for some sense, will you?" Jeff blurted. "Why don't you go to sleep?"

The instantly resulting silence endured till 7:00 a.m., when baby Charles awoke.

It was while Jeff lay prone on the bedroom floor next morning, doing his back-strengthening exercises, that his daughter Joan came trotting in to complicate his torment.

"For heaven's sake, Joanie, can't I be alone at all?" complained Jeff.

"I have come here at this time for a su-vere reason," said Joan, ominously closing the bedroom

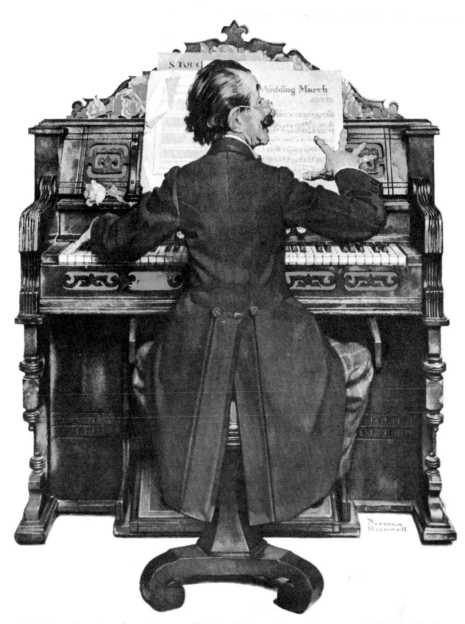

A keyboard artist of another era. Rockwell kept this antique organ in his studio for a long time, frequently played hymns on it, eventually gave it to a church.

door. "My mind is made up."

Oblivious to the grim cast of his girl-child's countenance, Jeff reached for a clean shirt and said: "What'cha want?"

"Simpully this," she replied, serenely: "If you don't buy me a horse, I will tell mother the secret about the piano."

Jeff turned, thunderstruck. "You wouldn't!"

"I have already picked out the horse."

"What horse?"

"War Admiral."

Jeff smiled feebly. "Say! You know what a famous horse like that would cost?"

"I bu-lieve you could get him for sixty or seventy thousand dollars. If you don't, I will——"

The pounding approach of her brother James ruined Joan's experiment in blackmail. Vainly she tried to hold the bedroom door against his greater strength and righteousness. Inside, James backed his sister to a corner, and threatened: "You tell mother that secret and I'll tell about your club with Betsy. I'll tell it all over, see?"

"You dare not!"

"You say anything to mother, and just see if I dare!" said James, menacingly. After exacting a hope-to-die promise, he opened the door

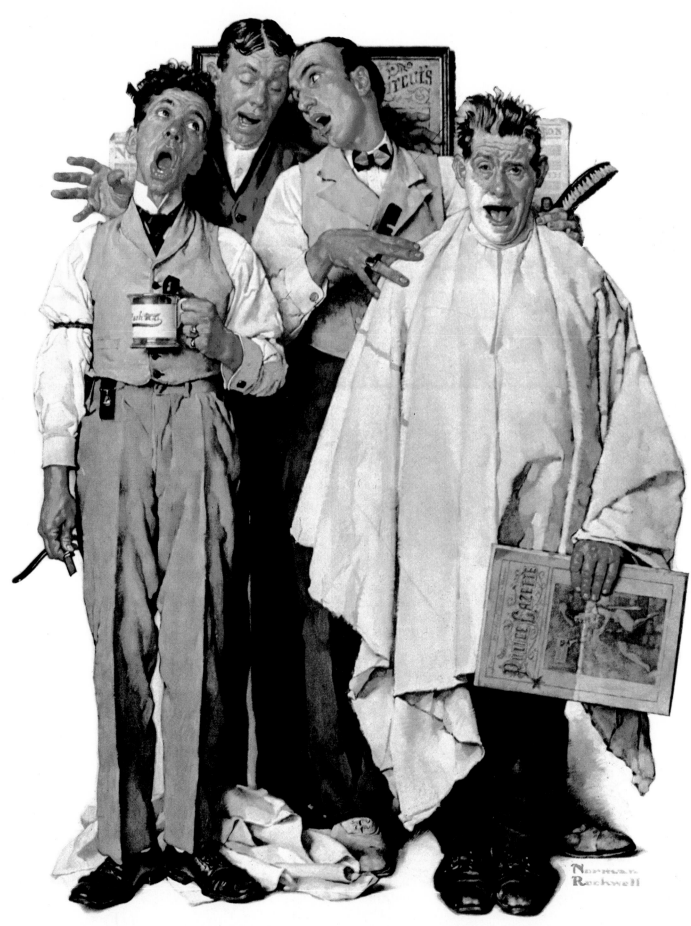

The harmonious thirds sung by a barbershop quartet (above) epitomize music for some. But for Alice Ross Raleigh, the sound of her husband, Jeff, singing bass in a quartet with his cronies was just caterwaul, "Men howling at the moon."

for her and hastened her out.

"Say, what's all this about, anyway?" Jeff asked, when he and his son were alone.

"Aw, it's nothing, Dad. But she thinks it is, and I was scared she might tell. I found their club charter. It said: 'We are wild horses. We do not like men!' Then there was Joan's name, and then Betsy's."

"Crazy kids!" sighed Jeff wistfully, as he tied his tie. "Who's Betsy?"

"Betsy Crawford."

"Crawford?"

"Yuh."

"Huh—don't seem to know any Crawfords."

After breakfast, Jeff called Alice out to his car for private speech.

"Look, Alice," he said. "Who's this Betsy that Joan plays with? Think she's all right? Name of Crawford. Know them?"

"Oh, Jeff, you pessimist!"

Jeff bridled: "I say it pays to know something about your child's playmates, that's all. But I don't know any Crawfords, myself."

"No, you wouldn't, of course."

Jeff stepped on his starter. "All right, I'm ignorant—if that pleases you. But this Crawford apparently knows horse racing!"

"Jeff, wait! Don't go like this! Kiss me."

He leaned from the car window and kissed her, and she said, quietingly: "Professor Andrew Crawford, dear—Northerst University. Music Department. I've got his book, *Piano Composers*. Plays beautifully himself—so I've heard tell."

Such a heady, pervading peace poured into the heart of Jeff Raleigh that he went limp. He drew Alice to him, kissed her again, and murmured: "O.K., darling."

"Mind relieved now?" she asked brightly.

"You said it," he sighed, and drove away, gratitude oozing through him for a world containing children, horses, Crawfords, and grand pianos.

Three days before Alice's birthday, Jeff stopped his car in front of Professor Crawford's faculty cottage in Northerst. He rang the doorbell and stood ill at ease, feeling as always a certain awe in proximity to the academic world. When a man in slacks and shirt sleeves opened to his ring, Jeff bowed and said: "I telephoned the other day from Springfield for an appointment. Isn't Professor Crawford expecting me?"

The man, slightly younger than Jeff, said: "Sure. Come on in. I'm Professor Crawford. Wife's in the mountains for a couple of weeks. Daughter joined her a few days ago. House a mess. Sort of baching, you know—friend of mine and I. But come on in, Mr.——"

"Raleigh," Jeff said, a little bewildered by the unexpected friendliness. "But I'm not here to sell you a car. I'm here for——"

Professor Crawford led Jeff into his study and showed him a chair.

"Well," Jeff began, "I—I guess I better lay my cards right on the table. Wednesday's my wife's birthday. She's a pianist, and I want to get her a good piano."

"A really good one?" asked the professor, leaning forward eagerly.

"That's it. A grand. And I tell you, I've been through the tortures of the damned, because—I hate to admit this to you, though—I simply don't know a thing about pianos, or music either. So I've come to you, to see if you wouldn't run down to the city with me and choose the right piano."

Professor Crawford lit a cigarette and leaned back, smiling. "Mr. Raleigh, buying pianos with someone else's money is my idea of heaven. But I've a friend staying here with me and no way of getting down and back. Wife's got the car."

"Bring your friend," Jeff begged. "I'll drive you down and back. I'll—I'll do anything, but I've got to have that piano!"

Professor Crawford stood up, his eyes alight with decision. "Wait a minute," he said to Jeff. Then, stepping to the front hall, he called across to the living room: "Hey, Vanya! How'd you like to buy a piano today? Won't cost you a nickel."

"Whoops!" came the instant response. "Let's go!"

"Well, come on in and meet Mr. Raleigh, then."

Presently there appeared in the study a short, stocky man, bald and beaming, with the palest blue eyes Jeff had ever seen. The man was about 50. He bustled. He simply radiated the joy of living.

"Mr. Raleigh," said Professor Crawford, indicating the stranger, "this fellow will assist in the choosing. . . . Vanya, this is Mr. Raleigh Mr. Raleigh, this is Mr. Sabinsky."

"I—uh—didn't quite catch the name," Jeff stammered dizzily.

"Sabinsky."

Jeff felt as if his knees were buckling. Could this be the living flesh of the very demon who had terrorized his dreams? He held out an uncertain hand and mumbled: "You mean—you're—the——? That is, you're Ivan Sabinsky?"

"Sure, sure," Sabinsky bubbled, grabbing Jeff's hand. The Russian went on, in flawless American slang: "I'm camping on Andy a few days before my Hartford recital. Andy's cooking's lousy, too."

"Well, I-look," said Jeff, hoarsely. "Maybe I could take you both out to dinner tonight, after we——"

"Sold!" said the irrepressible pianist. "With beer."

"Right-ho! With beer!" echoed Crawford, whisking his jacket from a chair back.

As they climbed into the front seat beside him, Jeff asked worshipfully: "Are all musicians like you fellows?"

Sabinsky considered gravely and replied: "Only the very good ones, hey, Andy?"

After the first ten miles, Jeff's hands steadied on the wheel. Simply by being their congenial selves,

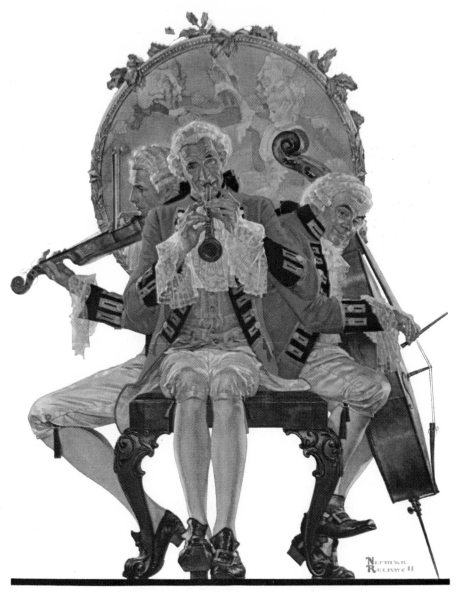

All kinds of music for all kinds of people. No doubt the chamber music played by the ensemble above would be more pleasing to Alice's musical ear.

his companions stilled his unwieldy excitement. They guided him unhesitatingly to a loft in a building in the city. The loft was as big as a gymnasium and as gloomy as a crypt. It contained virtually an acre of pianos.

"Where's Mack?" asked Professor Crawford, gazing disappointedly at the lanky, funereal salesman who emerged toward them from the gloom.

"Vacation," said the salesman dismally. "I'm fill-in."

"Well," said Sabinsky, "we want pianos, and lots of them."

The salesman laid a bony finger on a bass note of a concert grand. Glancing covertly at a list in his left hand, he said: "Maria Preble once played on this one."

Professor Crawford sprang to the bench, smote a tremendous chord, and said over his shoulder: "Well, just lie back and listen to Andy Crawford!"

The tomblike room came gloriously to life with the opening trill of Chopin's A-Flat Major Waltz. When Crawford paused, Sabinsky rushed forward, shouting: "Keep that box quiet, Andy! Let Vanya try one!"

The Russian sat down at an apartment grand, rich with ebony and ivory. The room filled with the dynamic power of the first few chords of the Liszt Hungarian Rhapsody No. 12. Sabinsky rested his magic hands on the keys, cocked his head, examined a price tag, and lifted horrified eyes to the salesman: "Fifteen hundred—for this? Hell, it's made of cardboard!"

"Maybe Mack could shave it a little—when he comes back."

"Let Mack keep it for furniture," suggested Andy Crawford. "Go nice in someone's front hall. Keep coats and hats on it."

To Jeff Raleigh, the scene in the huge, dim room was of the stuff of dreams. The two musicians, both in their shirt sleeves, were like creatures beside themselves. They moved like miracle men. They seemed swayed by mystic passions. They ran about the room, stopping suddenly to play, starting up again, hollering to each other for silence. They played excerpts from Schonberg, and Stravinsky's piano concerto. Sabinsky exalted the room with the difficult cadenza section of Tchaikovsky's B-Flat Minor Concerto. Jeff Raleigh leaned entranced against a wall, almost weeping in the great hunger and the overwhelming sense of beauty with which music sometimes fills the souls of listeners who cannot read or play a note.

"Oh, Lord," he said prayerfully, "I wish Alice was here. Oh, I wish she could hear this."

Jeff was not sure, but he thought he began to see a method in the pianists' behavior. Andy Crawford trilled on the apartment grand he had originally recommended for a hatrack. At the far end of the room, Sabinsky glanced up, as if he recognized the tone. Then Crawford abandoned the grand, as in a fit of disgust. Half an hour later, back at the same piano, he and Sabinsky were playing Bach fugues, four hands, and exchanging glances, while the salesman drowsed in a corner. Abruptly the two musicians stood up, moving pointedly away from the instrument.

"Hey!" yelled Andy to the fill-in piano salesman.

"Look, fellow," said Sabinsky, indicating a different piano. "What do you ask for that one?"

"Twelve hundred," said the salesman, after glancing at his list.

Sabinsky immediately turned toward the original apartment grand. "And yet you want fifteen hundred for that? Make sense, man. Make sense."

The salesman sheepishly consulted his list again. "Maybe I could let it go for fourteen hundred."

"Nope," said Crawford, putting on his jacket. "Tone's too brittle. . . . Come on, Vanya; let's go down to Sykes' and buy a good one."

The salesman came quiveringly alert. "Thirteen-fifty," he said, morosely.

"Make it thirteen hundred even!" barked Sabinsky.

"All right."

Andy whirled and pointed a finger straight into Jeff's face. "Sold! Buy it quick!"

Jeff did. His fingers trembled so he could hardly write the check. He gave the salesman involved instructions as to delivery, and the three men left the loft.

Jeff couldn't figure where the time had gone. It was nearly dark when they got outside. He touched Sabinsky reverently on the elbow, his other hand on Andy Crawford's shoulder.

He said: "That was the most beautiful music I ever heard. I—I just want to thank you fellows for——"

Sabinsky snapped his fingers. "It was nothing. We love pianos. And we love to sing. Can you sing?"

"Me?" Jeff grinned wryly. "Gosh, Alice, my wife says——"

Crawford halted them at the mouth of a deserted alley, and, drawing them all close, sang: "In-n-n the e-e-evening, by the moon-light——" Sabinsky came in with a clear tenor, and Jeff Raleigh timidly hit a bass note, praying it wasn't a dominant. It wasn't. Sabinsky's eyes twinkled as he punned, "Only God can make a trio."

Within half an hour, the trio had settled in Jimmy's Tavern on Worthington Street for as long as their voices would hold out. At some indefinite time during the night, Jeff called Alice to tell her, in a voice husky with long harmony and faintly blurred with the effect of beer, that he wouldn't be home to supper.

"Supper?" came the clear, sharp voice of his beloved. "What are you talking about? It's eleven o'clock! You woke me up. Where are you? What are you doing?"

"Oh," Jeff snickered. "Daylight saving time kind of——"

"What are you doing?"

"S-shinging. Swell fellows, deares'. You'd like 'em."

"I would not! And I advise you to come home!"

The click of the receiver for once did not chill Jeff's spirits. He made his way back along the bar in time to catch the bass for "I've been working on the ra-a-a-a-a-i-i-l-road——"

Jeff's entire conception of life, especially the musical and academic life, had undergone a major overhaul. The three singers were now calling each other Vanya, Jeff, and Andy. Sabinsky had personally complimented Jeff on a blue chord contrived in their third—or was it fourth?—rendering of "Aura Lee." And it was with genuine sadness that Jimmy Madden eventually informed them it was closing hour.

At 1:30 in the morning, chauffeured by one of Jeff's night men at the garage, they arrived at Professor Crawford's cottage. Sabinsky gave Jeff four autographed tickets to his first Bartok recital, insisted that he come backstage afterward, and said a poignant farewell.

When Jeff let himself into his own house, it was 2:00 a.m. He fumbled for the table lamp in the hall, but it did not respond to the switch. In black darkness he advanced toward the stairs. He had gone but a few steps when he stumbled over an unknown obstruction

and fell noisily. As he picked himself up, the upper hall light blazed, and he saw Alice standing on the stairs in her kimono.

Jeff grinned and whispered: "Hi, darling."

"Come upstairs, if you think you can walk," said Alice grimly.

"Now, Alice, please," Jeff beseeched. In his heart he was as pure as Galahad, and in his soul was peace. He pointed to indicate the two obstacles which had brought him low. "See for yourself, dear," he said, with a mere trace of martyrdom. "Baby pulls out baseplug connections. Light won't work. In dark, father falls over daughter's infernal chair-and-blanket stable! Horses! 'Tribute it all to horses. I love horses."

"Where have you been?" came the cold response.

"I wouldn't tell you—yet," said Thomas Jefferson Raleigh. "Not for a million dollars."

Alice turned abruptly up the stairs. She spent what remained of the night in the guest room.

For two days, while he checked and arranged the dramatic timing of the gift's arrival, Jeff moved about his home in the blissful state of the falsely accused husband. He could still any possible shudder of guilt merely by asking himself: What other man would unselfishly spend practically a whole night singing and drinking beer—his sole purpose to gladden his wife's birthday?

Alice was utterly bewildered. For what was to her his grievous sin, committed almost on the eve of her birthday, he seemed to be completely unpunishable. He was polite and considerate, but he made no overtures, nor did he once beg forgiveness. He looked at her through eyes almost fatuous in their innocence. When she accused him outright, he smiled in a maddening, sad-sweet way, and said: "If I have offended you, I can only say: 'I'm sorry.'"

On the morning of August seventh, he greeted her with "Happy birthday, dearest." And when she answered with her cool, reserved "Thank you," he looked at her with an expression of sublimely patient suffering. For once, Alice Ross Raleigh was baffled. She sensed that Jeff had something up his sleeve that he would spring on her witheringly. But how on earth could it account for his beatific air of holiness, after getting home at two o'clock smelling vilely of beer?

She was to find out, on her return at six in the afternoon from the movies, where, by skillful conniving, James and Joan had taken her to see Mickey Mouse, their birthday gift for her. No sooner had they departed than Jeff was at the telephone, issuing commands to the movers. In an hour the upright was gone and the beautiful apartment grand installed. For the next hour, a piano tuner worked to correct any faults developed during the moving process. When the tuner had gone, Jeff himself arranged some of Alice's sheet music on the piano. Then he opened the piano top, braced it, gazed rapturously at his handiwork, and sat down to wait.

James was first to enter. He came charging in, hissing: "Did it come?" Then he saw it, "Wow! Gosh!"

"Sh-sh-sh-sh!" said Jeff, sitting in his chair, ostensibly reading the paper.

Then Alice came in. Jeff's back was toward the door. He heard her stop short in the middle of something she was saying to Joan. "Maybe when you're 15 or 16, dear," Alice was saying. "But now I think——"

Jeff heard her gasp. He sat hunched in his chair, clutching the newspaper in tense fingers, as a ghastly thought occurred to him: After all his struggles, what if she didn't like it? Then he stood up and turned to see Alice's face whiten in astonishment and doubt. "Why—why, Jeff!" she said, coming a little farther into the room.

"Yes, dear?" he said softly.

"That piano! Who bought it?"

"I did," admitted Jeff. "Happy birthday."

She went swiftly to the piano. He saw her hands move toward the keyboard and hesitate, as if she were afraid to touch it. Then, struggling to show appreciation instead of the dread that claimed her at the thought of Jeff choosing an instrument, she said: "But—I——How did you——"

"Try it," Jeff suggested.

He watched as she tried a chord. Her eyes widened. "Why——"

"Go ahead; give it a workout."

Hy placed the bench for her, and she sat down and played some Grieg. He saw the old look of concentration on her face, then surging delight as the quality of his choice became apparent to her.

After a time, she paused, turned toward him, and said: "Did you say that you picked out this piano?"

"Like it all right?"

"Jeff! How could you?" There were tears in her eyes. "How on earth could you find one like this? Oh, it's the one I always dreamed of. Oh, I love it! I adore it!"

"Glad you like it," said Jeff humbly. " 'Course, a couple of friends of mine helped me—a little. Those fellows I was singing with the other night."

Alice looked incredulous. "What fellows?"

"Oh, just Andy and Vanya," Jeff replied, nostalgically.

"Never heard of them. Who are you talking about?"

Jeff made a beautifully casual gesture, and said: "Professor Andrew Crawford and Ivan Sabinsky."

"Well," Alice said laughingly, "it is a marvelous piano, but you don't expect me to believe that, do you?"

"No, dear; not if you don't want to. But here's fairly sound proof." From his coat pocket Jeff withdrew his four aces—the tickets to the Bartok concert, signed by Ivan Sabinsky himself—and dropped them on the keyboard at Alice's hands.

Alice picked up the tickets and stared. He saw in her eyes the swift change from disbelief to amazement.

Jeff's triumph was complete as she jumped up and hid her head against him, weeping: "How, Jeff, how? Jeff! You did! You really did—get—Sabinsky to pick out my piano, didn't you?"

"Yes," he said, holding her very close.

Then Jeff explained how it had all come about, and concluded: "So afterwards we went to Jimmy's Tavern, and sang—Vanya, Andy, and I."

Alice, her tension suddenly released, began to sob almost incoherently in her husband's arms. "Oh, darling. Jeff! D-did you end on a dominant—in front of—of Sabinsky?"

"I don't know, but Vanya said I was good. He wants us to come backstage after his concert. Want you to meet him, dear."

Through her tears came a torrent of questions: What had Sabinsky played? How had he played? What did he say? What was he like? When Jeff had satisfied her on all details, she drew the handkerchief from his breast pocket and mopped her eyes. "Oh, I've been so mean to you, Jeff," she said. "If only you'd told me where you were! How can you ever forgive me?"

Jeff kissed her forehead, and said: "Well, there's just one thing. I'd like to have you play 'My Wild Irish Rose.' "

"On my wonderful piano?" she asked. Already her mind was full of plans for Mozart, Beethoven, Bach, and Grieg. "On my piano—my wonderful piano that Sabinsky played on?"

"Certainly," Jeff insisted. "Why not?"

"Well, all right," agreed Alice. "But I wouldn't do it for anyone in the world but you."

Great
Post Covers

Parade of Hits

Rockwell made the Post *cover a museum for the country's moral yearning.
Good and good times are crystallized into the reality of the American dream.*

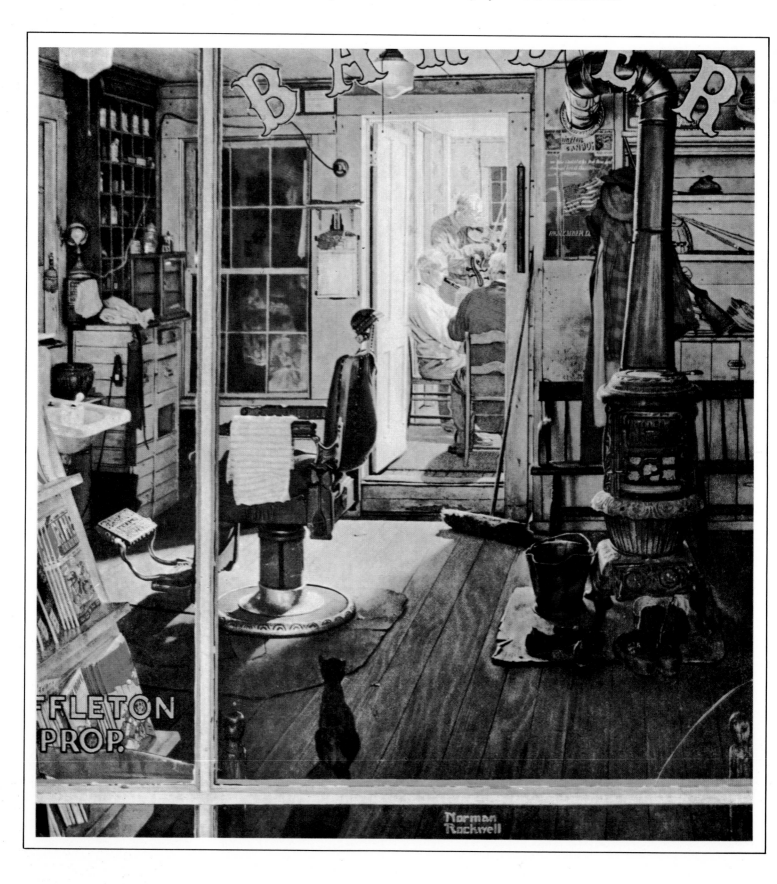

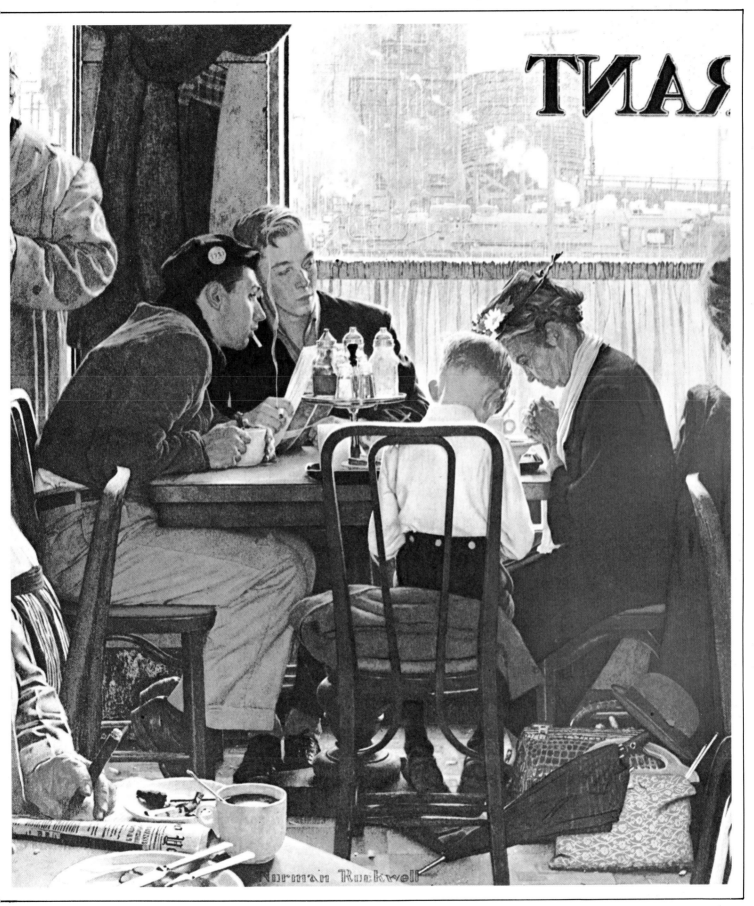

"The little lady is a quiet sermon in paint," a Post editor wrote when this Thanksgiving cover first appeared. "She gives thanks that she is alive, that she has America to be alive in, and that she has God for herself and America to lean upon today and all the days." (November 24, 1951)

Longhair music from the back room of an establishment devoted to shortening hair. The Rob Shuffleton who was Rockwell's barber in Arlington was also a cellist who regularly played host to musical friends after business hours. (April 29, 1950)

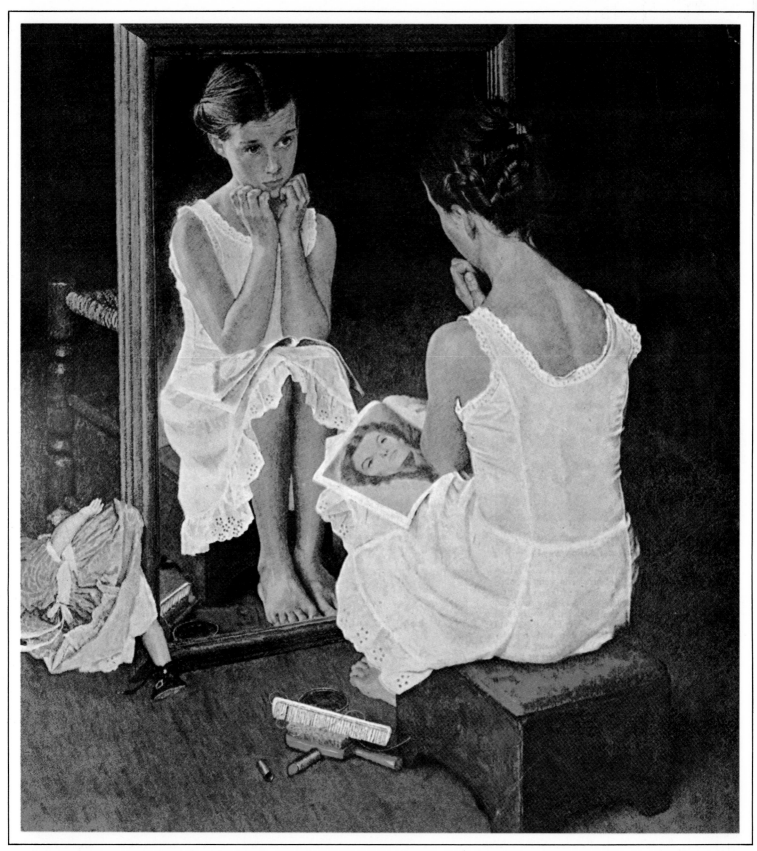

She's growing up? Or down—because a little while ago she was a grownup, mothering her doll, but now she's a very young young lady having a first go at gilding the lily. A wonderfully expressive face made little Mary Whalen one of Rockwell's favorite child models; she appears in a number of paintings that date from his Arlington years. (March 6, 1954)

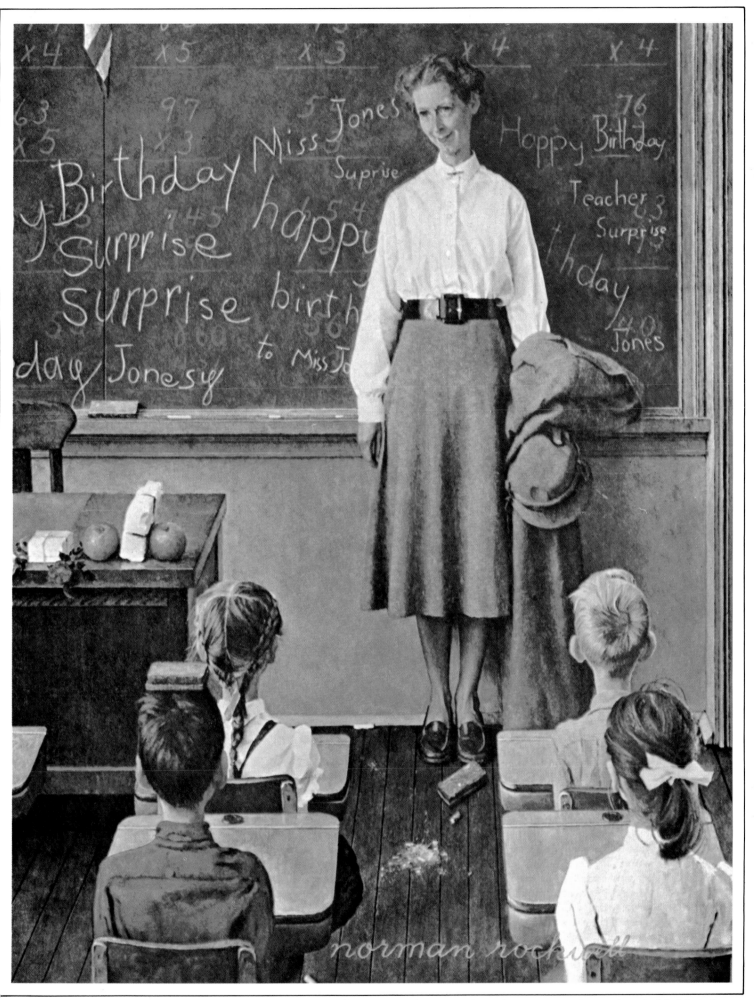

Tomorrow it will be business as usual in Miss Jones' classroom, but for today words warm with sentiment are superimposed on the blackboard sums. The model's shoes weren't right, Rockwell felt, so Mary Rockwell loaned her the pair shown here. (March 17, 1956)

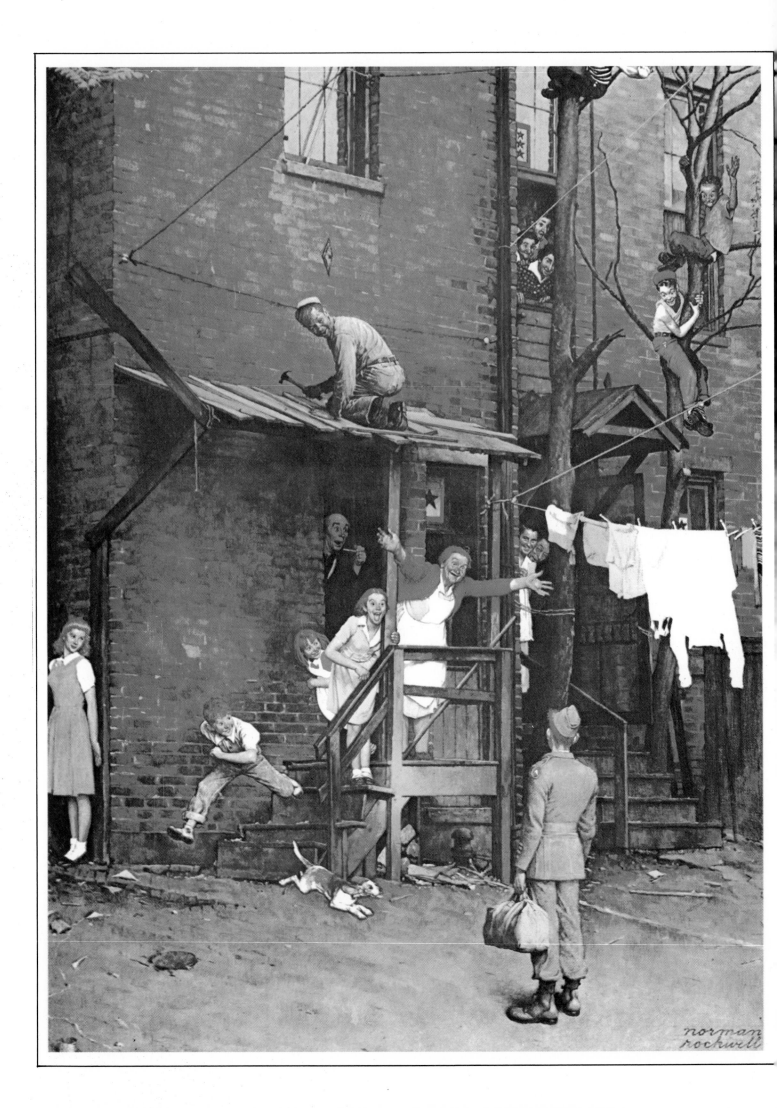

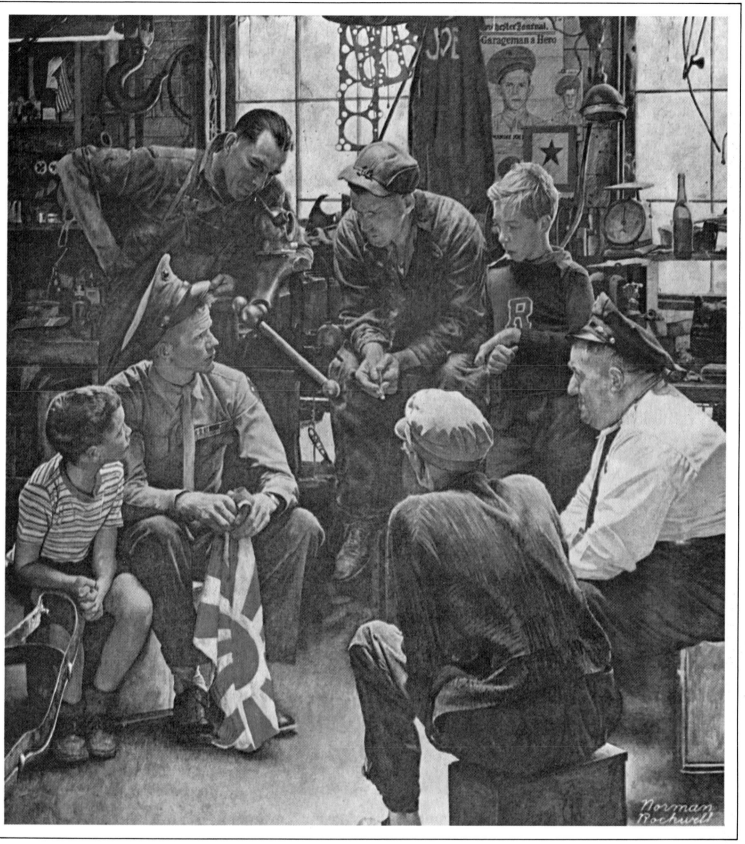

Visitors to the Society of Illustrators exhibition of 1946 voted Rockwell's Homecoming Marine *their favorite of all the paintings on display. The returned hero is Duane Peters, a real-life Marine entitled to wear the ribbons seen on his uniform. The youngster seated beside him is Peter Rockwell. Jerry Rockwell stands at the right, in front of the service flag. The setting is Bob Benedict's garage in Arlington, and that's Mr. Benedict himself behind the Marine. The cop is Nip Noyes, town clerk and editor of the paper. (October 13, 1945)*

The mood of the nation at war's end was perfectly expressed in this painting chosen as the official poster for the government's eighth war bond drive. *longtime* Post *editor Ben Hibbs called it "the greatest magazine cover ever published." (May 26, 1945)*

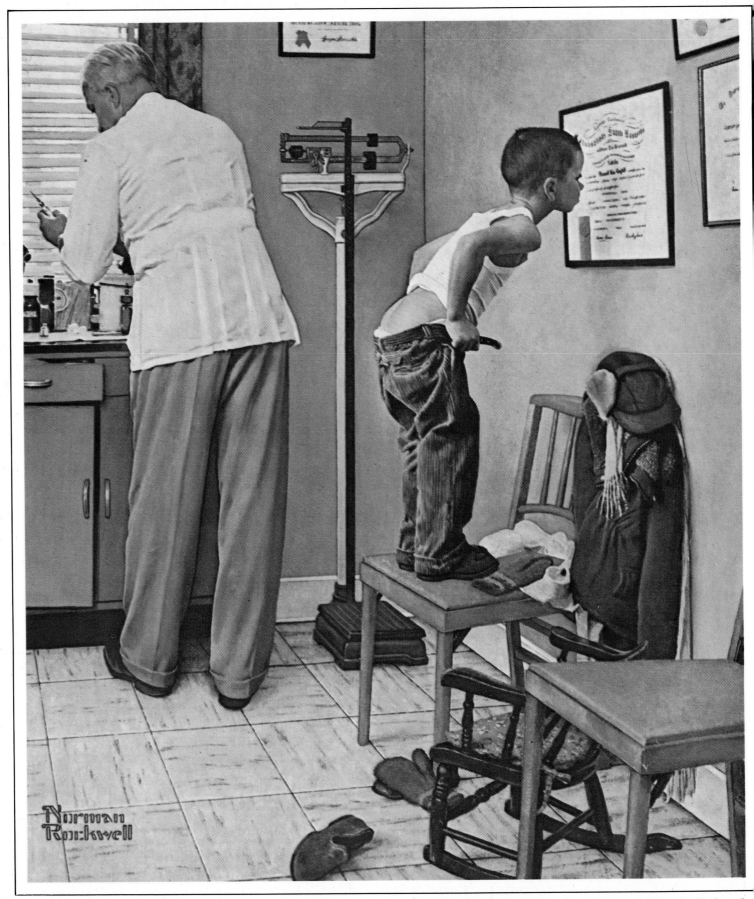

Posing for At the Doctor's Office *involved an argument as to just how far down the boy's pants should be, remembers Dr. Donald E. Campbe*
Stockbridge physician who served as one model. The boy model (he favored holding high rather than low): Edward F. Locke. (March 15, 1958)

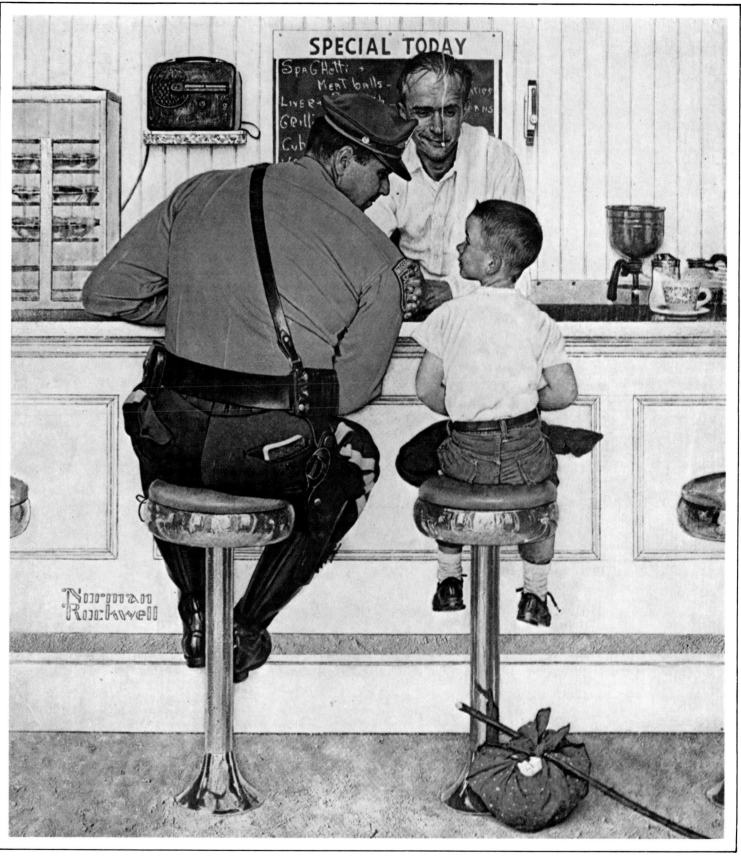

The policeman is a familiar figure in Rockwell illustrations. Here, he and the short order cook team up to determine what course of action should be taken with the little runaway. As it's tough to try and sort things out on an empty stomach, a piece of cherry pie topped with whipped cream is no doubt in order (September 20, 1958).

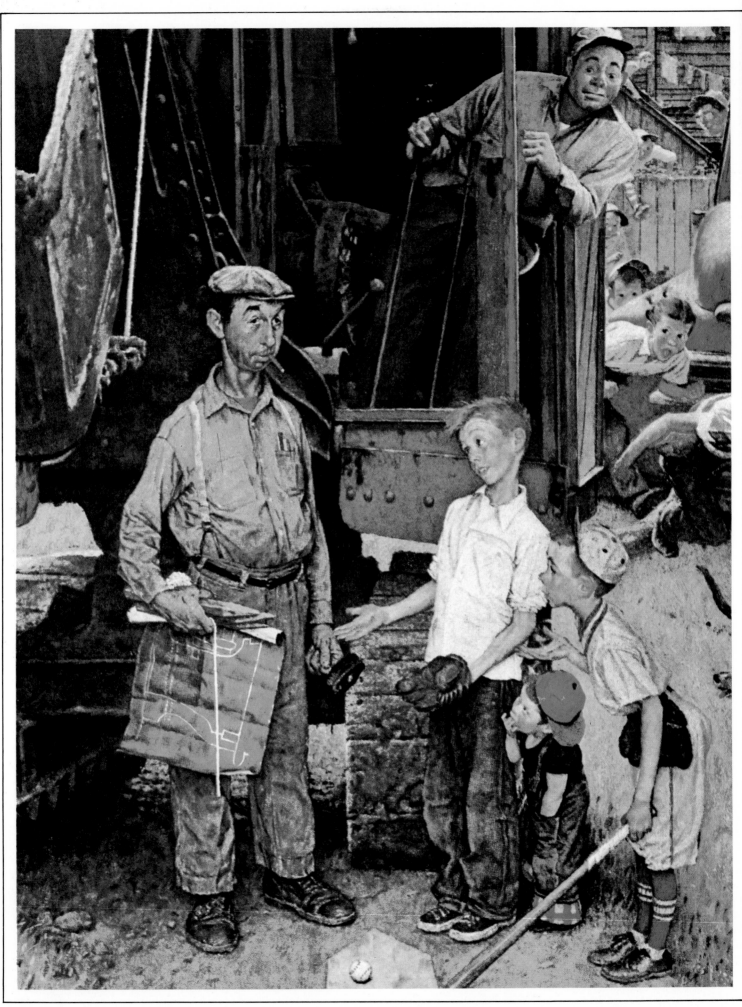

The artist sometimes went to great extremes to find just the right models. He discovered Kenneth Ingram (above with bat) and his brother Scott (sucking fingers) by knocking on Stockbridge doors in midwinter, asking for members of a Little League team (August 24, 1954).

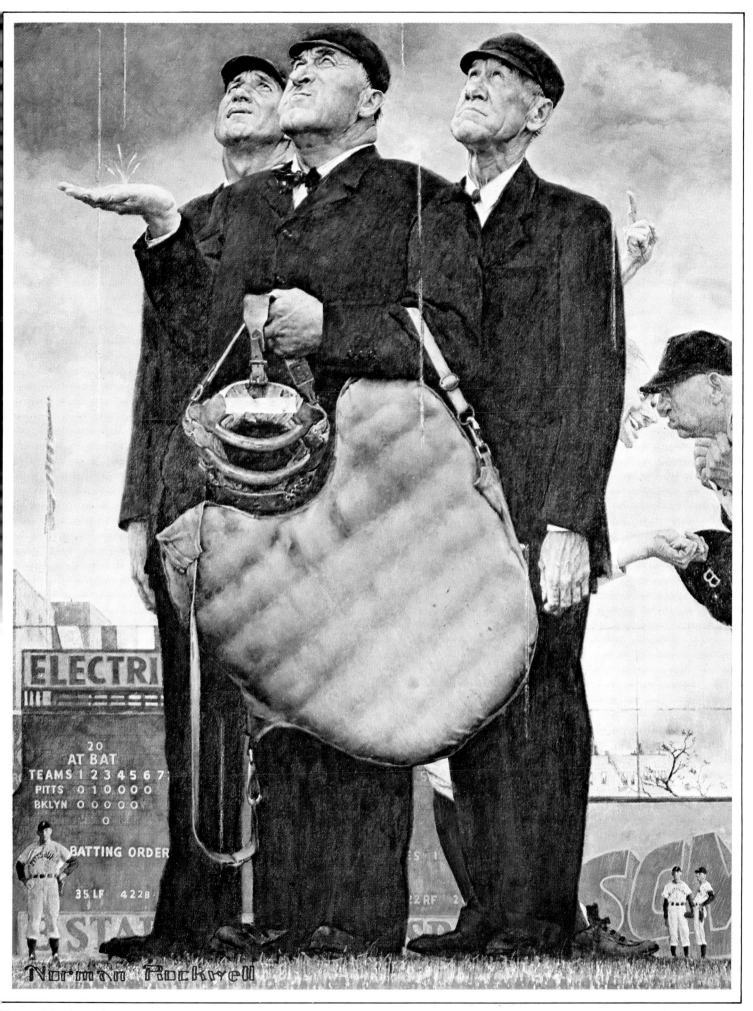

The models above also posed as themselves. Umpires Larry Goetz, Beans Reardon, and Lou Jorda, plus Dodgers coach Slyde Sukeforth and Pirates manager Bill Meyer learn of the hazards involved in playing games on Mother Nature's turf (April 23, 1949).

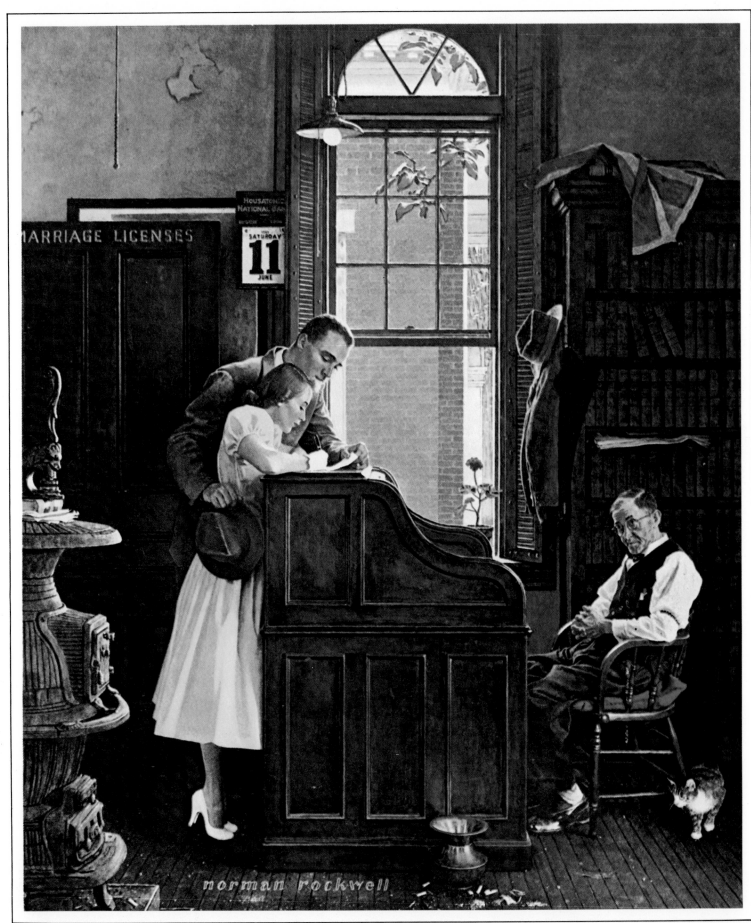

Looking younger than springtime in the dusty, humdrum atmosphere of a county clerk's office, Francis Mahoney and Joan Lahard posed as the couple obtaining a marriage license. They were engaged at the time, and their real-life wedding took place two weeks before this painting appeared on the cover of the June 11, 1955, Post. *A Stockbridge merchant named Jason Braman posed as the clerk.*

Travel is an educational experience for the young—never more so than in wartime when couples cuddle on trains and in railway stations with a minimum of self-consciousness. Anyone who remembers World War II can look at this painting and say, "This is the way it was." (August 22, 1944)

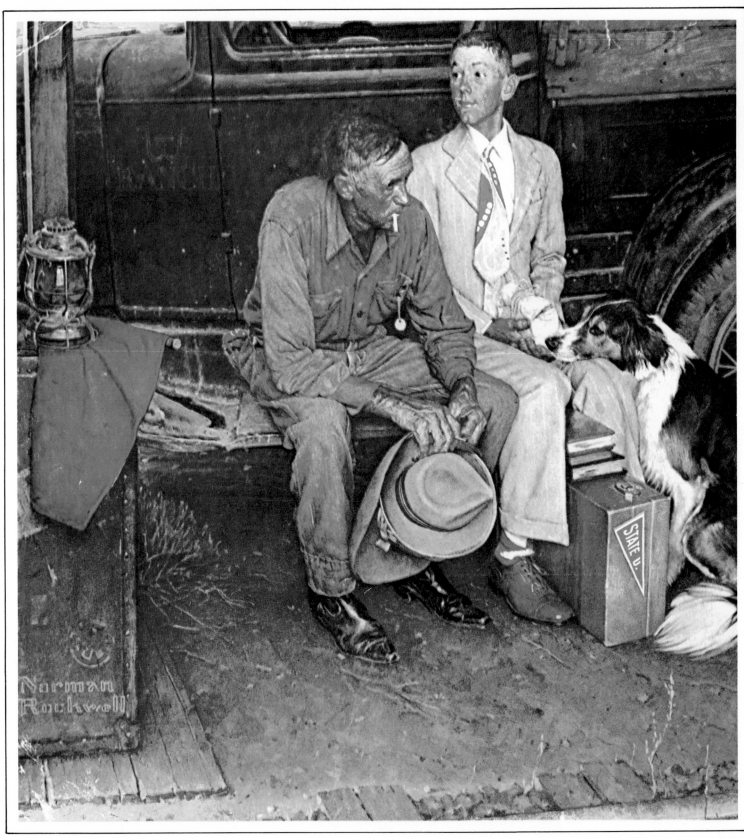

The farmer may be musing, "My boy forgot to do his chores pretty often, but I'll sure miss having him around here forgetting them." He's misty-eyed, and so is the dog. If collies can count, this one is figuring the number of weeks to Thanksgiving vacation. Rockwell painted "Breaking Home Ties" the first year that all three of his sons were going away to school (September 25, 1954).

"The Charwomen" (opposite page) was posed at Broadway's Majestic Theater shortly after Rodgers and Hammerstein's Carousel *opened there. Fearing the show might close before the cover appeared, Rockwell tricked up the playbill to represent a purely imaginary attraction (April 6, 1946).*

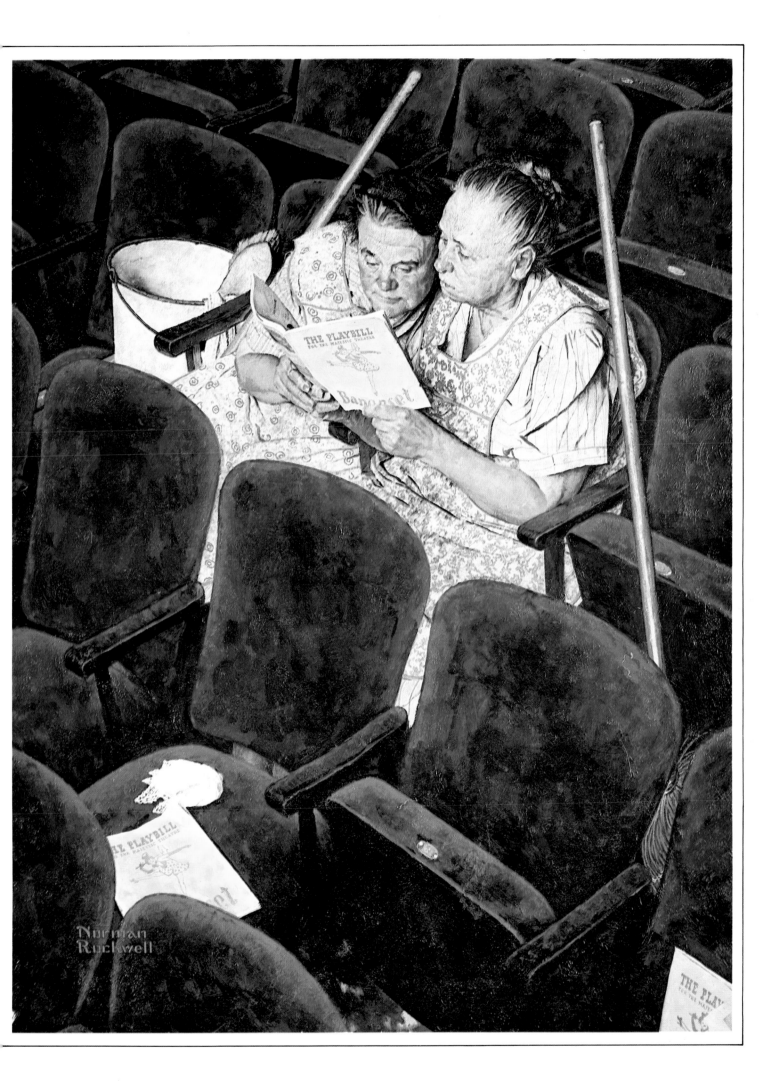

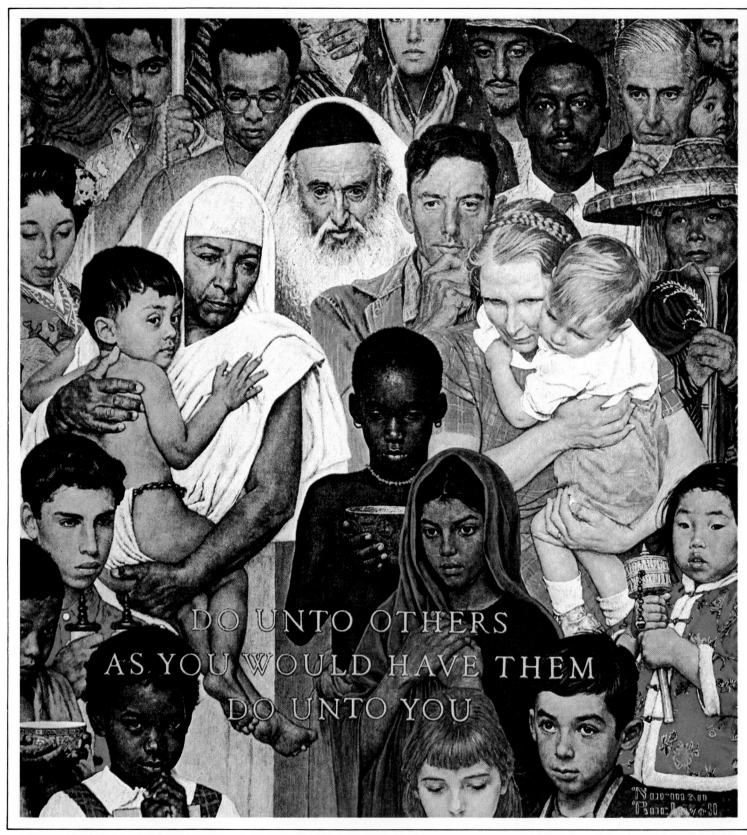

DO UNTO OTHERS
AS YOU WOULD HAVE THEM
DO UNTO YOU

The artist sketched a number of versions of this picture, sometimes including portraits of four prominent UN delegates, before arriving at his final plan for "The Golden Rule." He decided upon a mass of people—Chinese, Koreans, Africans, Italians, Poles, Indians, 65 portraits in all—who would represent all the peoples of the world. Why go to so much trouble? Said Rockwell, "I sincerely wanted to do a picture which would help the world out of the mess it [was] in. . . . [It] seemed to me that the United Nations was our only hope" (April 1, 1961).

Special Assignments

The Artist Merits a Badge

by William Hillcourt

It all began on a fall day in 1912 when an 18-year-old youth, bent on becoming an artist, stepped into the office of the Boy Scouts of America in New York's Fifth Avenue building and asked to see the editor of *Boys' Life.* He had learned that the Boy Scouts, established only two years before, were about to publish a magazine under that name. He wanted to get in on the ground floor as one of the first illustrators.

Edward Cave, the newly appointed editor of *Boys' Life,* immediately recognized the young artist's ability to produce the kind of artwork that his magazine needed. The youth walked out of Cave's office with a commission to illustrate a story for the next issue and a book the editor had written.

Two months later, the youthful artist was offered the job as *Boys' Life*'s regular staff artist at a salary of $50 a month. During that first year with the magazine he produced 101 oil paintings, charcoals, and pen and ink vignettes. His work was so satisfactory that the following year he was made the de facto art editor. His salary was raised to $75 a month.

He was getting along all right. But he was beginning to dream of getting into the big money, getting his work accepted by major adult magazines, even getting himself on the cover of that dominant magazine, the prestigious *Saturday Evening Post.*

He sketched out a couple of sophisticated ideas and showed them to a fellow artist, Clyde Forsythe. Cly smirked. Awful! Hopeless! He snatched up a sketch intended for a *Boys' Life* cover.

"Do what you know how to do," he said. "Kids! Do something like this—just do a more finished job to match the quality the *Post* expects of its cover artists."

The young art director accepted his friend's suggestions. He called in his favorite boy model, Billy Paine. He sketched a boy, dressed in his Sunday best, pushing a baby carriage, with a couple of boys in baseball uniforms jeering at him—

Billy posing for all three boys. Then another painting, with Billy the main attraction in long underwear, showing off as a circus strong man in front of an admiring audience.

His first *Post* experience was an exact duplicate of his entry into *Boy's Life,* with the same result: The art editor, Walter H. Dover, accepted his two finished paintings and asked him to make three

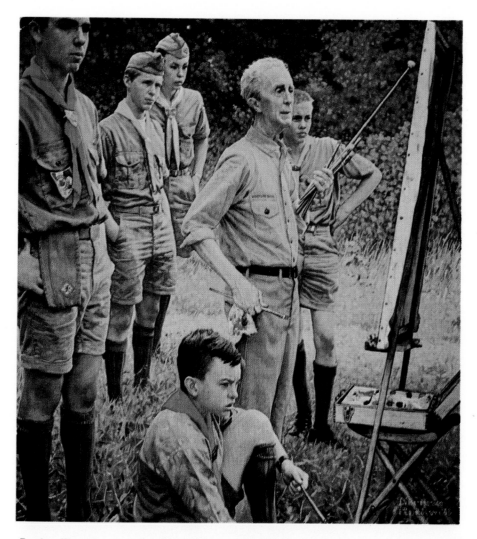

Rockwell's career and the Boy Scouts grew together. Rockwell was an independent, working artist at 17, two years after the Scouts had been established. (Above) In this 1969 calendar, we see the relaxed artist working in a loose style, bent on accurate observation rather than (right) positive propaganda.

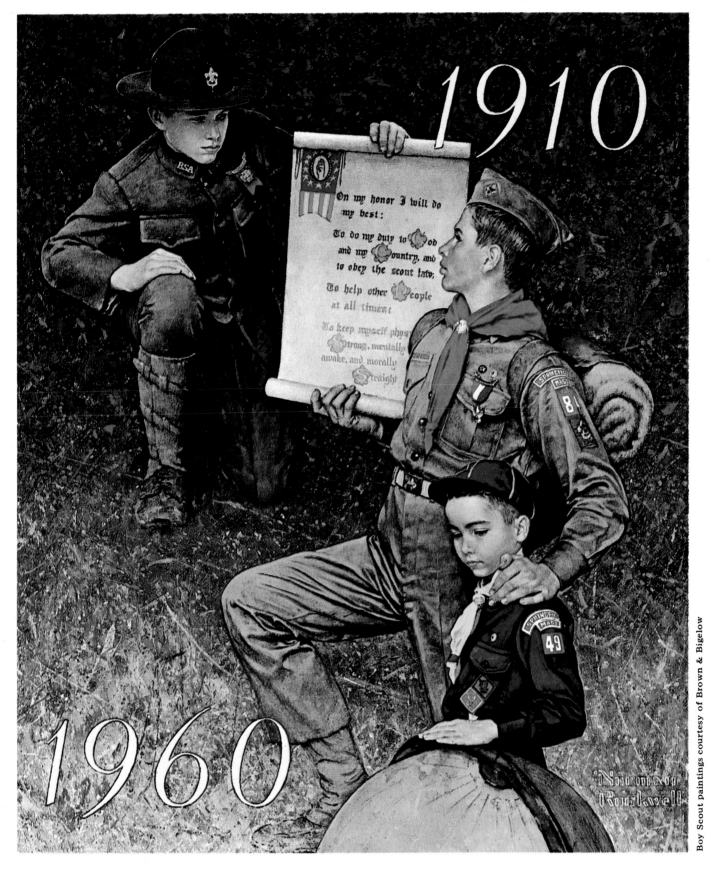

On my honor I will do my best:

To do my duty to God and my Country, and to obey the scout law;

To help other People at all times;

To keep myself physically Strong, mentally awake, and morally Straight

1910

1960

more covers from his sketches. He gave him a $75 check.

The young artist was elated. Two covers on the *Post*! An audience of two million! Seventy-five dollars for one painting—the same amount that *Boys' Life* paid him for a month's work. He had arrived!

Thus began the career of Norman Rockwell, a career that eventually made him, through his art, the spokesman for Scouting, its program, and its ideals.

Norman's last piece of art appeared in the *Boys' Life* issue for March 1916, the same month in which his cover illustrations were

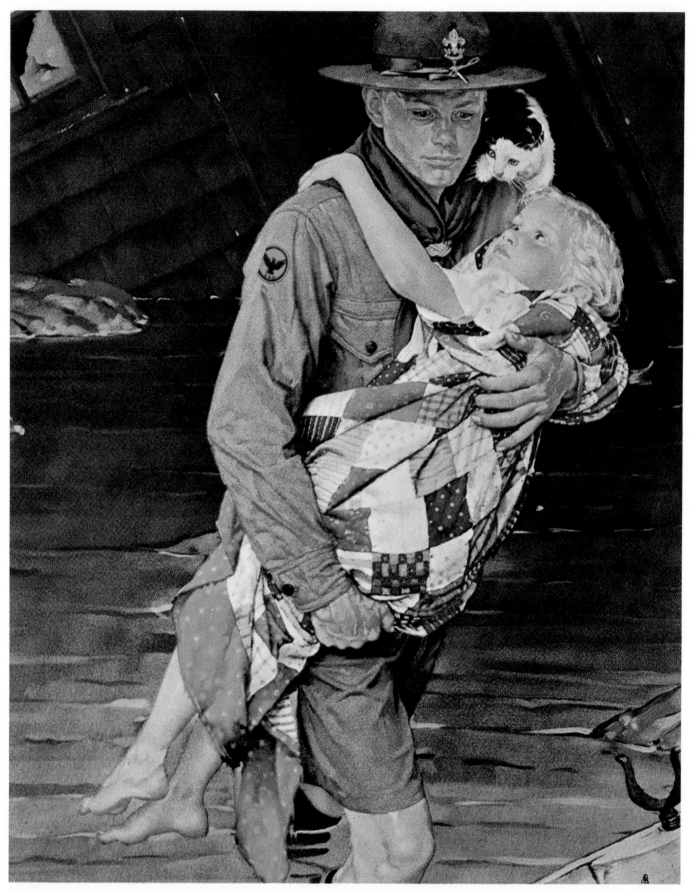

The 1941 Scout calendar painting (above) shows a Scout in his peacetime role as helper in time of natural disaster, and it has all the drama and urgency of a good story illustration. More numerous were calendars showing the fun and good fellowship of Scout activities, and calendars with patriotic themes. It was inevitable that the 1976 Bicentennial Year calendar (right)—Rockwell's last—should include the flag and at least a suggestion of a parade, along with an evocation of America's past. The virtues most often stressed in the Scout calendar paintings: leadership, reverence.

accepted by *The Saturday Evening Post.*

His apprenticeship was over. He said good-bye to the first and only salaried job he ever held: illustrator and art director for *Boys' Life.* He was completely on his own, a free-lance artist ready to conquer the world with his art.

Seven years later some forgotten genius connected with the country's largest publisher of calendars, Brown & Bigelow of St. Paul, Minnesota, had a brainstorm: "Why not," he reflected, "tie the country's fastest growing youth movement to the production of a series of calendars that would appeal to every boy in the country, to fathers and mothers, to every past, present, and future Scout and Scout leader?"

A representative from Brown & Bigelow was sent to New York to meet with James E. West, the Chief Scout Executive, to present the company's proposal. The Boy Scouts of America accepted it.

But Norman was not around to make a fresh painting. So the calendar firm picked one of the paintings that Norman had made in 1918 for the *Red Cross Magazine,* which the Red Cross had presented to the Boy Scouts. It was a painting of a Boy Scout doing a Good Turn, bandaging the paw of a small puppy. A boy and his dog—an unbeatable combination.

This 1925 Boy Scout calendar was an instant success. The calendar company immediately arranged for Norman to create another Scout painting for the following year, then for the year after and the year after that.

By 1938, 25 years had passed since Norman joined the Boy Scouts of America as the sole artist for *Boys' Life* magazine. Throughout these years he had been a true friend of Scouting and had done much to popularize the Scout movement, its activities, and its ideals.

That winter, at the meeting of the Court of Honor committee of the Boy Scouts' executive board, a unanimous decision was reached. Norman was to be awarded the highest award of the Boy Scouts of America: the Silver Buffalo, presented to men who had rendered distinguished service to the nation's boys.

The presentation took place the following spring at the Boy Scouts' twenty-ninth annual meeting in New York City.

The chairman of the National Court of Honor read the citation:

"Norman Rockwell, artist, distinguished delineator of Boy Scouts and of boyhood.

"To the people of America he has brought a deepened understanding of the psychology of boys of Scout age.

"At the very outset of his career he became an illustrator for *Boys' Life* in the first year of its publication by the Boy Scouts of America. He gave the joy and inspiration of Scouting ideals to hundreds of thousands of youthful citizens of the nation.

"He has assisted the Boy Scout movement through his interpretive paintings of the flesh-and-blood boys and has helped to win the American people to an appreciation of the fundamentals of Scouting."

In 1974, when he reached 80, he announced that his 1976 Scout calendar painting would be his last. He picked for his theme "The Spirit of '76" and for his composition the famous painting by Archibald M. Willard. But he changed

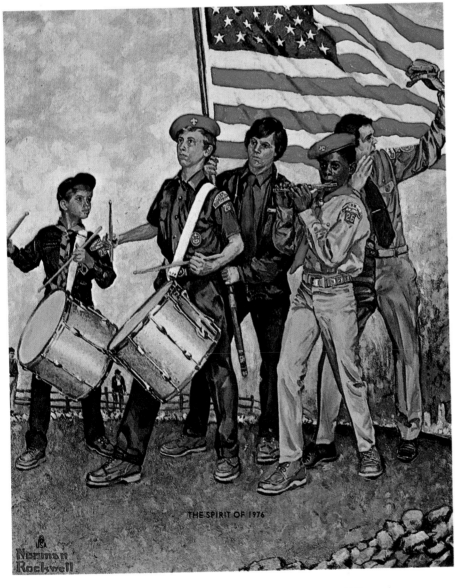

THE SPIRIT OF 1976

Norman Rockwell

the original Revolutionary figures into a Cub Scout, a Boy Scout, and an Explorer. The painting was Norman's final salute to the Boy Scouts of America and his contribution to the celebration of the Bicentennial.

The last Scout calendar picture that Rockwell would ever paint came off the walls as the nation closed its Bicentennial year and moved into 1977.

And the question arose: Would the Scout art that Norman had produced over more than half a century be lost to the Scouts and the Scout leaders of today and tomorrow?

No. The Scouts of the future will also be influenced by Norman and his art.

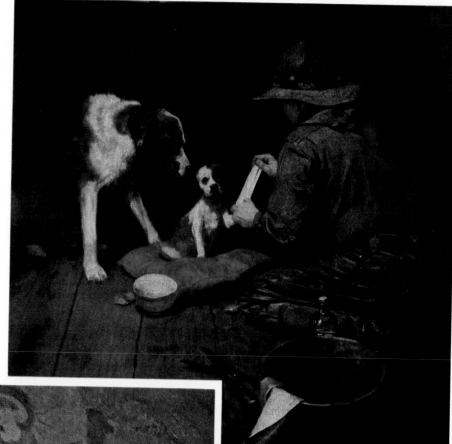

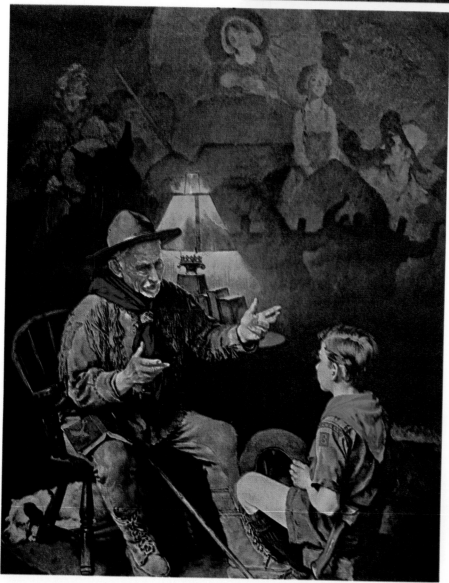

A new *Official Boy Scout Handbook* made its appearance in February, 1979, on the 69th anniversary of the founding of the Boy Scouts of America. Its cover is a Rockwell painting of a Scout troop having a glorious outdoor experience. And each of the parts of the book opens with a Rockwell painting in full color representing the fundamentals of the Boy Scout movement: camping, hiking, nature in all its forms, service to others, citizenship, growing into manhood. The book is dedicated to the American Scoutmasters, who have a special place in Norman's heart.

The Boy Scouts will always remember Norman. He is a part of their past. His art will beckon them on in the future into the romance and adventure of Scouting.

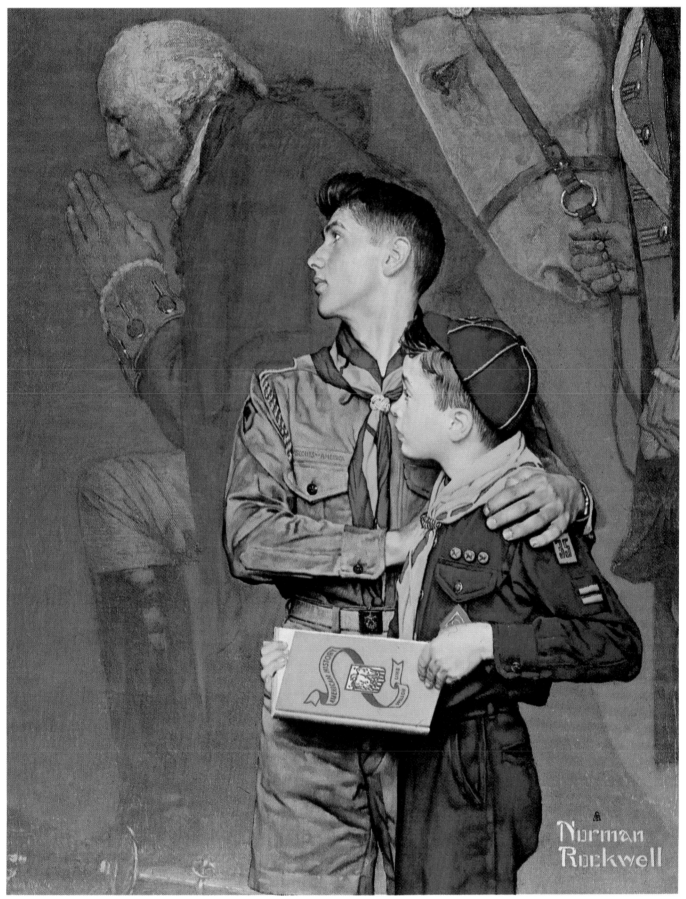

Jack Atherton, another great Post *cover artist and abstract painter, groaned when his neighbor Rockwell explained (reluctantly) the theme of the 1950 calendar (above). In lesser hands the concept would have failed. A painting that had been done for* Red Cross Magazine *in 1918 (left, top) served as illustration for the 1925 Scout calendar, the first in Rockwell's long series. Interplay between youth and age, a favorite theme Rockwell used many times, suggested the illustration for the 1931 calendar (left, below).*

The Life and Times of Cousin Reginald

Tubby Doolittle

THESE small sketches serve to introduce the characters of Mr. Norman Rockwell's new series of covers, the first of which appears on this issue. Master Reginald visits his country cousins and what they do to Reggie is *plenty*. Full of the real stuff, Tubby, Chuck and Rusty proceed to initiate their city relation into the joys of farm life. The trio, to say nothing of the dog, think he is such a "good thing" that they can't let the chances for some fun go by. Watch 'em.

Master Reginald Claude Fitzhugh

Chuck Peterkin

PATSY

Rusty Doolittle

Who was he? The archetypal city boy and bookworm. Bespectacled, of course, wearing an Eton collar, knickers, and knee socks.

Norman Rockwell created him and chose his name, Reginald. He appeared fourteen times on the cover of *The Country Gentleman* between 1917 and 1919.

But was Reginald's real name Norman? Maybe.

It is interesting to note that just twice in his long working life did Rockwell create a series of magazine covers that told a continued story. In each, one character appeared over and over again in different settings and situations. Yes, the character grew older and more mature as time passed—one expects that of Rockwell.

It is probably not significant that the two series appeared during the two world wars. One series was war-related; the other, sheer escapism.

The better known example is, of course, the series of Willie Gillis covers that appeared on *The Saturday Evening Post* between 1941 and 1946. In the first, draftee Willie is in basic training, receiving his first food parcel from home. In the last, veteran Willie Gillis, honorably discharged after combat service overseas, is attending college on the GI Bill.

The Willie Gillis series is the product of a mature artist, and it would be unfair to look for the same sophistication and polish in the Cousin Reginald series done a quarter century earlier. The Reginald covers present a boy's view of life with a boy's sense of humor, painted by an artist who was little more than a boy

himself at the time he created the pictures.

The plot is simple. Rusty and Tubby Doolittle, along with a neighborhood rascal named Chuck Peterkin, form a band of rollicking, frolicking country boys who set out to acquaint their visiting city cousin with the joys of farm life. Ah, what pranks they stage! What disasters lie in store for unsuspecting and innocent Reginald!

Together with their dog, Patsy, the trio of tricksters provide summer entertainment for Master Reginald Claude Fitzhugh (and for the thousands of readers who followed the cover series). As it turns out, of course, Reginald does most of the entertaining—at his own expense. He is the butt of every joke, but he is a good sport who always comes back for more. It is obvious that the country boys like and respect him.

Norman Rockwell was, of course, a city boy. Early photos show him bespectacled and dressed like Reginald in stiff collar, flowing tie, and knee-buckled pants. Like Reginald, young Norman spent his summers as a visitor in the country.

Did the artist's own memories inspire the magazine covers that depict rural shenanigans with the city boy always the fall guy?

In other words, was little Norman Perceval Rockwell the real Reginald?

If so, the experience wasn't terribly painful. Later, Rockwell described the rural summers of his childhood as "blissful."

126

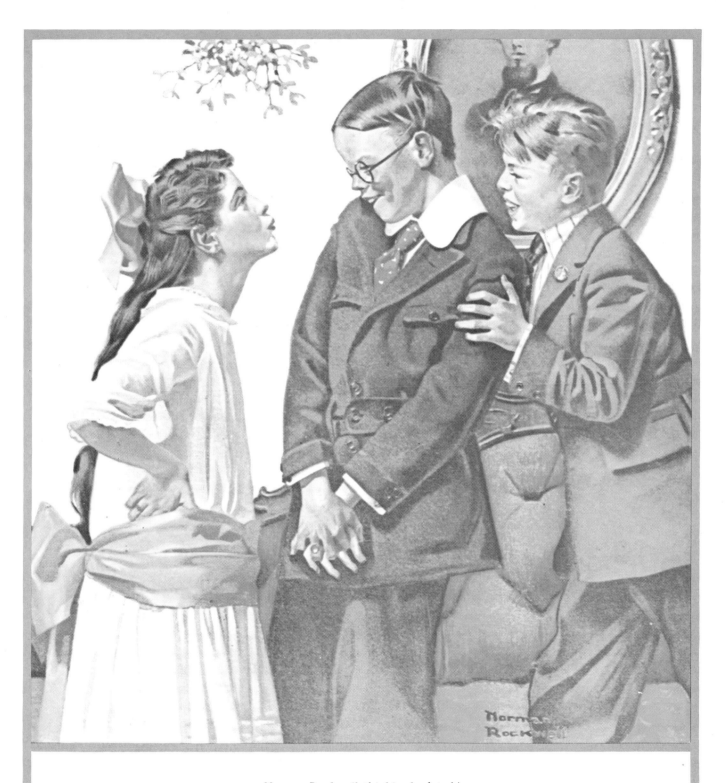

Norman Rockwell, thinking back to his
own boyhood, never found it difficult to
picture the sensations of the Eton-collar set.
Reggie's fright and joy at the goodies being
offered is autobiographical. And what of
Rusty's role in this drama? Did he impel
Reggie under the mistletoe? Or is he
restraining him from a rapid retreat?

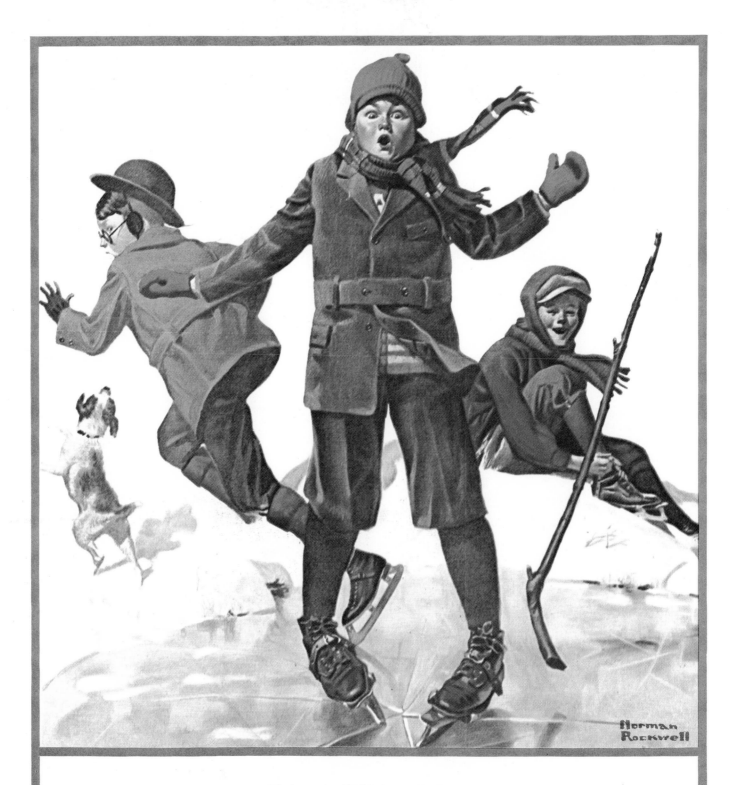

The boys play "tickly bender"—skating
over thin ice at the risk of getting a
dousing. It looks as though Reggie won out
for a change, as his stockier country cousin
breaks the ice and Reggie takes a flyer.
Judging from the delighted grin in the back-
ground, there must have been little real danger
for Tubby; the fun's all in the finesse.

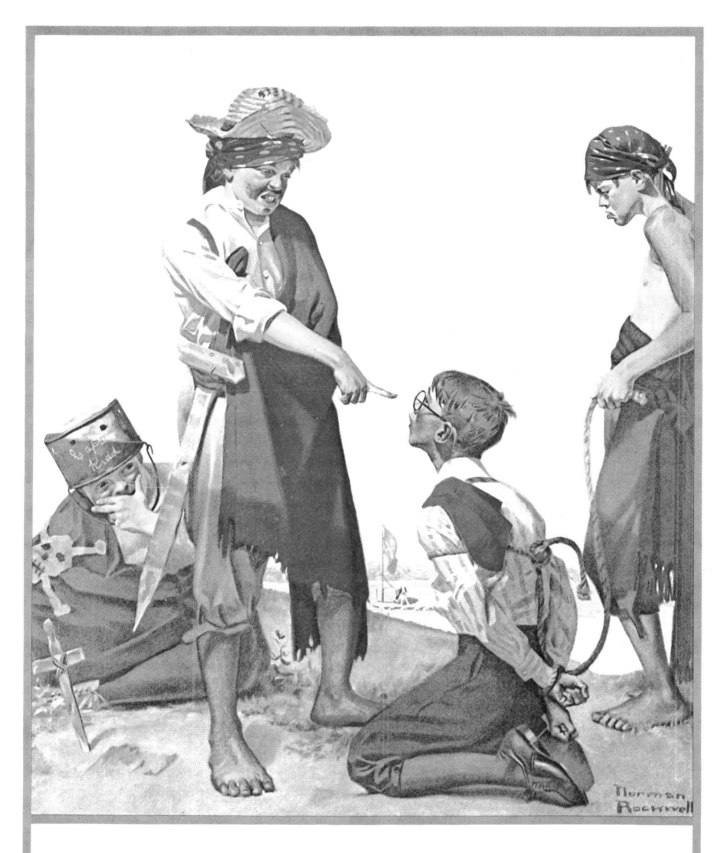

*Playing pirate is usually good fun—for
the pirates. Reggie's beginning to get an
inkling of things to come. The buried
treasure is him!*

*The country cousins move fast to let
Reggie know life isn't all that slow
down on the farm. A trolley ride in the
big city was never like this.*

Country boys fish for lots of things—
sunnies 'n' trout 'n' perch 'n' catfish—but
in Reginald they've caught themselves
a sucker. As for Patsy, woof.

The Norman Conquest
(How the Artist at Home Won the Big War Overseas)

Rockwell painted 201 covers for the *Post* before World War II became the big canvas for the magazine's illustrators. Some *Post* artists went to the front, some calling themselves correspondents, others forgetting their brushes for positions as real soldiers. But Rockwell's pen proved mightier than any sword the government might have offered the 46-year-old would-be warrior, already a veteran of 1918. Conflict spurred him to create National Monuments: *The Four Freedoms*, Willie Gillis, Rosie the Riveter, *The Homecoming*. Amusing silhouettes of earlier covers gave way to gravely beautiful stories told in paint; the artist's ideals became his models. He did 24 war-related covers. Even the comic illustrations have a seriousness that helped shape the character and vision of the war and put America in Rockwell's debt. In his own words:

I involve myself through my work. . . . During the war I did not collect scrap or work in an airplane factory; whatever contribution I made to the war effort was through my work—posters, *Post* covers of wartime scenes, *The Four Freedoms*.

For a time, however, I was deputy commander of civil defense for the township of Arlington. But I didn't last long. During the first exercise I disgraced myself and was promptly demoted.

The civil defense organization had been formed to defend the town against Hitler, some famous reporter

Army censors allowed no photography aboard troop trains, but permission was granted Norman Rockwell to sketch one group of young soldiers (below) bound from Fort Benning, Georgia, to—where? Probably to the European Theater, where their campaigns would be monitored by Dad (opposite) via the radio reports of H. V. Kaltenborn and Edward R. Murrow.

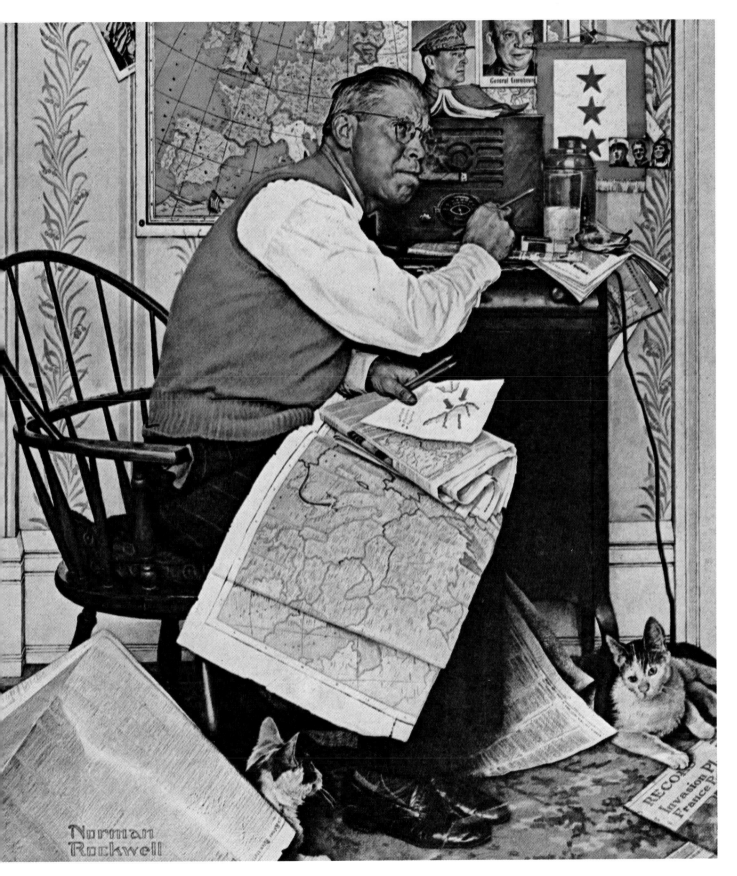

Norman
Rockwell

having predicted that the Nazis would strike at the
United States from Canada, invading Vermont and
penetrating down Route 7, which ran smack through
the center of Arlington. There were the rescue squads
(nurses, Red Cross ladies, stretcher bearers), the fight-
ing squads (which were to push trucks loaded with cans
of gasoline down on the Nazi tanks), the plane-spotter
corps (A certain spotter team consisted of two elderly
women: One had no teeth and could hardly be under-
stood over the phone, the other couldn't see very well.
But together they made a team, the former spotting the
planes, the latter phoning them in to the control cen-

ter). Everybody wore arm bands and used code words and said "Roger!" instead of yes. As deputy commander, I was assigned to a telephone in the control center. My job was to relay reports to the commanders.

The imitation Nazis—two schoolteachers, a man and wife, with swastikas painted on cardboard strapped to their chests—entered the town from the north. An outpost spotted them. "Panzer division advancing down Route 7 by the Wagon Wheel Restaurant," I announced to the commander. "Roger," he said.

And the holocaust of war descended on Arlington. A massacre at the high school! Houses aflame! The covered bridge at Chiselville blown up! Four bodies, bomb casualties, in front of the Colonial Inn! The control center was a flurry of activity.

Then the guard at the Chiselville bridge phoned in, very distressed. Dr. Russell insisted on crossing the bridge, he said, but it was blown up. What should he do? "I don't know," I said. "Wait a minute, I'll ask the commander." "You'd better speak to the doctor," said the guard; "he's hopping." "O.K.," I said, "put him on." "Listen, Norman," said Dr. Russell, "I've got a

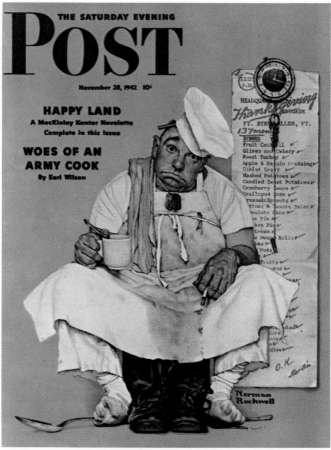

Post covers emphasized the lighter side. Mead Schaeffer painted sailors (top) skylarking in a San Francisco festooned with wartime "no vacancy" signs. The last of J. C. Leyendecker's long series of New Year's designs showed an aggressive cherub (left) crushing the Axis under a rosy heel, and Rockwell depicted an army chef (above) undone by Thanksgiving dinner.

134

woman who's going to have a baby across that damned bridge. I'm going across whether it's blown up or not." And he hung up and crossed the bridge.

The thought of Dr. Russell fuming while the guard, standing in the center of the bridge, explained that the doctor could not cross the bridge because it was lying at the bottom of the ravine, smashed by bombs, was too much for me. I got to giggling and garbled my reports. When the commander said, "Rog-er!" I dropped the phone, and then I couldn't find it under the table. In short, I disgraced myself. And the next day I was demoted. From deputy commander of civil defense for the township of Arlington to assistant to Jim Edgerton, whose duty it was to alert West Arlington by banging with a crowbar on a piece of railway track hung from a tree. If Jim wasn't home when the attack came, I was to do the banging.

So I went back to my painting.

Most of the pictures I did during the war took their subjects from the civilian wartime scene—the armchair general, women war workers, the ration boards. That was what I knew about and what I painted best. During

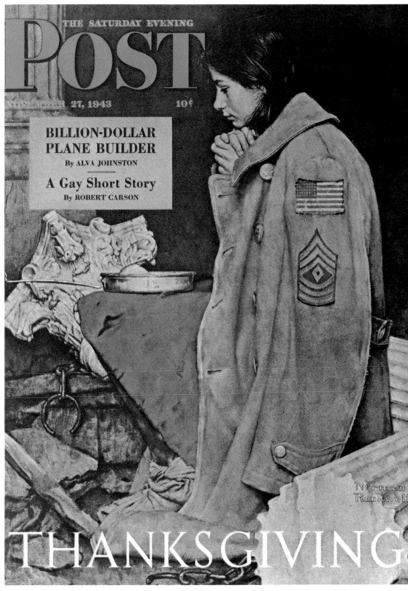

THANKSGIVING

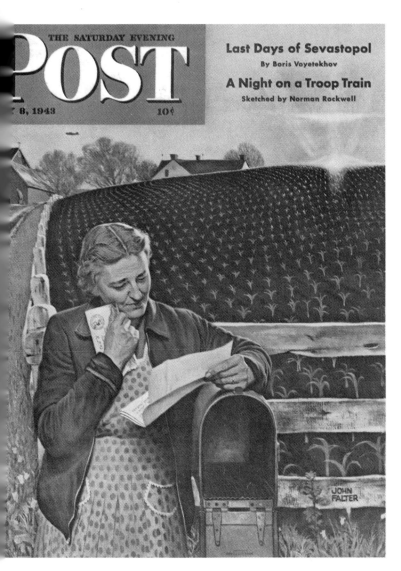

One understands why it was that in wartime humorous covers outnumbered serious ones—it was necessary to laugh to keep from crying. The darker themes of separation from loved ones, hunger, and devastation surfaced in these by John Falter (left) and by Rockwell (above, below). This was the real war, but the magazine reader's tolerance for such reality was limited.

the First World War I had done pictures of the dough-
boys in France, but it had all been fakery. I'd taken
familiar scenes—a little girl pinning a flower in a sol-
dier's buttonhole, a mother mending her son's socks—
and altered them to fit the new locale by dressing the
models in costume—soldiers' uniforms, Dutch caps,
wooden shoes. It hadn't seemed to matter that the
pictures lacked authenticity. I had been young then
and unsophisticated, just trying to get ahead, establish
myself as an illustrator. But in the intervening years I
had developed a style and a way of working. Now my
pictures grew out of the world around me, the everyday
life of my neighbors. I didn't fake things any more. So,
naturally, I didn't attempt to do battle scenes—the
troops in Italy or on Saipan. I painted scenes and
people I knew something about. And if I had a picture
to do of a scene with which I was unacquainted, I
researched it.

There were, for instance, the sketches of a troop

train. For that one I visited a paratroopers' training
base.

I went up with one squad of paratroopers when they
made their fifteenth jump. As I boarded the plane the
pilot pulled a parachute off a rack and, turning me
around, started to strap it on my back. "Oh no," I said,
"not me." "Supposing the plane crashes?" suggested
the pilot, kicking the side of it so that the metal plates
rattled tinnily. "I'll stay with it," I said. All the para-
troopers laughed.

They were a wild, crazy bunch. Small, wiry men for
the most part—daredevil, proud, and fierce. The offi-
cers encouraged these qualities in their men. You had to
be proud, daredevil, absolutely courageous, and even
somewhat wild to jump from a plane, usually behind
enemy lines. . . .

I sketched all the time at the base and during the
train ride to the port of embarkation. (I was put off the
train before we reached the port, however, because it
was top secret and no one was allowed to know what it
was.) Then I went home to Arlington, and the para-
troopers boarded their ship and sailed to England. A
few months later they were dropped behind the Ger-
man lines in France on D-Day.

And, finally, there were the homecoming covers—
the marine describing the landing at Iwo Jima to his
friends in a garage; the sailor basking in a hammock on
the front lawn of his parents' house; the soldier surpris-
ing his family and friends in the backyard of his tene-
ment home. His mother is holding out her arms to him,
his little brother is running to meet him, people are
looking out of windows, boys in trees are shouting, his
girl is standing quietly to one side. The whole neighbor-
hood is surprised and happy. He has come back. The
war is over.

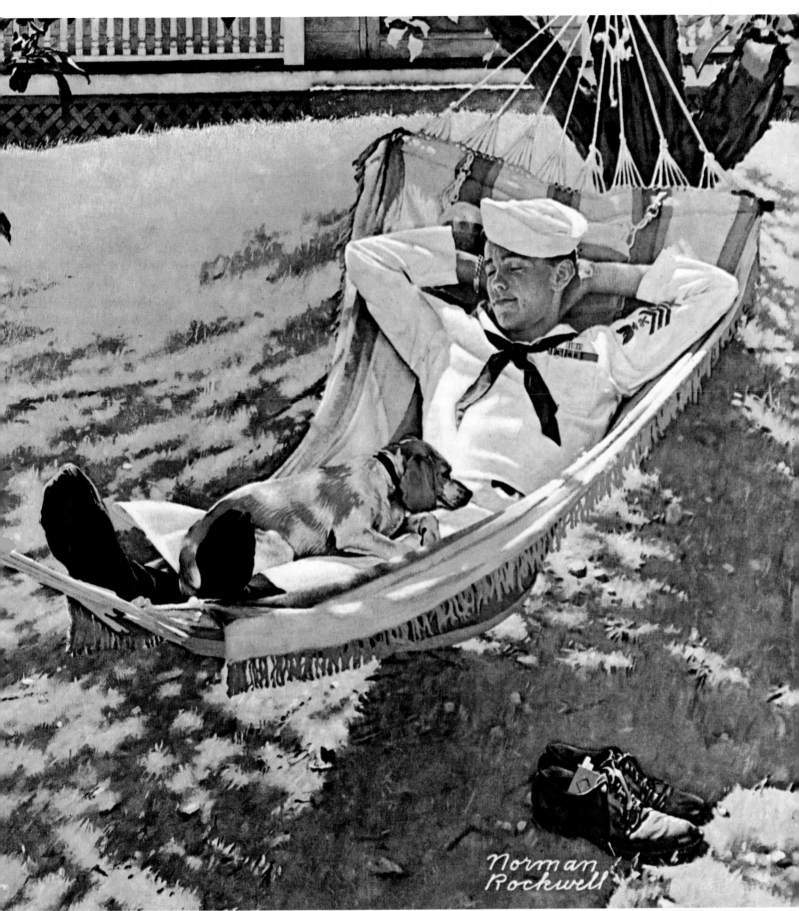

For the most part, Rockwell left battlefield and bombs to other artists; his war was the war at home, and his most eloquent wartime covers are the ones with "homecoming" as their theme (pages 78 and 79). For this serene evocation of the joys of small-town summer his model was a sailor in training at Williams College. The house in the background is Arlington neighbor Vic Yalo's. The shoes are Rockwell's, and the dog is his son Tommy's. (Opposite) More sketches from "A Night on a Troop Train."

The Soda Pop Saga

Pictures for Parker pen ad. Three college girls standing together, ohing and ahing over new Parker pen sent to one of them by her father. Commotion. Pop arranging their heads, shoulders, hands, wrappings of pen, card from father, urging models on. Pop: 'You're excited. Lift your eyebrows. Up. Up. Oh *boy*, look what I've got! Daddy sent me a *beautiful, beautiful* Parker 61 pen!' "

These notes, taken by Norman Rockwell's son, Tom, in June of 1959, describe the artist at work in one of his major areas of illustration: advertising. Between the years 1912 and 1965 Rockwell created nearly 1,000 advertisements for some 75 different companies, and many of them compare favorably with his best work.

Like his magazine covers, Rockwell's ads tell stories. The plots are brief and the outcome obvious, but they are still stories that give us varied characters in interesting situations. A grandmother showing children how easy it is to make Jell-O. A boy and girl using contrasting methods to eat corn-on-the-cob—he messy but enthusiastic, she neat and prim. A painter refinishing the antique cradle he finds in the family attic with a brand of paint that will preserve it for future generations.

And the people in Rockwell advertisements, like the people in his magazine covers, are real people. As a matter of fact, they are often the same people. The gaunt mustachioed model who is, on the cover, painting a flagpole or considering the purchase of a saxophone may appear on an inside page of the same magazine extolling the virtues of Maxwell House coffee or the Encyclopedia Britannica. The plump, jolly-looking man who is, on the cover, the visiting grandfather with a puppy in his pocket, may be sampling Campbell's tomato juice or Budweiser beer inside the issue. This double exposure occurred most often in the 20's and early 30's, when Rockwell used over and over again the professional models whose faces interested him. (Professional models were the only people who had time to pose, hour after hour, for an artist who worked "live." Later, when Rockwell worked from photographs, modeling was a matter of minutes rather than hours and all kinds of people were eager to pose for him.)

Sometimes the idea for an advertising picture came easy, sometimes it came hard. Rockwell tells how in 1921 he accepted a contract with the Orange Crush soda pop company. They commissioned him to do 12 pictures at $300 apiece and, for that kind of money at that time, the artist couldn't resist. After completing the first two or three pictures without any trouble, how-

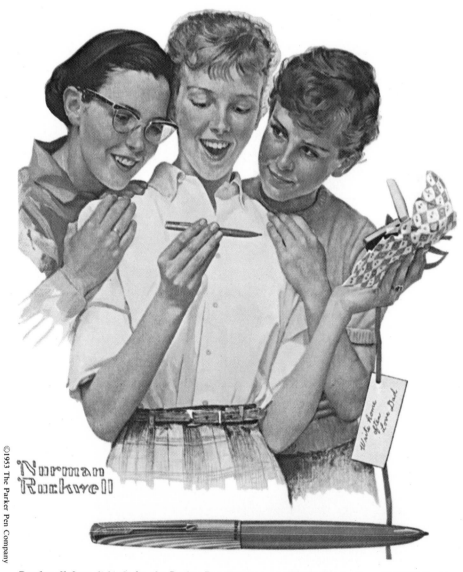

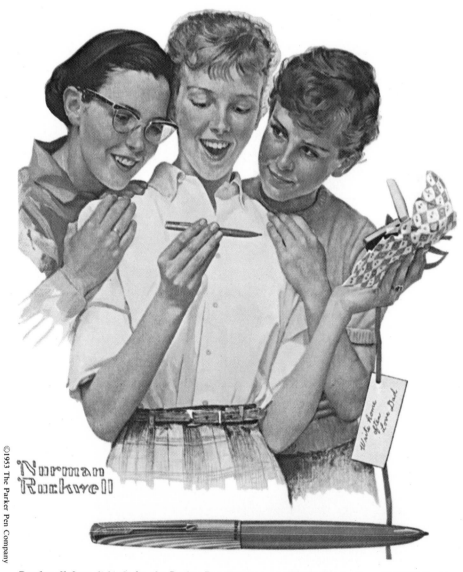

© 1953 The Parker Pen Company

Norman Rockwell

Rockwell first did ads for the Parker Pen Company in 1928. It wasn't until 1953 that he did a second series. The ad pictured above is from the latter group.

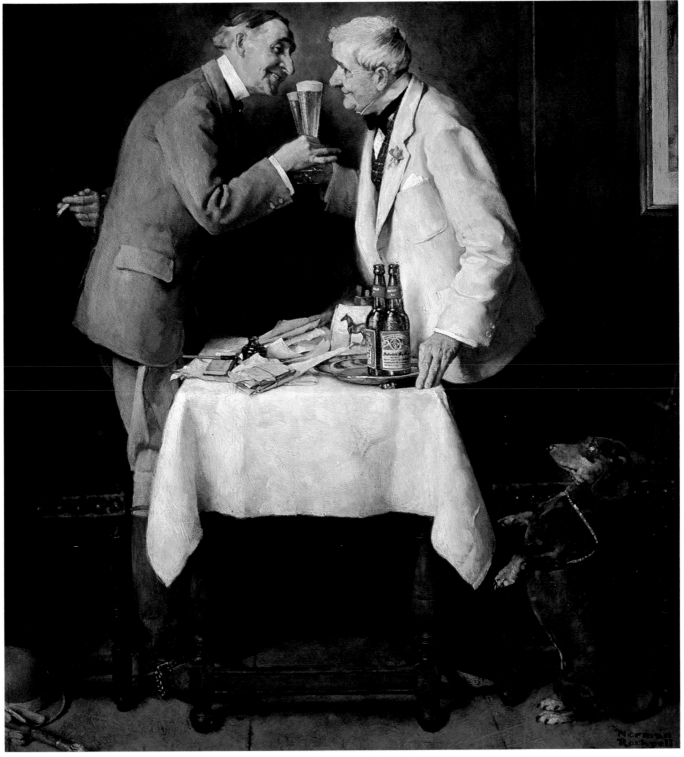

Entitled "When Gentlemen Agree," this ad for Anheuser-Busch, Inc. (Budweiser) first appeared in The Saturday Evening Post *in 1933. Early renditions are unsigned. A later version shows a signature. Both have been widely reprinted.*

ever, he began to experience difficulty working the bottle into the scenes, as the product had to be prominently displayed and the label clearly legible. In his autobiography, he describes the contortions he put himself through in an effort to produce one of the ads—and only the fifth or sixth of the twelve-ad series at that!

"All right, I'd say to myself, I've got a young man and woman sitting in a car. They are drinking Orange Crush, the delectable refreshment (I had to keep repeating the slogans to work up the proper enthusiasm). Now the girl is drinking from the bottle. How's that? No, the label would be upside down. Well, shall I have the man handing the girl the bottle? No. His hand would cover up part of the bottle. How about putting the bottle on the running board of the car? No, then they're not enjoying it; then it looks as if Orange Crush isn't the most important thing in their lives."

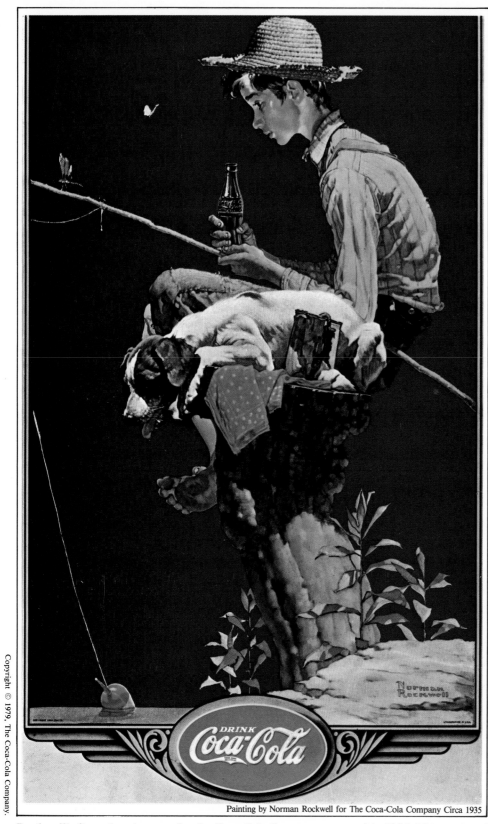

Painting by Norman Rockwell for The Coca-Cola Company Circa 1935

Rockwell's first advertisement for the Coca-Cola Company appeared in 1928. This portrayal of the familiar country boy with straw hat, fishing pole, and spotted dog dates from 1935.

"The boy who put the world on wheels" is one of a series of advertisements that appeared in 1953 commemorating the 50th anniversary of the founding of the Ford Motor Company. The mechanically inclined youngster is, of course, the first Henry Ford. Rockwell showed him at the age of 10, at the bedroom shelf that served as his first workbench. Beside him, watches he repaired for neighbors.

140

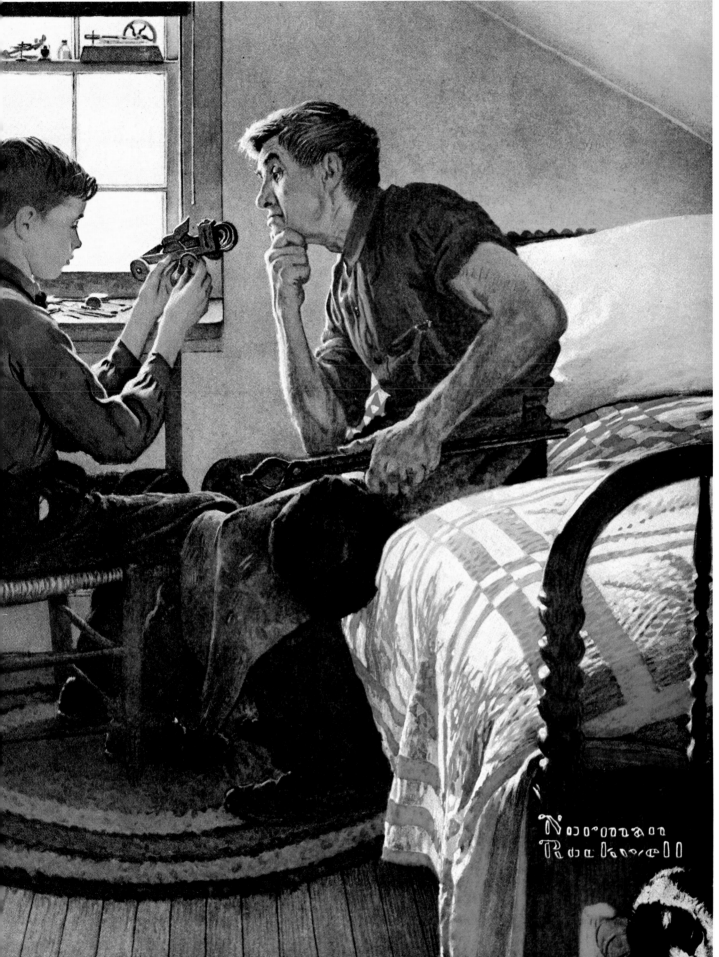

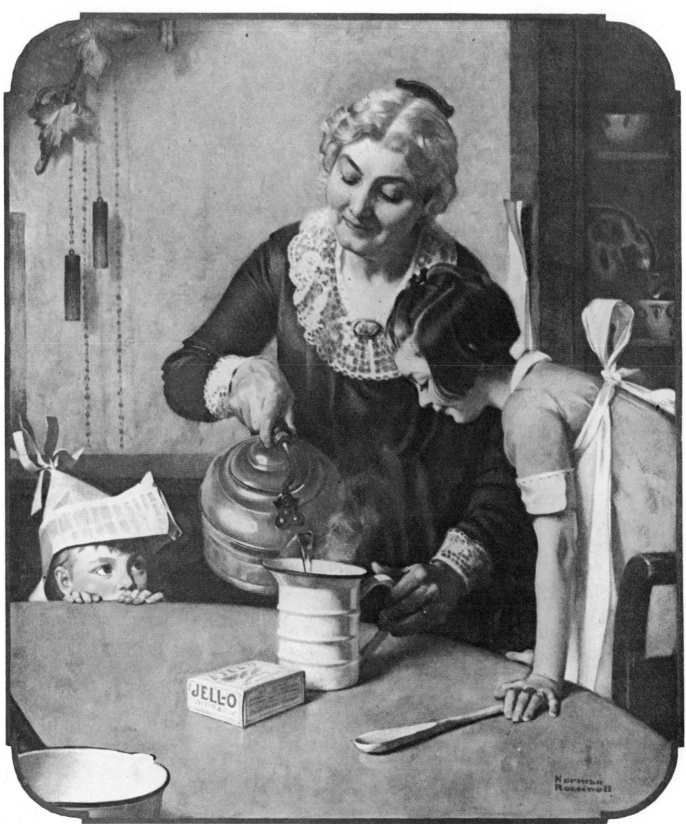

And on and on it went. He ended up standing the man outside the car and balancing the bottle precariously on the door with the woman's fingers pushing at the back of it as if she were giving it to him. By the time he got to the eleventh and twelfth pictures, he was having nightmares in which huge bottles of Orange Crush, their labels all distinctly readable, marched down upon him. Rockwell did one ad a year for Coca-Cola for a number of years without any trouble, but without a contract. "It was the contract that did it to me," he said later about the Orange Crush series. "Just knowing I had to do 12 pictures featuring those darned bottles!"

Very special skills are needed in

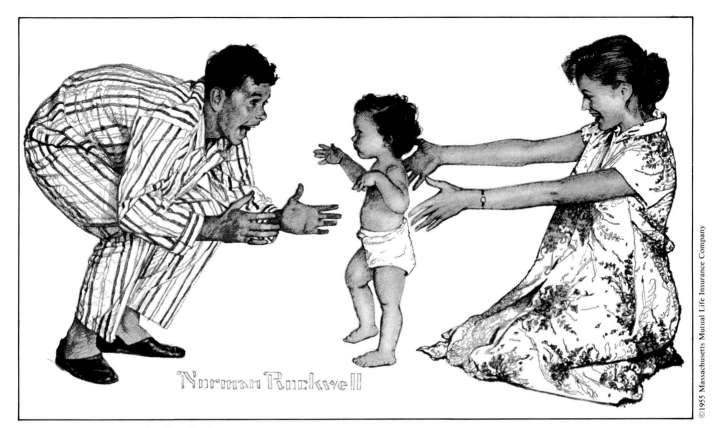

Eloquent faces! In the Rockwell advertisements as well as in his work done for magazine covers and story illustrations, children and grownups express a galaxy of emotions: rapt attention, excitement, pride. On the opposite page, a 1923 painting for Jell-O. Above, a 1958 pencil drawing, one of a series of 79 created for Massachusetts Mutual Life Insurance Company.

order to create a great advertising picture. One must know what to put in—and what to leave out (so the eye is not distracted by extraneous details). How to arrange persons and objects so that the viewer's eye is subtly led to the product advertised.

Tom Rockwell took the notes describing how his father set up the Parker Pen ad in 1959 more or less as a joke. In the process, he recorded something important about the way Rockwell ads were born. Rockwell set up the scene like a stage director. Like an actor, he communicated his own enthusiasm. He was creating the moment he wanted to capture. Here, as well as in the sketching or painting, Norman Rockwell was a great artist.

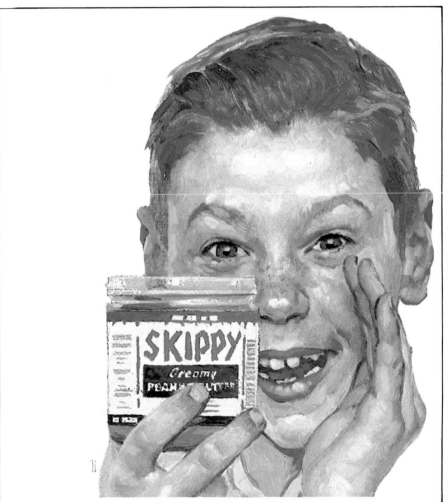

The typical Rockwell child is freckle-faced, wide-eyed, gap-toothed. Such a face goes well with baseball bats, puppies, marbles—and, of course, peanut butter.

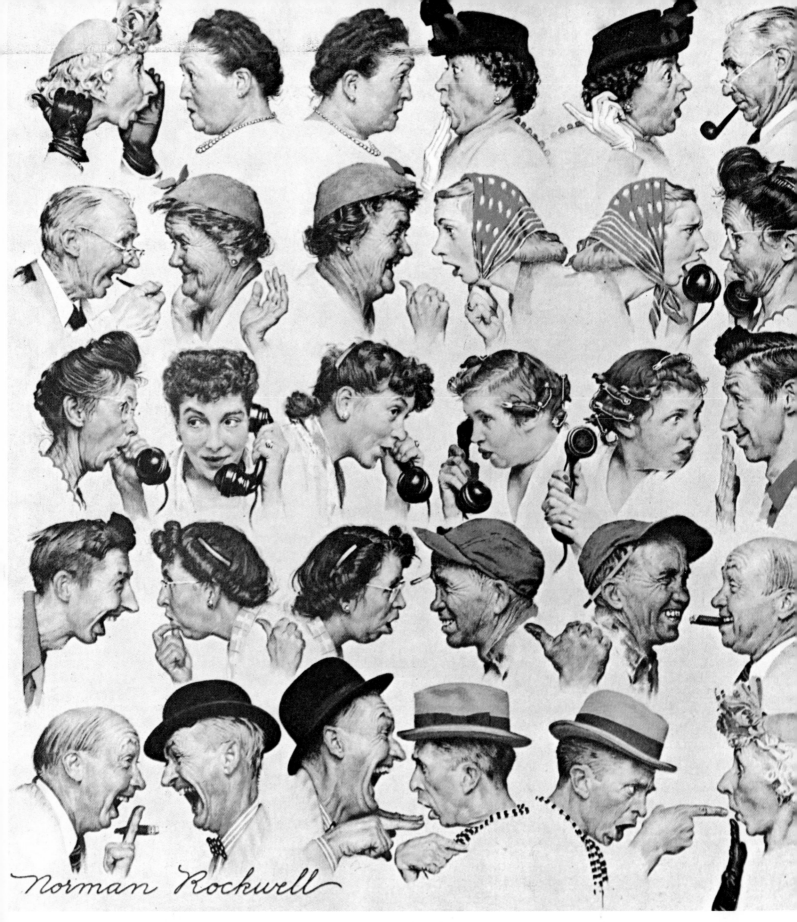

ACKNOWLEDGMENTS

Photo credits: Black-and-white photos on pages 45, 46, and 47 are from the Bettmann Archive; the photo on page 18 is from Brown Brothers.

The publisher wishes to thank the corporations that granted permission to reproduce advertisements created by Norman Rockwell. In all cases the art is the property of the corporation and cannot be reproduced without permission.

All art not otherwise credited is the copyrighted property of The Curtis Publishing Company and cannot be reproduced without permission.